Celebrating Inuit Art

1948–1970

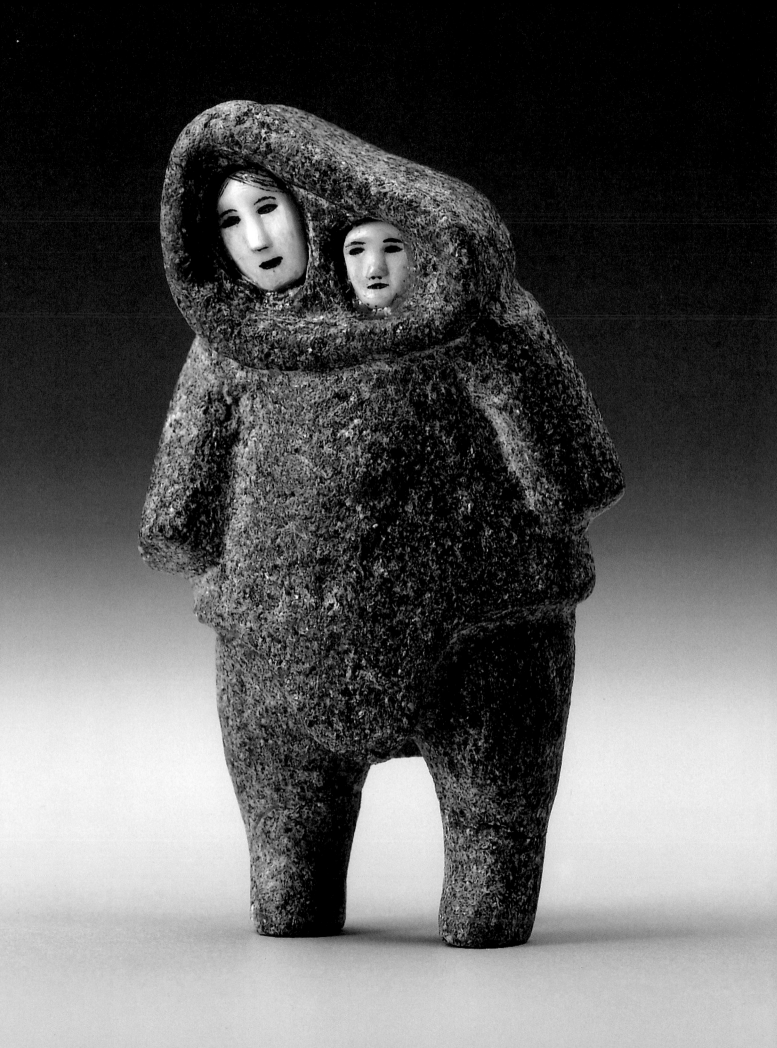

Celebrating Inuit Art
1948–1970

Edited by
Maria von Finckenstein

Foreword by
Adrienne Clarkson

Essays by
James Houston
and
Ann Meekitjuk Hanson

CANADIAN MUSEUM MUSÉE CANADIEN
OF CIVILIZATION DES CIVILISATIONS

KEY PORTER BOOKS

Canadian Cataloguing in Publication Data

Celebrating Inuit art, 1948-1970

Essays by Ann Meekitjuk Hanson, James Houston and Maria von Finckenstein.
Sponsored by the Canadian Museum of Civilization.

ISBN 1-55263-104-4

1. Inuit sculpture – Northwest Territories. 2. Sculpture – Quebec (Province) – Hull. 3. Canadian Museum of Civilization. I. Hanson, Ann Meekitjuk. II. Houston, James, 1921- . III. von Finckenstein, Maria. VI. Canadian Museum of Civilization.

E99.E7C44 1999 730'.89'971207193 C99-9315-6-4

The publisher gratefully acknowledges the support of the Canada Council for the Arts and the Ontario Arts Council for its publishing program.

Canadä

We acknowledge the financial support of the Government of Canada through the Book Publishing Industry Development Program (BPIDP) for our publishing activities.

The Canadian Museum of Civilization gratefully acknowledges the support of Cancom.

Key Porter Books Limited
70 The Esplanade
Toronto, Ontario
Canada M5E 1R2

www.keyporter.com

Frontispiece : Unidentified artist, *Mother and Child* (details on page 114).

Photographer: Harry Foster
Photo Credits: Paul von Baich, pg 22, 40. Courtesy of Indian and Northern Affairs Canada.
Typeset in Meridien and Today Sans Serif
Design: Peter Maher
Electronic formatting: Jean Lightfoot Peters

Printed and bound in Canada

99 00 01 02 03 6 5 4 3 2 1

Contents

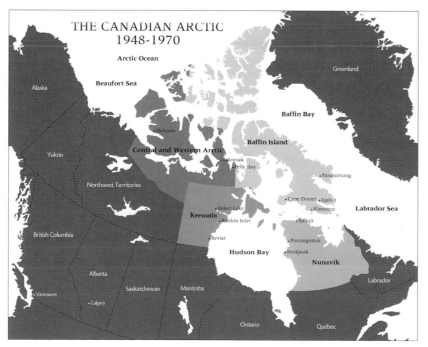

Historical Names	Current Names
Arctic Quebec	**Nunavik**
Inukjuak	Inukjuak
Povungnituk	Puvirnituq
Sugluk Salluit	
Baffin Island	**Qikiqtaaluk**
Cape Dorset	Kinngait
Lake Harbour	Kimmirut
Frobisher Bay	Iqaluit
Pangnirtung	Pangnirtung
Keewatin	**Kivalliq**
Eskimo Point	Arviat
Baker Lake	Qamanittuaq
Rankin Inlet	Kangiqliniq
Central Arctic	**Kitikmeot**
Pelly Bay	Aqvilikjuaq
Spence Bay	Taloyoak

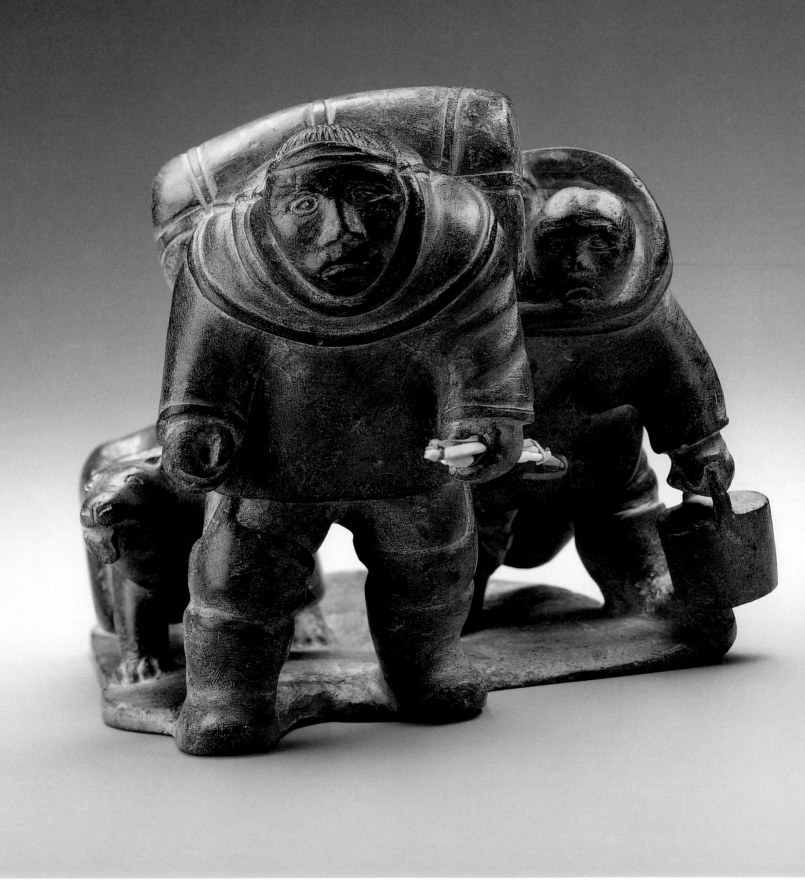

Juanisialu Irqumia, *How They Hunted Caribou Inland (details on page 86)*

Expanding Our Boundaries

Cancom (*Canadian Satellite Communications Inc.*) is proud to support the Canadian Museum of Civilization's extraordinary Iqqaipaa exhibition. The art reflects tradition, culture, courage and resilience, and the mysteries of destiny that led James Houston to expose Inuit talent to the world.

Since its formation in 1981, Cancom has involved itself in communications in the Far North. Few TV signals reached small and far-flung communities at that time and Aboriginal peoples had no way of distributing programming in their own languages. Inspired by Yukon businessman Rolf Hougen, Canadian broadcasting entrepreneurs formed Cancom, the world's first satellite-to-cable broadcast company. From the outset, Cancom has supported Aboriginal radio and television with free satellite services. One of the beneficiaries, Television Northern Canada (TVNC), the world's first Aboriginal satellite television service, evolved into the national Aboriginal Peoples Television Network (APTN) which was launched September 1, 1999. APTN's Chief Operating Officer, Abraham Tagalik, sits on Cancom's board and is an Inuit artist in his own right.

Over the years, in helping Canadians take full advantage of satellite technology, Cancom has developed new services ranging from interactive distance learning to mobile communications for trucks. In 1997 it became a principal player in Globalstar Canada's satellite-based telephone service, which will extend communications to virtually every corner of the world. On September 1, 1999, Cancom entered a whole new field of satellite activities by acquiring Star Choice, the first Canadian company to provide broadcast services direct-to-home (DTH). The "new Cancom" now has a foothold in the most exciting and dynamic sector of the satellite industry.

Communications technologies present opportunities to push back frontiers to allow more voices to be heard by more people, as the Museum of Civilization demonstrated by Webcasting the opening of the Iqqaipaa exhibition. For their part, Aboriginal broadcasters make it possible to preserve and disseminate rich oral traditions in the languages of their people, much as the Inuit artists carve their way of life so beautifully in stone.

On behalf of Cancom's board, management and staff, I salute them all.

RICHARD STURSBERG
Cancom Prsident and CEO

F o r e w o r d

Adrienne Clarkson

On April 1, 1999, I was fortunate to be invited to participate in official ceremonies marking Nunavut's inauguration as Canada's newest territory. In recognition of this historic event, many organizations presented special programming designed to showcase the enduring artistic and cultural traditions of the Inuit. At the Canadian Museum of Civilization, this programming included the wonderful exhibition *Iqqaipaa: Celebrating Inuit Art, 1948–1970*. Sponsored by Cancom—a company with a longstanding commitment to Northern communications and broadcasting—the exhibition was curated by Maria von Finckenstein, with James Houston as special adviser.

The 150 works in that exhibition were the genesis for this book. Designed to provide a voice for the artists themselves, *Celebrating Inuit Art* highlights the artistry, lives, and pragmatism of the Inuit people. Portraying a centuries-old culture during a time of dramatic transition, these marvellous works of art depict traditional ideas and ways of life through a lens imposed by the modern world. It is perhaps this dichotomy, so gracefully expressed, that gives Inuit art some of its vitality and appeal. From joyful celebrations of myth and legend to tender evocations of the bond between mother and child, it is an art that speaks to us all, for it speaks in the voice of elemental human concerns, beliefs, and aspirations.

It is also an art that has so successfully transcended artistic and cultural boundaries that it has come to represent the very essence of Canada. I remember a time—not so long ago—when the only art that seemed to identify Canada without question was either by the Group of Seven or by Inuit artists like Kenojuak Ashevak, Peter Pitseolak, Pitseolak Ashoona, Lucy Qinnuyuak, and others.

We may be surprised that this should be so, for the Inuit are not part of the Canadian mainstream. Relatively few in number, their homes lie far to the north of major population centres, and for many decades they were virtually cut off from the rest of Canada. Southerners still tend to think of the Inuit as inhabitants of a land without trees; a land of polar bears and caribou; a land of aurora borealis, midnight sun, intense cold, and an environment that one might politely call "inhospitable."

And therein, perhaps, lies another face of Inuit art's appeal. For it is an art that

wrestles something sublime out of a life-and-death struggle for survival. It is an art that explores humankind's relationship with nature. It is an art that evokes the spiritual essence of a country like Canada—and our intrinsic loneliness in the face of a landscape that is vast, often empty, often unknowable. It might be this, above all, that makes Inuit art so evocative of what it means to be Canadian—and perhaps, at heart, what it means to be human.

The publication of this book coincides with the fiftieth anniversary of the first sale ever made by an Inuit artist. It was a sale facilitated by Mr. Houston, who had seen Inuit carving on his early northern travels, and knew that the rare beauty and spirit of Inuit art would quickly find a wider audience. Others soon followed his encouraging example—including factors of the Hudson's Bay Company, private collectors, and galleries and museums around the world—all of whom recognized the captivating way that Inuit artists are able to meld myth, tradition, experience, and humour.

Inuit art speaks to the intrinsic courage, whimsy, and optimism of the human soul. It also speaks to our ability to adapt and thrive—whether in response to a harsh physical environment or to the pressures of an extra-traditional world. These characteristics have given Inuit art an intrinsic charm and grace—and a ready audience around the world. We are proud to present this book honouring the people of Canada's newest territory— showcasing an art that observes no boundaries in its celebration of the human spirit.

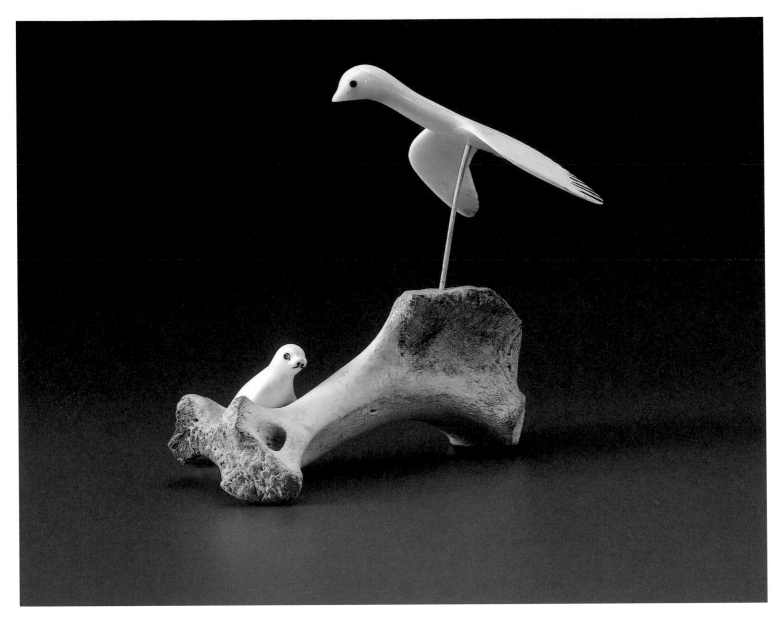

Maria Niptayuq

1943–

Pelly Bay

Flying Bird and Seal on a Base 1966

bone, ivory, black colouring

10 x 5 x 10.5 cm

unsigned

Canadian Museum of Civilization, gift of the Department of

Indian Affairs and Northern Development, 1989 (NA 1188)

Introduction

Maria von Finckenstein

The North has been Canada's last frontier. Until the Second World War it had remained largely ignored by the rest of Canada, except for the very bold and adventurous. Since the mid-1700s a succession of explorers looking for the Northwest Passage, of whalers looking for oil, Hudson's Bay traders looking for fox pelts as well as missionaries looking for souls ventured into the North and met its inhabitants, the Inuit.

Although these visitors to the North introduced some new trade goods, especially rifles and tea, tobacco and flour, the nomadic lifestyle of the Inuit hunters remained fairly untouched by the intruders. In the late 1940s most Inuit still lived in small family camps, used dogsleds for travel, lived in igloos during the winter, and divided their time between trapping white fox and hunting.

All this was to change dramatically over the next two decades. For a variety of political and strategic reasons the federal government of Canada started to take an active interest in the welfare of its northern citizens. In 1939 a ruling of the Supreme Court had accorded Inuit the same rights to health, welfare, and education as Canadian Indians. In 1947 family allowance cheques began to be issued, administered by the Hudson's Bay Company or the RCMP, followed by old-age pensions in 1948. During the 1950s annual visits by a government ship administered medical surveys and tests for tuberculosis. In 1956 a program of low-cost housing was introduced. In 1955 a selection of children were sent to Chesterfield Inlet to be taught by the Grey Nuns until, in 1959, federal day schools were built across the North. By 1970 the process of giving up a nomadic lifestyle and moving into permanent settlements was completed.

One of the reasons the Canadian government felt compelled to intervene was the receipt of reports from visitors to the North about the deteriorating conditions among the Inuit, partially caused by the fact that the price for white fox had plummeted on the world market. Consequently, the main means for procuring cash had dried up for Inuit trappers. Although as hunters they lived largely off the land, they had become

dependent on cash to buy their rifles and ammunition. With nothing to trade, families experienced severe deprivation and periods of starvation.

Against this background of rapid cultural change, contemporary Inuit art came into being. Soon sculptures replaced the white-fox pelts as a way to procure cash. The transition from one object of barter to another was fairly smooth. For two hundred years Inuit hunters had, whenever possible, bartered little souvenir items with any of the groups finding their way into the North. However, this production and trade of carvings, usually made out of ivory, was sporadic at best and only took place locally.

When James Houston, a young adventurous artist from Toronto, landed in Inukjuak in Arctic Quebec in 1948 he was presented with one of these whittlings and, with the eye of the artist, recognized its beauty. He solicited more and brought back a whole selection that he presented to the Canadian Guild of Crafts in Montreal and so the adventure began. The Guild, the Hudson's Bay Company, and the federal government established a distribution system and a market in the South was created. The stage for the enthusiastic reception of contemporary Inuit art was set.

If we want to appreciate Inuit art from this period, 1948 to 1970, we need to be conscious of its context. Here was a group of people displaced and dispossessed, out of their element, trapped in a small community with other Inuit groups with whom they had never before had occasion or desire to associate. They had lost control over their lives. The powerful trio of the RCMP, the church, and the Hudson's Bay Company made all the vital decisions for them. Next in line was the Northern Services Officer from the Department of Indian Affairs and Northern Development, who represented the awesome power of the federal government.

Was it any wonder that people grabbed with such fervour the opportunity to make a living through carving? This was their way out of humiliating dependence, all the harder to bear since they had enjoyed total freedom and independence before.

Life as hunters and keepers of the camp had not prepared them for settlement life, which required different skills, such as a working knowledge of English. Making art provided a solution. All the superb skills, honed over centuries in the struggle for survival—knowledge of Arctic animals, an astonishing visual memory, infinite patience and perseverance—could be applied to making a sculpture. Also, the law of survival had taught the people to be creative in an environment that required knowing how to repair

a rifle or fabricate little spare parts if necessary because the next hardware store was thousands of miles away.

Making art also helped to survive emotionally. My father's experience serves as an illustration. After the Second World War, he was dispossessed, his familiar way of life radically changed. A refugee from East Prussia, he was barely tolerated by the West Germans. To maintain a connection to his roots, he wrote a novel set in his beloved East Prussia, which was no longer. His endeavour was a means to hold on, to deal with the loss. I believe it was much the same for this generation of Inuit. Creating artworks depicting the nomadic lifestyle was a way of preserving it in their minds as they had to become acclimatized to a new and alien culture. It was also a way of regaining control over their lives. Every artist became an entrepreneur, quarrying his own stone, fashioning his own tools.

The artists had no romantic notions about art—it was a way to survive, and they accepted the new vocation unquestioningly. The ones less fitted for making sculpture took other jobs whenever possible.

The astonishing fact is that this art, born out of economic necessity, has such evocative power. Its appeal lies in its honesty and stark simplicity.

Having focused minds and imaginations not burdened with the redundant images that flood people living in an industrialized world—these were pre-television times—these self-taught artists created images of stunning visual power and archetypal significance—reason for celebration, indeed.

Celebrating with George Pitseolak

Ann Meekitjuk Hanson

George Pitseolak, son of Pitsiulalaq and Akavak of Kimmirut, begins his story by describing the life he vividly remembers season to season:

This is what is was like: in the season just before autumn, we would move to Eviit, our winter home. It was a beautiful place. When we arrived, we would inspect our things. They were exactly as we had left them. There was our winter hut, bared to its shell with its floor intact, my mother's quliq, *sealskin-drying racks, the* tatigiit, *meat storage on stilts. If we happened to arrive after a snowfall, we saw many prints of animals and birds. Our voices and laughter boomed throughout the land. With the little instructions from our parents, we set out to do our chores.*

The women went to gather crowberry bush and Arctic heather to insulate our hut. Sometimes my grandmother Simataq had gathered crowberry bush before we left and neatly piled them all over the place. If it had snowed, there was soft snow on top of them. When you touched it, it dropped to the bottom right away, and the pile shook but stayed. The smell of the bushes was very refreshing

The young girls tended the younger children. The men made or repaired dog harnesses, ropes, reinforced sleds, repaired the shell of the hut, which was made from wood, inspected all hunting tools.

The older children were instructed to be responsible for bringing water or ice. They were to keep the human-waste pots empty and clean.

When all the crowberry bush and arctic heather were gathered and delivered near the hut, everyone was called. All hands were needed to hold the canvas down while the stronger ones gathered rocks and placed them on the bottom.

Once the shelter was completed, my mother and father inspected it inside and out. My mother was responsible for the platform for our bedding, the seal-oil lamps, drying racks, the placing of windows and the air vent. My father was responsible for the outside, making sure the structure was sound, and that it had a porch. When we were finally allowed to enter, it was warm, comfortable, and cozy. It was good to be home.

We were ready for the winter. Now it was time to see what kind of winter it would be. Our father watched the weather instinctively. Our livelihood depended on where the animals, mammals, birds would cross our paths. The floe edge, where the sea ice ends, was our biggest food source. It never freezes in the winter but is never the same from year to year. Sometimes the ice is so thin that it shakes when you walk on it. Sometimes it is uneven and sometimes smooth. Some winters it is near the land or it is very far out.

As my father watched the weather and the ice conditions, we waited for his decision. When the floe edge was near enough to our winter home, we stayed. If it was too far to travel back and forth regularly, we moved nearer to it. We made snow houses on the land and hunted at the floe edge. We stayed until there was enough food for our families, dogs, ample fat for the heat and light, skins for boots, trousers, mitts, ropes, or sinew for threads.

One time I especially remember my grandmother Simataq was left behind. I don't recall for how many days. We had many people to take with us. We made snow houses for everyone, made the temporary home livable, then my grandmother was picked up at our winter home.

We lived in this temporary winter home following the variation in the floe edge. When the ice broke up during the spring season, we moved to our spring and summer home. My father, Akavak, always made sure that the spring and summer home had a good place to anchor his boat safely and that it had a river for our water supply.

Moving to the summer home was a considerable effort because we had to go back and forth many times to transport people and gear. The women and children would go first. We had to leave some people behind to look after the dogs, the last to be moved. They were not very good boat travellers! They were nervous in the boat.

Many activities took place at the spring and summer home. There was fishing, berry picking, clam

digging, kelp gathering, drying meats, caribou hunting, egg gathering, skin and pelt drying and tanning for winter use. Spring and summer were times of comfort and plenty.

Toward the end of summer, some fish, seal, and walrus were caught along the shore for winter use. They were prepared so they would not spoil too much. This was done when the weather cooled down enough to preserve the meat. Rocks were piled around the meats and on top so foxes, wolves, weasels, and polar bears would not get them. These meats were just-in-case food for us and our dogs because some winters were so harsh that starvation was never too far away, when few animals appeared. Also the aged meats are a delicacy to some people.

With autumn and winter on us, it was time to go back to our winter home. This is how we lived season to season. This is not in great detail but a general description.

George Pitseolak recalls hearing announcements in Inuktitut on the short-wave radio when Ann Palluq reported from Montreal, as did Ittuaq from Churchill, Manitoba. It was exciting to hear what was going on in the outside world. People gathered around the radio as the voices boomed, fading and crackling when the reception turned bad. The Inuit announcers played various music, with country and western being the most popular. They talked about the life in the big city, describing many buildings, cars, trees, flowers, stores with food to be bought. They reported about our relatives in the southern hospitals.

Then there was one announcement that changed the Pitseolak family and that of all the Inuit forever—the Inuit were required to move into communities where there were schools, learning centres. George remembers not moving right away. He heard the announcement many more times before making the big decision.

All the children would have to attend school. He thought about his own children, their future. He remembers thinking he wanted them to have an opportunity to learn things he never had the chance to. George says, "The move was entirely for the children. In my mind, I wanted to remain in our home on the land. I was reluctant to leave. No one came to get us. We delivered ourselves to a new life." If the children did not attend school, the government would discontinue their only cash income, the family allowance.

Once they were in Kimmirut, George got a job with Hudson's Bay Company. The family was fortunate to have a house to move into. Many others had no houses or jobs. They lived in tents as long as they could, then made huts from scrounged scraps of wood and cardboard. Several years later the government of Canada built houses for the Inuit.

Life in the community was very different from the one left behind. George remembers being homesick and missed the freedom to hunt. He says he could tell that his wife, Nellie, and the children were longing to be home. No one spoke much about individual feelings, but distress was quietly understood as they adjusted to their new life.

The most noticeable change was not having their children to themselves. "Privately," George notes, "we as parents felt our responsibility was lessened toward our children because they had new people to be accountable to. It felt like the children were taken away from us at first." There were other adults, the teachers, for them to answer to. George and Nellie had new worries about their children—that they might be bothering people or being hurt by others. The children studied English by day and spoke Inuktitut by night. George believes his children are fortunate today because they learned another language and that they know many more things he could not even think about. He is pleased they had the opportunity to absorb Inuit ways from their mother and from him too.

The other change was felt by the hunters. George saddens when he says, "I saw the once-strong independent providers not having enough to eat, not able to wear newly sewn clothes that signified their prominence. It is a sad image in my mind, especially the first winter we spent in the community. The hunters did not hunt as often because the very people they wanted to teach were in school all day, and they had no more dogs." When the snowmobiles were brought in, the hunters no longer tended their dogs. The animals were shot because people were afraid they might be idle pests around the community or maul the children.

Life on the land was living with few families, few neighbours. Life in the community was getting used to many more people. People visited each other, exchanging stories, talking more. This was the new age of gossip. George noticed people had less food or a variety of food because the hunters had to travel farther or be gone for many more days.

With leisure time and the need for money to provide food and clothe the family, the men turned to carving. George recalls, "We made mostly seals and seal-oil lamps because they were most identifiable and easiest to do." The carvings not only brought in extra cash to the families but also taught skills and kept the culture alive and meaningful. The carver's mental agility and imagination were stimulated by creating sculptures of animals, traditional stories, or shared memories. The Inuktitut language was enhanced as the people carved their stories in stone. Many artworks originate in legend—Talilajuuq, the mermaid, drum dances, dancing bears, shamanistic pieces, masks and countless animals, birds and fish. Lumajuuq, the woman who turned into a beluga, is one of many favourites to keep the legend of Kiviuq (a heroic figure) alive.

George Pitseolak believes that a carver must have an open mind. He likes to create what no one else has, and this takes a lot of thought and planning. He confesses with

modesty, "I am not a great carver. I do not carve to cause great amazement, but I like to create something that is original."

To a serious carver, money was not the main objective initially, George explains. "It was to find something to occupy the mind. People did not want to waste their time and energy. I appreciate that by creating the pieces, we keep memories alive because it is impossible to forget once you have seen and touched the past. I remember my joy when Inuit carvings were appreciated. I am always grateful and proud when I hear how the great Inuit artists are recognized and rewarded for their work. I celebrate their great work!"

When George started to carve to supplement the family income and the hunting, he did not think he was starting a family tradition. Four of his sons, Mark, Simataq, Donny, and Terry, are all accomplished carvers and artists. He now knows his sons must have been watching closely while they were growing up. Each time their work is praised, George feels that "it is as if I am included."

George remembers with loving laughter that "when my young sons finished their work, they asked my permission to sell their carvings. I inspected their work. I looked over their work carefully and when there was a flaw, I showed them how to finish it properly. Today they can show me how to finish my work properly!"

His second wife, Annie Manning, and George know that no one can go back to the former life and that memories are not enough to keep the Inuit ways and culture alive. They have taken action to confirm their strong attachment by organizing "on-the-land programs" for the young people and elders in Cape Dorset. During these programs they share their knowledge and love of nature. The elders talk about weather, ice conditions, plant life, sea creatures, songs, customs, survival in all seasons, shelter, life and death, birds, medicine, astrology, different ways to prepare and eat what the land and sea offer, and all aspects of the Inuit world.

George expresses that he and Annie want to "give our young people the chance to reconnect with the land because when you are born in town and do not get out to experience its peace and gratification, there is something missing." He would like to think that their program deters some of the despairing thoughts some people might have.

The collective strength of character to go from living on the land to moving into a big community, giving back to a community, passing on creativity, raising accomplished artists, continuing traditions is something to celebrate!

Fifty Years of Thinking It Over

James Houston

Ayii, Ayii, Ayii,

There is one thing

And only one thing,

To live to see

The great day that dawns

And the light that fills the world.

Ayii, Ayii, Ayii.

–Eastern Inuit song

Over a half century ago, late in the summer of 1948, the winds of chance carried me into the Canadian Arctic on a rare emergency medical flight. I had been drawing among the Swampy Cree Indians of James Bay and leapt at this extraordinary opportunity to fly into the Canadian Arctic. We stopped at two fuel caches beyond the treeline and landed in the single-engine Norseman floatplane at an Inuit camp north of Inukjuak on the east coast of Hudson Bay.

When we landed, my colleague Dr. Harper immediately went about his medical business while I hauled out my sketchbook, only to be immediately surrounded by the rest of the camp of smiling, laughing Inuit families. I knew three words in their language: *igloo, kayak,* and that familiar word *Eskimo,* or *Esquimau,* which was completely accept-able at that time. Those Inuit seemed to me short, tanned, good-natured, and exotic-looking people with their fur-trimmed hoods and their sealskin pants and boots. The women were carrying plump infants in the hoods of their long-tailed parkas.

Most of them stood on their toes and carefully observed the drawing I was making of a man standing near me. He held still for a while, then eagerly grasped my pencil and

sketchbook and started making a strong, sure drawing of me, even copying my strange habit of licking my lips in time with my pencil strokes. All eyes watched him intently, parents holding up their children to see his sketch. It was a good, quick profile drawing. I still have it. Then another person took my pad and drew an old woman. These drawings were surprisingly accomplished, with no distortion in the portrait of me in the head, the large chin, or the heavy eyebrows.

My thought was, *What manner of people is this? I've been doing outdoor sketches in Canada, Scotland, France, and Italy, yet no one has tried to take away my sketchbook and start drawing.* Then I remembered that I had never dared ask anyone to slide along on a piano stool

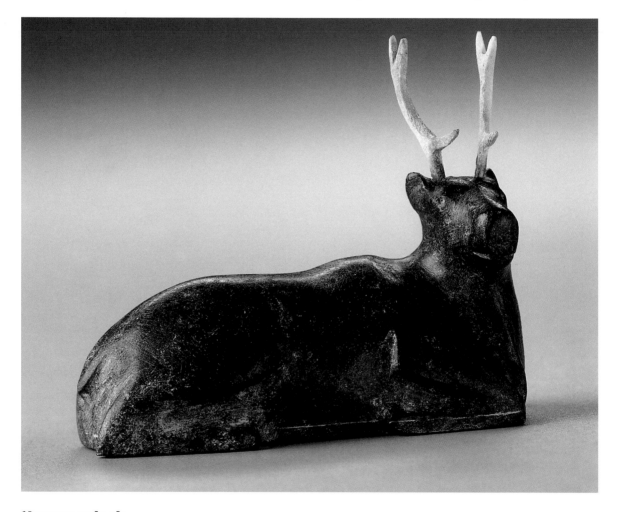

Nayoumealook

(1891–1966)

Inukjuak

Kneeling Caribou with Antlers 1948

black stone, antler

6.2 x 7.6 x 3.8 cm.

Collection of James Houston.

Provenance: James Houston, gift from the artist, 1948.

while I took over and played my impossible version of Chopin. Could that be because I never had the nerve? Someone had already convinced me that music is far beyond my capability. I'd been utterly awed by Michelangelo's drawings and sculptures, and even at art school in Toronto and in Paris I knew I still stood low on the artistic ladder. But I could see how these Inuit, thank God, seemed totally unaware of our strange artistic rules, unconsciously thrown up to intimidate our children to the south, not theirs.

That afternoon, at my request and to the doctor's horror, the small, rugged floatplane flew south without me. I wanted to stay among these interesting people in this vast, unknown part of Canada. They graciously allowed me to share their food and bed.

While I was making another drawing next day, a man (whose wife I had sketched the previous night) approached me, holding out his clenched fist. *This could lead to a punch in the nose, thought I.* But instead, Naomialuk opened his hand and revealed to me a small stone carving of a caribou with bone antlers. To my delight, he gave me this gift, which appeared ancient, like the ones I had seen in museums in the South. Later I received more strong Inuit drawings in my sketchbooks, and several other carvings. I wondered if these old carvings had been done by their grandparents or great-grandparents.

A few days later I hurried south along the rocky shoreline, guided by some young Inuit, to the Hudson's Bay trade store at Inukjuak. I immediately liked the Scottish trader there, Norman Ross. I opened my clenched fist as Naomialuk had for me and asked him, "How old do you think this carving is?"

He took a look, laughed and said, "Carved last night or maybe this morning, I'd judge—just for you."

I felt a sense of disappointment, like an antique collector discovering that his ancient treasure has just been newly made. Then a light went on for me. Could this mean that these people, roughly equipped with crude tools, dressed in shabby clothing and living in ragged tents, could this mean that they already possessed a better way of providing for themselves? Money was not known or used. In 1948 their main trade items were white-fox pelts, which had fallen in value to $3, and sealskins traded for 25 cents' worth of goods. No trade in carvings then existed. Could their ability as carvers help the Inuit to support themselves? An idea flashed into my mind. It was by far the most important thought that I have ever had in my entire life. I might be able to help these people develop a channel for their art from the North to art galleries, museums, and collectors in the South.

After I'd shown my small collection of carvings in the Canadian Guild of Crafts in Montreal in December 1948, the president, Jack Molson, and vice president, Alice Lighthall, were so enthusiastic about the carvings that I came to believe that the whole process would go forward. They offered me no salary for my second journey into the

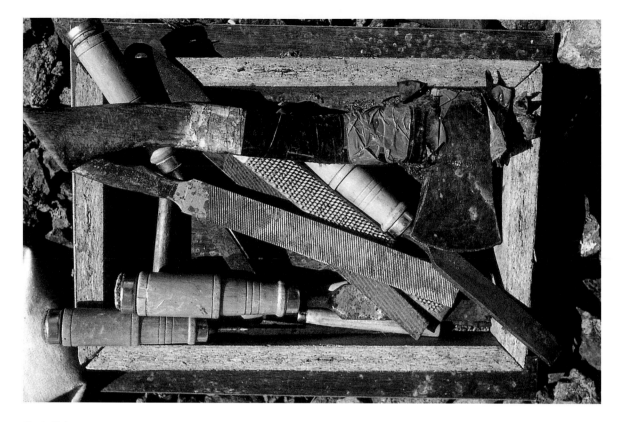

Carving Tools

Arctic, but the Guild did agree to finance my train and air travel north. That was enough for me. I started planning and packing, thrilled at the prospect. Then Jack Molson arranged credit for me with Hudson's Bay Company posts in Arctic Quebec for $1,000 to purchase carvings.

When I reached Inukjuak again, good stone carvings almost immediately began to flow to me. I was staying alone in a tent beside the small, unoccupied Anglican mission, where I stored the carvings. Soon I had to write another cheque to the Hudson's Bay Company for $500 additional credit. That was part of the money I had been given to make a new start in life in 1945 after five years' active service in the Canadian army.

When I was about to leave Inukjuak after a wonderful summer, friends gathered with many Inuit to say goodbye—the new schoolteacher, the nurse, the Royal Canadian Mounted Policeman, the HBC men, the radio man. All came to the plane. They looked aghast at all the wooden boxes I had nailed tight that filled the plane. My friends smiled, then shook my hand vigorously. "Goodbye. It's been fun knowing you, but we know you're never coming back. When your outfit sees those awful-looking bits of stone that you're flying out, they're going to fire you on the spot." The Inuit, not understanding, smiled encouragingly at me.

Back in Montreal, I helped the Guild to hold its first selling exhibition of Inuit

carvings with lots of free publicity from the city's papers. As I explain in much greater detail in my memoir, *Confessions of an Igloo Dweller*, the enthusiasm in Montreal was keen and the entire show sold out, including the carvings I had daringly purchased on my own. The Guild gladly reimbursed the money I had spent.

I was offered a job by the Canadian federal government to expand this new Arctic work. Early in the spring of 1950, I flew up the east coast of Hudson Bay to Inukjuak, stayed awhile, then took a dog team north to Povungnituk and Akulivik, visiting all the camps in between, noting the wonderful pot stone these people had for carving and encouraging them to start carving in exchange for useful trade goods like blankets and cartridges.

James Cantley, an elderly deputy commissioner with the Hudson's Bay Company, advised me against trying a dog-team journey up the east coast of Baffin Island, suggesting that I dog-team instead over to west Baffin Island. When I asked why, he said, "Those people are not always easy to get on with, but they have fire in their bellies." That turned out to be more than true. Early in 1951, after I'd met Allie Bardon in Montreal, we married and together made a long, hard, thirty-day dog-team journey across Baffin Island, visiting every remote Inuit camp on the south coast in order to encourage carving and check the availability of stone.

Cape Dorset, on west Baffin Island, became our headquarters and our home for the next eleven years. During that time I visited every Canadian Arctic settlement by boat, plane, or dog team to ascertain the possibilities of carving in stone, old whalebone, and caribou antler and to see what progress was being made by various artists who lived thousands of miles apart.

These Inuit artists of the 1950s and '60s always used a variety of carving materials: walrus ivory, stone, antler, bone. The Canadian eastern and central Arctic possess many rich, open deposits of workable pot stone, *okosiksak*. Deposits of stone suitable for carving are usually located along the barren coasts, sometimes below the tide line. Though inaccessible during the frozen months of winter, the stone is traditionally quarried during the long light that comes with summer, and differs in hardness from area to area, varying from the dark steatite to rich green jadelike serpentine, a material easily polished by hand. It is used for 90 per cent of contemporary Inuit carving.

Carvable pot stone was also used as an early trade item among Inuit who sometimes exchanged it for native copper over great distances. Some pot stone was also used for creating small likenesses of animals and humans much earlier, in the periods called Dorset (3,000 years ago) and Thule (1,000 to 500 years ago). There is an ancient, apple-size, green pot-stone human mask in the Churchill Museum, and there are a few other small pot-stone carvings there, collected from the nineteenth-century whaling trade.

Caribou antler is also a good carving material and abundant in some areas, since the animals shed their horns each year. An even hardier material is whalebone, which to be suitable for carving must have been dried for scores of years. Fortunately the American and Scottish offshore whalers left piles of the huge bones after they had taken the oil and baleen corset bone from these great Arctic bowhead more than a century ago. It was not until about 1953 that old whalebone was rediscovered as a suitable material for the carvers' art. No wonder Inuit carvings on a larger scale began to appear.

Collectors have long held walrus ivory in high regard. In the early contemporary period, 1948–1970, Inuit carvers greatly reduced their use of walrus ivory as carving material. If they had continued to rely on ivory, the whole art venture would have collapsed, for Canada, thankfully, has effective game laws against the slaughter of walrus not for their meat but for their ivory, a practice still unfortunately allowed in some countries.

Once free of the demand for ivory carvings to be used in cribbage boards, toy kayaks and other small models, Inuit carvers were inspired to use local pot stone in almost any dimension they cared to imagine. These two materials, pot stone and whalebone, as much as any other, caused contemporary carvings to become far more important than little native curios.

The artist hunters of the Far North are skilful butchers of meat, and that has led to their keen understanding of animal and human anatomy. Flesh and bones and sheaths of muscle seem to move in their artistic works. They show us how to drive the caribou, how to poise the harpoon, how to hold a child, how to move cautiously over thin ice.

I believe that Inuit in the past never developed a word for *art* because they felt no need for such a term. Like most other hunting societies, they thought of the whole act of living in harmony with nature as their art. So the small objects that they carved, such as animals and humans, were considered insignificant reflections of their total art of living. They share this belief with the Hopi, the Ainu, and some other native societies. They believe that the very act of hunting, of killing for food, is part of a dangerous religious act. Why else would they have traditionally returned a portion of the walrus liver to the sea, replanted birds' feathers in the snow, given the dead seal a drink of fresh water? Why would carvers and printmakers have continued to reflect these old ideas, as I observed in the 1950s and early '60s?

Today some Inuit openly declare that they carve only for money. Unlike our more cautious Southern sculptors, painters, musicians, and performers, they are painfully truthful, eager to tell Arctic sociologists and anthropologists all about it. Most artists— unless they are like Degas, Manet, Munch, or Toulouse-Lautrec, who inherited wealth—

work for some kind of necessary reward. Even sociologists who study the motives of Inuit artists are themselves using their studies to work toward further degrees that will advance their salaries in museums and universities. They are unprepared for the stark honesty of Inuit artists.

These carvers were, of course, willing and eager to trade, to sell their work as artists and craftsmen have done throughout history. The artist creates his work for kings, popes, shamen, tribal chiefs, or modern collectors so that they in turn may glorify their ancestors, their religion, their homes, even themselves. The act of creating a work of art is the essential thrill for the artist, not the act of collecting it. And Inuit artists have created their work freely and often with astonishing originality.

Some Inuit carvings created throughout the 1950s and '60s have proved as fine as any art discovered in Canada over thousands of years. In the very best of their creations during this period, we see vibrant animal and human forms that stand quietly or tensely, radiating a feeling of life. We can see, and even feel with our hands, the lively sleekness of seals, the hulking weight of walrus, the icy swiftness of trout, the flowing rhythm of a goose taking off. In their art we catch brief glimpses of a people who fear storms, sickness, and hunger yet do not seem to share our fear of death.

In the 1920s the famous Danish ethnologist Knud Rasmussen travelled for some years throughout the Canadian Arctic as leader of the Fifth Thule Expedition. The published findings of the expedition stand as a most important ethnic study of Canadian Inuit. Specifically, Rasmussen's own writings, *Intellectual Culture of the Iglulik Eskimos (1929)*, *Intellectual Culture of the Caribou Eskimos* (1930), *The Netsilik Eskimo's Social Life and Spiritual Structure* (1931), and *Intellectual Culture of the Copper Eskimos* (1932), are four volumes that give a true insight into the Inuit mind and spirit world and provide the background for an understanding of contemporary Inuit carving.

In the 1940s and '50s, on my travels, I found that most Inuit still used igloos and lived in isolated camps. Their lives had changed little from the time when Rasmussen had travelled among them. In the mid-1950s, with the building of the Distant Early Warning (DEW) Line, a network of radar stations, the sudden intrusion of more outsiders (like me, I must confess) and the development of settlements with medical and school requirements, changes in Inuit lifestyle began to accelerate. There was a requirement of housing beyond the igloo, and so the 512-square-foot dwelling came into being.

Inuit carvings went from small ethnological objects to large art objects rather too swiftly for some people. But who would have counselled Inuit to hold back in the face of the arrival of the Southern civilization? Inuit used their innate artistic skills to help build their own bridge into their changing world. Carvings and prints have unquestionably provided an important source of pride—and very necessary income—to

many Inuit in the Canadian Arctic. By trading their carvings and prints, Inuit living in remote camps and settlements have often obtained vital trade goods when no other means was available to them, thus saving themselves from the humbling necessity of government relief.

Yet this was much more than a cold, calculating way of making money. Some Inuit at the very height of their fame, with newfound wealth pouring in with each new creation, would totally cease to carve for months, or even years, because of some disenchantment or because fresh images would not come to them. Suddenly, without explanation, he or she might start to create again. Such inspired and uninspired periods are shared by true artists everywhere. This is not, I want to stress, a commercial approach to art. Out of the fresh inventiveness of the 1950s and '60s came a wealth of images of lasting importance. It represents the strongest Inuit creative spirit of the twentieth century.

In the late 1950s, Dr. Jorgen Meldgaard of the Danish Museum said of contemporary eastern and central Arctic carvings, "With these sculptures, Eskimo art has acquired a fresh purpose and a different 'social position'; it stands on its own, freed of the traditional ties which in modern times have often restricted the rest of the Eskimos, and made them copyists either of their own past products or of those from the New World. It is significant that this freedom reached the Canadian Eskimos while they were still living like Eskimos. That is why they produce genuine Eskimo art."[1]

In 1970 the Metropolitan Museum of Art in New York, in an exhibition titled *Masterpieces of Fifty Centuries*, showed no fewer than three contemporary Canadian Inuit sculptures. They were displayed along with the great works of Egyptian tomb builders and Greek temple makers, with Leonardo da Vinci and Rembrandt, with Hokusai and Picasso. It was a heartwarming sight to view these three stone carvings of the Arctic—a sea goddess, a seated woman with child, and a wild green bear—all resting in timeless harmony with so many other works of genius.

The fifty-eight families trading into Cape Dorset during the 1950s called themselves Sikusalingmiut. These 364 persons lived in thirteen nomadic camps scattered around the vast coastline of west Baffin Island's Foxe Peninsula. Warm-hearted family people, they shared food and treated their neighbours with respect. They were sea hunters, skilful carvers, singers, dancers, practical people with the strongest sense of survival. These families, among the last of the hunting societies anywhere in the world, preserved a gift of observation that city dwellers have long forgotten; this characteristic is immediately apparent in their art.

The Inuit language of Inuktitut is vastly different from our own, but with their

prints and carvings they have been able to reach across the barriers of language, time, and space. Most Inuit may not have competitive feelings on seeing carvings done by their neighbours. Rather than attempting to imitate each other, they have quite evidently tried to excel in true originality. Through their images we see that they are fully aware of the joys and dangers of life around them. Inuit reveal themselves, often showing us their ancient links with the almost global religion of shamanism. A generation or two earlier, Inuit were governed by an awesome spirit world. To establish a sympathetic magic between the hunter and his prey, small, carved amulets were worn in the clothing, hidden in the kayaks, or left as charms to strengthen the lamps and pots they carved. These small figures of animals and humans have practically disappeared, but the same ideas and references to a spirit world persist today in their carvings and their prints.

Let me tell two stories that demonstrate what I mean about their creative gifts. First, at Cape Dorset in 1953, Inuki, Seokjuk's brother, said to me, "I can see a bird in this piece of stone. Yes, there is its wing on the side. I'll cut this lower part away. You'll see its feet. Tonight I'll let out this owl's head and we'll both see the whole bird."[2] Second, on another occasion in the winter of 1953, I visited Saggiak at his camp at Etiliakjuk, west Baffin Island. When we returned from hunting on the ice all day and most of the night, we were cold and tired. We ate and slept heavily until the following noon. Opening my eyes, I saw a thick, hand-size piece of pot stone resting on the edge of the sleeping platform between my head and that of Saggiak.

"Do you see anything to carve out of that piece of stone?" his wife, Lizzie, asked him.

Saggiak did not answer as we both hurried outside to pee. Two mugs of tea were waiting for us when we returned.

"When are you going in to trade?" Lizzie asked her husband.

"Tomorrow, maybe. We'll go together," he said, nodding toward me.

"I like sugar in my tea and we'll have no tea here after tomorrow." Lizzie sat staring at the stone.

Saggiak picked it up. "That bump there looks like a baby on its mother's back." He went outside with the stone, set it on an old wooden block, and began to hack at it with an old hatchet worn very short. He had no reference drawing. He was simply carving a spontaneous image in his mind, inspired by the shape of the stone. Then he took up a large, rusty file salvaged from a shipwreck and began to smooth and round the carving. I was amazed at the simple roughness of his tools.

A cold wind was rising, so we went back inside their winter tent, where he took a smaller file and with its chisel-sharpened end began carefully digging out the details of the hood and faces of the mother and child.

The carving seemed almost finished. "If the weather's good," Saggiak said, "we'll start tomorrow."

Saggiak sorted through his worn-out sandpaper. Choosing the roughest one, he started smoothing the carving. Taking a smoother piece, he rubbed it hard, then dipped his finger in seal oil from their lamp and rubbed it on the unfinished carving. It turned dark serpentine green.

"Wonderful!" I said.

He handed it to his wife. We both took meat from the pot. Saggiak's eyes were drooping when he lay on the bed. I climbed into my sleeping bag beside him, excited by what I'd seen.

Before I went to sleep, I watched Lizzie and her young daughter, Eva, examining the carving. Then, using sandpaper worn finer, Lizzie rubbed the piece until her hand grew tired, and she passed it over to Eva, who continued the work. The last motion I remember was the two of them sprinkling on white Bon Ami, a household cleanser used for pots and pans. Lizzie rubbed the carving vigorously with a patch of damp, hairless caribou skin.

In the morning I was overwhelmed by the rich green polish the mother and daughter had achieved on the stone. They wrapped the carving carefully in an old towel, then some sacking. They came out to the *kamotik*, sled, as we prepared to leave. Lizzie pointed meaningfully to holes in the weather-worn canvas stretched over their winter tent.

As we moved west along the sea ice toward Cape Dorset, Saggiak said, "The wife wants *tupiksak*, tent material, to sew into a new summer tent."

When we arrived, we ate together—with sugar in the coffee. I made out a payment slip equal to the carving's value for him to trade at the HBC post next day. The following morning, I saw Saggiak walking down to his dogs and sled with large folds of new canvas dangling over his shoulder and a small sack probably containing sugar and tea.

Printmaking began among the people of Kingait (Cape Dorset) in the early winter of 1957. Osuitok Ipeelee sat near me one evening studying the sailor-head trademarks on a number of identical packages of cigarettes. He noted carefully every subtle detail of colour and form, then stated that it must have been very tiresome for some artist with a little brush to sit painting every one of the small heads on the packages with the exact sameness.

I tried to explain in Inuktitut, as best I could, about "civilized" man's technical progress in the field of printing little packages, which involved the entire offset colour-printing process. My explanation was far from successful, partly because of my inability to find the right words to describe terms such as *intaglio* and *colour register*, and partly because I was starting to wonder whether this could have any practical application in

Inuit terms.

Looking around to find some way to demonstrate printing, I saw an ivory walrus tusk that Osuitok had recently engraved. The curved tusk was about fifteen inches long. Osuitok had carefully smoothed and polished it and had incised bold engravings on both sides. Into the lines of these engravings he had rubbed black soot from his wife's seal-oil lamp.

Taking an old tin of writing ink that had frozen and thawed many times, with my finger I dipped into the black residue and smoothed it over the tusk. I laid a piece of toilet paper on the inked surface and rubbed the top lightly, then quickly stripped the paper from the tusk. I saw that by mere good fortune, I had pulled a fairly good negative image of Osuitok's incised design.

"We could do that," he said, with the instant decisiveness of a hunter. And so we did.

The concept of printmaking as a method was new to Inuit, but the images and ideas they created were firmly based on centuries of their ancient traditions, myths, and skill of hand. Following Osuitok's beginning, six young men—Kananginak, Iyola, Lukta, Eegivudluk, Kovianaktiliak, and Ottochi—soon became interested in a printmaking project, and we all embarked on a long series of tests.

We gathered other examples of flat, incised, low-relief carvings done by Inuit on stone not intended for printmaking, and we printed them, but with mixed results. Printing ink was not available at first, so we tried making ink by mixing seal oil and lampblack. It was awful. We tried schoolchildren's poster paints with better luck. Since there was only one official mail a year, at ship time, government correspondence was not a large feature of my life, so I borrowed almost all the official supply of government onionskin stationery, which proved adequate for proofing prints. We began further experiments using old flooring material.

We soon discovered that the close-grained carving stone, steatite or serpentine, so named for its rich, serpentlike green colour, reacted best to ink. This stone, which was abundant on southwest Baffin Island, provided for our needs, as it had done in the case of the carvings. It was semi-soft and not too porous, a perfect texture to chisel and carve like the best quality of marble, and it had proved hard enough to take a fine polish. Much of it tended naturally to cleave away from the rock face in large, flat sections several inches thick, too thin for most carvings, but perfectly suited as stone blocks for printing. Apprentice printmakers prepared the stone by chipping the printing face flat with a hand axe, then filing and sand-polishing it into a smooth, even surface. Onto this level face an outline could be drawn. A low relief could be cut, the basis of the print, from an artist's drawing. Some of the best blocks were very large, two feet long and as much as six inches thick, often weighing more than a hundred pounds. Good stone was plentiful and nearby.

But still the whole question of printmaking hung in limbo, no one knowing whether the idea would be accepted by west Baffin Islanders or the public in southern Canada. We worked to gain support from Pootoogook and Kiaksuk, those two important elders of the Kingaimiut, the people of Cape Dorset. I got up my nerve and went and asked Pootoogook to make me a drawing of something about caribou he had been trying to explain to me. He did several such drawings and sent the results over next morning. I asked his son, Kananginak, to help print his father's elegant drawing of two caribou. Kananginak gladly did this, helped by Eegivudluk and other relatives in the new printing place we had built. Pootoogook greatly admired the two-colour results, and after that the whole project was accepted and off to a powerful start. It was a time of high excitement for Inuit trading into Kingait. Everyone was aware that something entirely new was happening.

West Baffin Island has always had an abundance of uninhibited artists and craftspeople eager to express themselves in a variety of ways. Printmaking, with its multiple production of images, seemed perfect for them. These potential printmakers needed only this small, heated building in which to work and a system of creating and pulling limited series of prints from the blocks that they created. The main problem in developing this art was technical.

In the early days, snow-white paper seemed impossible to keep clean. Fingerprints were everywhere. In winter's cold, ink stuck to and came off the stone unevenly. At times there seemed only to be a few good single impressions pinned to the walls around us, including bird prints they had sometimes, logically, hung on the ceiling. But far more important, we had the basic Inuit skills, patience, and good nature to carry us forward.

When we had achieved a numbered series of thirty, we cut the image off the stone block so that there would be no more to flood the market. By the spring of 1958, we had laboriously assembled some small print series from half a dozen different artists. These prints were sent south to the government, the Guild of Canadian Handicrafts, and the Hudson's Bay Company, each of whom arranged exhibitions. The first was at the Stratford Theatre in Ontario during the annual summer Shakespeare festival of 1958. These three events were in every way successful, and all these early prints were sold.

Stone-block printmaking in Cape Dorset continued with enthusiasm. To make a stone cut, Inuit carefully flatten and polish large stone, which is quarried locally. Then they carve in low relief the forms and figures they desire to print. They ink the block and place a sheet of fine paper on it. By rubbing with their fingers or a small sealskin tampon, they transfer the inked impression up onto the paper. This method is slow and painstaking, but produces more sensitive results than a press.

One day, quite unexpectedly, the print project extended itself into a whole new medium.

In *Confessions of an Igloo Dweller* I tell of the day I watched an old trap boat come in at low tide to touch Kingait's summer beach, a vast, dark stretch strewn with slippery, skull-size rocks woven over in places by long fronds of seaweed. I saw Kenojuak climb out and help several of her younger children down. She had that familiar bump signifying another infant riding in the back of her parka. Two of her older children followed her, while two others stayed with their father, Jonibo, to help anchor the boat.

I continued along the beach toward Kenojuak, a bright-eyed, red-cheeked, cheerful woman whom I had always liked. She appeared healthy, with a great deal of bounce, considering that at that time she had already borne eight children—and would have more.

"*Kunoipiit?*" she called in greeting.

I noticed that she was carrying a sealskin bag on her shoulder. It was not unlike other bags I had seen Inuit carrying, but hers had something on it. I asked Kenojuak to show me. Her yellowish bag had almost-black sealskin images cut and sinew-sewn onto its surface.

"What's on this bag?" I asked.

"*Okalik isumalook kikkoyuk memuktualuk.* Rabbit thinking of eating seaweed," she said in a way that she knew I understood.

Kenojuak stepped into the tide and showed me one particular kind of seaweed. "*Mumungitok*! Not good eating. Here, take this kind," she said, and gathered some. "Take this with you to your wife, Arnakotak, the Long Woman. Get her to cook it for you. It's good. It turns bright green. Rabbits come down to the shore to eat it."

I wasn't so interested in the seaweed as I was the bold, clear image sewn on her work bag.

After Kenojuak and her family had set up their summer tent, we all went a few nights later to a large dance. It was one of their typical midsummer pleasures: the families, with their children, ate, then slept during the early evening, and rose refreshed and ready to start the dancing at about 11:00 p.m., and would carry on until they tired, that being when the bright morning sun had sailed past all of us.

I took a pencil and two good-size sheets of paper to the dance and gave them to Kenojuak, asking her to make a drawing of her rabbit eating seaweed. She smiled and stuck the paper in her parka hood, then gave the parka and her current infant to an elder daughter when she heard the button accordion start to wheeze, then play. She leapt into the local version of a wild Scottish whalers' reel and so did I.

A few days later, when everyone had recovered from the muscular activities inherent in these dances, Kenojuak came and showed me both sheets of paper I had given her. They were covered with pencil drawings of two very different subjects, on one the rabbit, and on the other an owl. These were rolled for protection in the very piece of

sealskin from which she had cut her rabbit eating seaweed. The images were in two separate pieces.

I asked Osuitok to join me in an experiment. First, we spread the sealskin on a table over a piece of my own drawing paper. Then onto a spare piece of window glass I mixed and spread some blue paint. From the school I had borrowed an unused stencil brush and taped it to make a mark about the size of a half dollar. I tapped the brush in the paint, picked up the blue paint I needed, then pounded the bristles through the shapes Kenojuak had cut for the images she had sewn on her bag.

When we lifted away the skin, Kenojuak and Osuitok were impressed with the sharp, clear image. Here was a skin stencil, an emerging new development of an ancient art form. Kenojuak was delighted, and believe me, so was I.

In the summer of 1958 the government reminded me that I had accumulated a lot of unused leave. I had forgotten about any sort of a vacation during the past winter, when we had been trying to improve our printmaking skills, but I had read an article in a British art magazine showing the works of several contemporary Japanese printmakers and discussing their techniques. The best printmakers in the world were in Japan. I decided to go there, learn from them, and carry back to Baffin Island as much knowledge as I could. I went south in early autumn and sought assistance from the Japanese embassy in Ottawa, and in Tokyo they contacted Kokesai Bunka Shinkokai, a Canadian-Japanese cultural relations organization.

During the previous two years I had made enough drawings and watercolours of my own work for a one-man exhibition, which my friend and dealer, John K. B. Robertson in Ottawa, was keen to mount. Through their gallery, John and Mary offered me an advance on sales that they felt I would earn. With this I bought a return ticket to Tokyo via Vancouver.

Very few Canadians were travelling to Japan forty years ago, but my whole experience there from the autumn of 1958 into the spring of 1959 was completely rewarding. I was shown great kindness by the Japanese, who were intrigued by the idea that their printmaking techniques might be of some benefit to Inuit. During my stay I made a number of long-lasting Japanese friendships. I was invited to live in the Japanese household of Professor Murai, who was later appointed president of Waseda University. Each day I worked with the very distinguished seventy-year-old Japanese print master Unichi Hiratsuka, in his studio on a one-to-one, teacher-student basis. His daughter was our interpreter. Sometimes I learned to cut and print woodblocks until the middle of the night and slept in his studio, avoiding the long search for a taxi to cross Tokyo.

Ukiyoe was the old and famous eighteenth-century system of Japanese

printmaking practiced by Hokusai, Hiroshige, Utamaro, and other artists of world renown. They made the drawings, and the printmaking was done by others. *Hanga* is the more modern Japanese technique, where the artist and the printmaker are one. Because of the nomadic habits of Inuit and the need for dry paper, and heat so that the ink would print, I concluded that the older *Ukiyoe* methods would prove the best solution for that transitional period in the Arctic. I learned many invaluable printing methods in Japan.

On my return to Canada I could scarcely wait to get back to Kingait. I was eager to have Inuit printmakers try the new tools, the papers, the techniques that I had learned. I gathered Kingait's most enthusiastic and talented stone-block printers together, and we started to develop a new printing technique that would blend the wild, free talents of Inuit artists' styles with centuries of Japanese ingenuity. Inuit artists and craftsmen in the co-op were always searching for fresh ideas. We soon discovered that water-based paints stuck in cold weather. Inuit printmakers judged that Japanese rubbing tampons made of dried bamboo leaves were not as available or as good as their new local version made of hair sealskin, which was much stronger and more available on Baffin Island. The hunters in the *senlavik*, the workshop, felt that Japanese woodcutting tools, traditionally made of soft metal, were not as suitable for cutting stone as worn-out steel files, which Inuit carvers favoured and could be made into razor-sharp chisels to better suit their purposes. The Japanese *Ukiyoe* system of registering a print, they agreed, was marvellous, and they thought the fragile transparency and beauty of Japanese paper could be too easily destroyed but was perfect for printmaking.

Asked how he became a printer, Iyola explains: "I remember very well how I started out. Kananginak was a printer and he went out [to his camp] on holidays. James Houston [Saumik] asked if I could take his place for one week. But after I started James Houston wanted me to work more, so I stayed on."[3]

The artists were using imaginative drawings that would form a record of Inuit history, a record of their lives from the past, the present, and, I trust, their dreams of the future. Christianity flourished in the 1950s on Baffin Island, but old shamanistic practices had not yet faded. "When I once asked Kenojuak how she drew her compositions, she told me that a small blue line often seemed to be moving just before her pencil and it guided her hand. This takes us into the realms of shamanism where few of us have dared to venture."[4]

Strong individual artists from west Baffin emerged over the fifty-year period, as indeed did others on the west coast of Hudson Bay and in Arctic Quebec. Kananginak, from Dorset, is quoted in a documentary film, *The Spark*, on August 16, 1998: "When I pick up a rock, it gives me the idea right away of what I want to carve out of it. Drawing

is different. I have to think a lot of what I'm going to draw on the wide, blank paper which will later go on a stone block."[5]

Inuit young and old in Cape Dorset have taken to saying lately that it is much easier to create a lively stone carving than it is to draw a picture on a blank white sheet of paper. The reason some give is that a piece of roughly broken pot stone almost immediately suggests some shape, some direction that the carving must go, that they can immediately see some animal or human lurking in the stone just waiting to be released. Then they, with their rich imagination, launch themselves straight into the work of freeing the figure.

Drawing on blank paper came easily and naturally to many Inuit, especially the women. It was an entirely fresh experience that few of them had ever tried before. The creative ones took up drawing with that same wild abandon that we associate with our young children, but with skilled hands and astonishing results. Now over the past forty years, I believe they have come to have a sort of hesitant respect for their own drawings that the printmakers will turn into powerful stone-block prints and stencils. They see possibilities so endlessly wide that the large, empty sheet of paper begins to represent those same frightening barriers that it does for almost all of their southern neighbours.

Pudlo Pudlat has said, "I enjoy using acrylic paints more than ordinary pencils and paper. I find painting easier than drawing and I like the way the finished picture looks better...."[6]

And he has also said, "When I hear that people like my drawings, I can really feel it inside of me. It pleases me. When I drew those pictures, they didn't make any sense, but now that they are printed, they look more sensible. I am happy a lot of people in the south have never seen me, but they know me by my drawings."[7]

Inuit have told us again and again that these images made by them on flimsy paper were too fragile and destructible, not at all like solid stone or bone. They could not believe that any paper holding their freely cut images could be of any real, lasting value.

One day I brought into the new co-operative workshop two white-fox skins and asked the printmakers how much they thought they would receive in trade for these skins. They told me with great certainty that two good foxes would provide them two boxes of cartridges, a twenty-pound bag of flour, a pound of tea, some strong rope, and a large tin of tobacco.

I laid one of Kenojuak's prints beside the white pelts and asked them how much they thought the print was worth. They laughed and said the print was on paper only good for rolling cigarettes. I then made a conservative estimate of how much I thought one of her prints would bring back to her and to the co-operative. I judged it to be worth four

foxes, but still I had greatly underestimated the true value of her work. The printmakers narrowed their eyes but seemed cautiously impressed. My guess about Kenojuak's print was true at that time, and now, years later, that same 1959 print, twice sold and then resold at auction for many thousands of dollars, was perhaps worth half a roomful of white-fox skins, which were even then going completely out of style. Oh well, the Queen Mother on high occasions still wore her ancient white-fox cape in memory of the old days.

One of Kenojuak's series of fifty stone-cut prints of *The Enchanted Owl*, printed twenty-five red-black and twenty-five green-black, originally sold for $90 each in 1960. A single red print from this series was recently resold at auction for $27,000. Every indication pointed to the traditional increase in value of a print series that had sold out.

According to Iyola, a printmaker, in the book *In Cape Dorset We Do It This Way*,

Kenojuak's work … has changed over the years. It has changed because she learned from the stonecut. … The printers don't tell the artists what to draw that will make it into the printing process. But Kenojuak, she's learned by just watching. … I think that she knows enough now that she can't make a drawing that's just going to sit around, not getting anywhere. She would feel that she wasted the co-op's money, which she got when she sold her drawing. … I think probably most of the artists think of it now. Kenojuak knows that if she drew something like those tiny figures there [in another drawing we were discussing], it wouldn't make it into the printing process, so she makes sure her drawings have the sort of things that you can make into a print.[8]

A third new version of Inuit art was beginning to bloom, based on the skills of women trading into the settlement of Cape Dorset. Kenojuak's design on her sealskin bag had set me thinking and experimenting. I knew that Inuit women were magnificent sinew sewers. They were adept at the ancient art of skin appliqué, cutting animal hides with their *ulu*, making silhouette forms for decorations to be sewn onto clothing and more rarely onto carrying bags.

On one visit to a far camp, I stayed in a snow house where the hunter's wife had cut a number of figures from some sealskin scraps, had licked them on one side, and had placed them on the snow wall above the sleeping platform to freeze in place. These helped, she said, to tell the story of Lumiuk, a person who was towed endlessly through the ocean by a whale. He was still said to appear each summer and scream magic words to the hunters.

I did not so much think of those cut-out images so pleasingly placed on the igloo

wall. I did think about the holes they must have created in the cut skin. I wanted to find that skin and press paint through it to make multiple images on good long-lasting paper, not allowing the images to be lost when the spring sun warmed and consumed the walls of this family's snow house.

The stencil is derived from this traditional practice of cutting skin appliqués for decoration—mostly for clothing—and Inuit artists discovered that colours could be brushed through an opening to create a print.

Stencilling is perhaps the most immediate graphic art form ever developed. Perfect for schools, it is a simple medium, and one can achieve direct results in a matter of minutes. In Cape Dorset the stencil of skin quickly evolved into a wax-hardened type of paper stencil. This change occurred as sealskins were becoming too valuable to use for stencils. As in most Arctic events, this change developed based on Inuit ingenuity and the available materials at hand.

The early prints done before 1960 were limited to thirty. On the advice of the Canadian Eskimo Arts Council, an advisory board to Canada's minister of Indian and Northern Affairs, the print series was expanded to fifty numbered impressions, then closely restricted to only five artist's proofs. After each series is completed, the image on the stone block is removed and the stencil is destroyed. In the stone-block print, Inuit usually follow the early European and Japanese traditions, wherein the artist creates the original drawing and this is then cut and printed by experts in their field. For this reason, two signatures in syllabics—that of the artist and the printmaker—appear on each print. Each of these signatures is placed above the symbol of the community. For example, a small red igloo signifies Cape Dorset, and a bow and arrow, Baker Lake. Often there is a blind-embossed seal verifying that the print has been approved by the Canadian Eskimo Arts Council. Its syllabics read *namatuk* in Inuktitut, meaning "no more, genuine."

It must be remembered that during the successful rise of Inuit art, the hunters began to abandon their dog teams in the mid-1960s in favour of the then-new snowmobiles. They did this just as quickly as we in the South had abandoned the horse and cart in favour of cars and trucks. Inuit needed gasoline to drive these thrillingly fast, dogless vehicles. Suddenly, instead of needing walrus or whale meat to feed their disappearing dog teams, they needed the money earned from prints and carvings to buy snowmobiles, gasoline, rifles, clothing, and satellite television, which would all begin to change their ancient Arctic world forever.

Forty years ago I asked the printmakers what they wanted in exchange for all the successful work that they were doing, thinking that they would ask for tents, rifles, boats, and outboard engines. Kiasuk, who after Pootoogook's death had become their elder spokesman, answered for all of them, as was their custom. "We want a store of our

own." And, by george, they and their own West Baffin Eskimo Co-operative got one!

Since then, a huge number of original Cape Dorset pencil drawings have been carefully collected and are held in a study collection in Kleinburg, Ontario, and will undoubtedly prove interesting to scholars in the future. But the West Baffin Eskimo Co-op was organized in my time with the full understanding among us all that we hoped to have their art prove beneficial to living Inuit artists, to provide them with a fair reward for their creations through Southern outlets since they lived lives remote from the buying public.

Other enterprising Inuit have also built their own co-operatives, and through them have marketed carvings, stone-block prints, stencils, and tapestries. In this way they began to show self-sufficiency in modern terms and to share in Canada's future while they continue shaping their own destiny. This was one of their essential components in the opening of the Canadian Arctic and their long-sought desire to develop Nunavut ("our land").

Over the years, original Inuit pencil drawings have not found a ready market in Canada, the U.S., or elsewhere where attempts have been made to offer them for sale. Charles Gimpel of the famous Gimpel Fils, located in London, Zurich, and New York, encouraged the co-op to offer pencil drawings across Canada and elsewhere. The attempt was unsuccessful. At the same time, their stone-block and stencil-print series were eagerly purchased.

Here are several Inuit thoughts about prints versus pencil by Iyola, a printmaker at Dorset's co-op. One is that "when I see that place [the printshop], it reminds me of my past when things were going good for me, like my voice, my youth; I miss it a lot....I have seen a lot of changes. We had fewer tools to work with. It was just our bare hands that we used, but now we use more tools to help us out, like the printing press. I like the prints that are made from stone cut; I think that they are the best."[9]

Oriental printmakers using glue traditionally attached their original drawings face down on woodblocks to make a reverse print image to guide the cutter's knife. Thus, the original drawings were intentionally destroyed. Art collectors as well as the artists in Cape Dorset said that they preferred seeing their art and that of their fellow printmakers in limited editions as coloured prints rather than pencil drawings.

Printmaking developed rapidly because the Inuit trading into Cape Dorset during the late 1950s possessed strong and ancient artistic roots firmly imbedded in the age-old Inuit practices of incising ivory and stone carving, and of the important women's art of skin appliqué. Their art, religion, songs, dances, and legends, along with their hunting techniques, were inherited from their nomadic ancestors who, thousands of years ago, made the long trek from Asia into the vast, open tundra of arctic North America. Their

creative ability is one of the lasting gifts that these, their children, were able to carry inside them.

It is now fifty years since the first contemporary carvings appeared to startle the art communities from Toronto to New York, Paris, Berlin, and Tokyo. It is forty years since the first stone-cut prints surprised international collectors with the boldness and liveliness of their design and the originality of their way of viewing life. For the most part Inuit from the Canadian eastern and central Arctic have retained their singular grasp of their subject matter and have widely established these strong art forms that seem uniquely their own. This new exhibition comprises carvings, stone-cut prints, stencils, and engravings selected from the abundance of works from Inuit of Nunavut, their vast new territory in the Canadian Arctic.

Anyone who questions the importance of contemporary Inuit art as an expression of the people's true feelings would do well to recall the words of the famous artist Pitseolak, translated from a tape as part of her autobiography, *Pictures Out of My Life*, edited by Dorothy Eber. Of her drawings and stone-block prints, she said, "I am going to keep on doing them until they tell me to stop. If no one tells me to stop, I shall make them as long as I am well. If I can, I'll make them even after I am dead."[10]

Just as each community had become so successfully involved in their carvings, so printmaking seemed to come to life to help Inuit exactly when they desired independence, during a period of great change occurring across the whole of the Arctic world, when Nunavut was readying itself to be created.

JAMES HOUSTON, *former member of the Canadian Eskimo Arts Council and retired chairman, was chairman of the American Indian Art Center when for twenty years it was a major outlet in New York City. He continues to write and lecture worldwide, and remains active in encouraging Inuit art.*

The Artists Speak

Maria von Finckenstein

"I enjoy carving, and it helps with buying food, too"

The years from 1948 to 1970 are the two decades during which most Inuit in the Canadian Arctic gave up their nomadic existence and settled into one of the communities slowly developing around the Hudson's Bay trading posts that had been in existence since the early 1900s.

James Houston's essay in this book conveys his experiences during the fourteen years he encouraged and worked with Inuit, a crucial period in the history of Inuit art. My intention here is to present the perceptions and experiences of a number of artists from the first generation of Inuit who lived in the Arctic settlements, a generation profoundly shaped by the life on the land as hunters and trappers. Since virtually all the artists of the group speak only Inuktitut, I collaborated with Henry Kudluk, who works with the Inuit Art Foundation, to obtain as much first-hand information as possible. Kudluk conducted twenty telephone interviews; he asked the artists, men and women, about their memories of this pivotal time in their lives. He also asked them about the role and importance of making art, how they first became artists, and what carving or drawing/print-making means to them.

Their answers were often not what I expected, and one fact became very clear: most artists had experienced hardship and deprivation beyond what any of us in the South could imagine. When they settled in their permanent residence, be it Baker Lake or Inukjuak, few—if any—ways to earn a living were available to them. Not surprisingly, people embraced the opportunity to feed their families through making art. They threw themselves into this new activity with the single-minded determination that had served them well as hunters and trappers. When John Arnalujuak says, "Every day of the week,

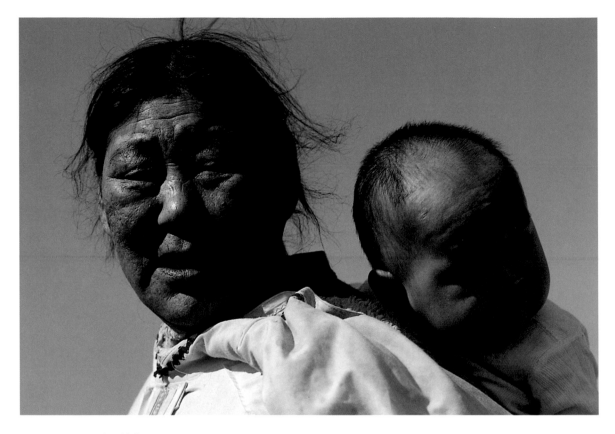

Lucy Tasseour Tutsweetok with baby in Avriat.

except for Sunday, I carve from early morning until the evening,"[1] he speaks for most of his generation of artists. Houston describes how often the example of one successful carver would inspire others to follow suit. "However, as time passed, the natives found an unknown deposit of stone and Oshaweetuk, a particularly fine carver, brought in three carvings, for which we were able to pay him $42.00. The Eskimos all learned of this in a short time and all settled down to carving in earnest."[2]

The issues addressed in Kudluk's interviews are best highlighted by a reconstruction of Thomas Sivuraq's story. In addition to Kudluk's interviews, I am making use of existing literature, notably the *Inuit Art Quarterly*, and interviews from Mame Jackson, Dorothy Eber, Jean Blodgett, and Marybelle Mitchell (Myers).

Becoming an Artist

Thomas Sivuraq, who now lives in Baker Lake, grew up a hunter in the Keewatin, the Barren Grounds, on the windswept tundra, in caribou country. His ancestors had developed a technology that helped them to survive in one of the world's most hostile environments. As a small boy, he could not wait to be taken on his first hunting trip by his father. His father taught him how to harness the dogs, how to navigate a sled over dangerous and unpredictable terrain, how to build an igloo, and how to stalk the caribou. To be a hunter was the only possible way of life. His driving ambition was to be a good hunter who provided successfully for his family. Disaster struck. The caribou herds on which his camp depended for food and clothing changed their migration path, leaving the people destitute, without resources. World market prices for fox trapping had plummeted, jeopardizing income. Like so many of their ancestors who depended on game, the Sivuraq camp was in danger of starving to death. Sivuraq's siblings were rescued by government helicopters, but Thomas preferred to stay behind because his dogs, which he prized, did not fit into the airplane. As a trapper, he depended on his dogs for tending his traplines and for occasional trips to the Baker Lake trading post. When his parents died, Sivuraq lived alone for a while until, as he put it, he was at his wits' end. In desperation he attempted to walk with his dogs to the trading post. On his way he was picked up by another hunter travelling by kayak along the river leading to Baker Lake. The dogs, weakened by lack of food, had to be carried into the kayak.

People from various camps had put up their igloos in Baker Lake, where they had become dependent on government relief. Sivuraq watched people bringing in carvings to the Hudson's Bay trading post and leaving with tea, flour, or ammunition. He decided to do the same. Somehow procuring stone, a hatchet, and an old file, he set to work. Thus began his career as a distinguished artist. It was difficult for Sivuraq to understand why the Hudson's Bay trader would exchange such valuable goods as tea or flour for pieces of stone. As one of the old carvers in Sanikiluaq commented, "The white people have so much imagination,

they can make incredible things. What do they want with our wretched hunks of rock when they can make such wonderful things themselves?"[3]

Sivuraq applied to this new activity the same discipline he had developed as a hunter. Successful hunting requires precise knowledge of the animals, the weather, and the land. He knew every cliff, valley, lake, stream, and landmark in his former hunting territory. This visual memory—we might call it a photographic memory—enabled him to detect the slightest change in weather conditions, which could often be a matter of life and death. Explorers have often been utterly amazed by the accuracy of maps (relative to a purpose) drawn from memory by Inuit hunters, and the anthropologist Edmund Carpenter also commented on the powers of observation that made Aivilik men (a group that traditionally lived in the Repulse Bay area) "first-class mechanics." As he said, "They delight in stripping down and reassembling engines, watches, machinery. I have watched them repair instruments which American mechanics, flown into the Arctic for this purpose, abandoned in despair."[4]

Imagine the skills an experienced hunter like Sivuraq brought to carving: manual dexterity, keen observation, an extraordinary visual memory, intense focus. Komwartok Ashoona from Cape Dorset eloquently describes the discipline required by Arctic hunters.

I remember my father very well. He was a hard-working man. We would go to Netsilik to hunt for caribou because caribou skin was the main thing used for clothes. My father had such a big family so he was…trying his best to get some food and also to get some clothes for his children and also for himself and his wife.…I am proud when I think of my father.

My father also used to hunt out on the ice. At that time it was quite hard to go out hunting just by yourself. But he would hunt–just by himself–out on the ice. And he would get food.…Men would sometimes stay there all night. They would be just motionless by the seal hole on the ice. They had to be very still in order for the seal to come. Even though it was cold they would just stay right there. That was the only way they were going to get food.[5]

Shaimaiyuk, a graphic artist from Pangnirtung, brings home the point even

more vividly: "I draw what comes to my mind from the days when I was young and try to make it close to what I have seen…Somehow I want to show how hard [life was for] the older generation of men. It is not easy to go hunting again, when one has not eaten for two days or more and has had only warm water to drink in the morning. Sadder yet is returning to camp without having caught anything to feed your hungry family."[6]

It was with this conditioning that people put their minds to the creation of sculptures and drawings. What they brought to making art was the ability to slip into a timeless space, the same ability that enabled people like Ashoona to stand motionless above the seal hole. That meditative trance is described by artists the world over. The Swiss artist Paul Klee described it as follows: "Everything vanishes around me and works are born as if out of the void. My hand has become the obedient instrument of a remote will."[7] Jessie Oonark, a textile artist from Baker Lake, referred to the phenomenon of becoming absorbed in making art when she said, at the end of her life, "Drawing has provided a release from everything in the world."[8]

Inuit artists also brought to the art-making process a strict work ethic acquired during years of struggle for physical survival. Jessie Oonark's son, William Noah, has described the gruelling circumstances that led to his and his mother's settling in Baker Lake: "I remember my father very well when he was dying. It was a sad day for us, especially for my mother and me. My father was a real hunter who knew how to take care of a big family. After his death we had hard times with no food and poor clothing." He goes on to say that he travelled to Baker Lake to alert the Mounties to his family's plight. "A few weeks later I heard that the R.C.M.P. had brought my mother and sister to Baker Lake by plane. So I went among the igloos to look for my mother's igloo. I found it right away because my dog was standing in the doorway waiting for me."[9]

Jessie Oonark worked as a janitor at the Anglican church in Baker Lake before she became a world-famous textile and graphic artist. Eager to find a more satisfying way to make a living, she brought to her career as an artist skills refined over a lifetime—she was then in her fifties. Her experience scraping and softening skins and sewing them into fine garments for her family of ten she transferred

to fashioning appliqué wall hangings. Even when she could rest a little, the harsh, relentless work ethic of her formative years never left her. She would sometimes complete forty to fifty drawings in a week. Jack Butler, arts and crafts officer in Baker Lake in the early 1970s, explains what may be true of this entire generation: "Accustomed to a life where one is working constantly, she is not able to stop now."[10] Inuit of Jessie Oonark's generation are forever marked by their years of hunger and deprivation.

Pitseolak Ashoona, from Cape Dorset, described the endless traditional work this way: "In the old days I was never done with the sewing. There were the tents and the kayaks, and there were all the clothes that were made from the different skins—seal, caribou and walrus. From skins we also made cups for drinking and buckets for carrying water."[11] Oshuitok from Cape Dorset says of his working habits, "Nowadays, I generally begin work at something I'm going to carve in the early morning when it's nice, just beginning to get light. I carve at it all day, the next day and even into a third day. I won't get tired of it. I won't get bored."[12] Andy Mamgark from Arviat talks about what he was taught by his stepmother: "Taukijak taught me that the only way to live happily and provide for one's family was to work hard—to live the Inuit way."[13]

Another Way to Provide

Like most Inuit, our respondents, when asked why they make art, invariably say for the money. Such directness may surprise us in the South, accustomed to "lofty" motivations, but an understanding of the arduous lifestyle and personal experience of the Inuit leads to appreciation of the deep feeling implicit in the declaration. Thomas Sivuraq's answer, "I think of how much this piece is going to get me," is really, I think of how much food I will be able to buy for my family. It is very much like the hunter looking at a caribou with satisfaction, considering how much food and clothing it is going to provide for his family. In fact, hunting was often very dangerous and accidents did occur. Josephee Kakee described the dangers of walrus hunting in open water: "I know that down on

the left-hand side of Cumberland Sound there are many many walrus. It can be very frightening to find oneself far from shore among the walrus. I wouldn't use a kayak to travel long distances, as a walrus would come up and tip the boat at any time. My cousin was killed in just that way. The walrus were hunted in this manner by real men, by hunters who would not give in to fear."[14]

In the Inuit artists' value system—inherited from people like Komwartok Ashoona's father—to provide for family is the most noble pursuit. It is perhaps equivalent to the value other cultures placed on soldiers giving their lives for their country. When Pauta Saila from Cape Dorset says, "I've been carving soapstone the whole time so my family won't go hungry,"[15] he says it with all the pride of the hunter who is successfully looking after his own. To expect him to carve with the wish to create, to fulfill, or "express himself," would be ludicrous and disrespectful, disregarding his cultural roots and the environment that has shaped him.

This does not of course suggest that Inuit from the first generation of professional artists did *not* express themselves in their art or enjoy the process, but their motivation was and is first and foremost commercial. Those who are still alive are still working, including Johnny Inukpuk at the age of eighty-seven. Tiktak from Rankin Inlet says, "I do not think out what I will do. My thought comes out while I work. My work expresses my thought."[16]

Pudlo from Cape Dorset says simply, "I only draw what I think but sometimes I think the pencil has a brain too."[17] Pauta Saila has commented, "I like to carve what I feel, not merely what I see."[18] Pitseolak Ashoona from Cape Dorset similarly remarks, "I became an artist to earn money but I think I am a real artist."[19]

Pitseolak Ashoona, mother of Kumwartook Ashoona, had every right to call herself an artist. Like Jessie Oonark, she was a widow with a large family when she settled in Cape Dorset in the 1950s. During the next quarter of a century she produced a never-ending stream of drawings—approximately seven thousand in total—in which she recorded the memories of her past nomadic life. Without her income from drawings, the widow Pitseolak Ashoona would have had to rely on social assistance and the charity of relatives. In her memoirs, she explains: "Since the co-op began I have earned a lot of money with my drawings. I get clothes

from my drawings and I earn a living from paper. Because Ashoona, my husband, is dead I have to look after myself and I am very grateful for these papers—papers we tear so easily. Whenever I am out of everything I do some drawings and I take them to Terry [Ryan] at the co-op and he gives me money with which I can buy clothes and tea and food for my family."[20] The pride behind her words is evident, her satisfaction that she can look after herself and her family.

Johnny Inukpuk from Inukjuak expresses directly what Pitseolak's words imply. "Saumik [James Houston] gave us independence we have never had before."[21] He is talking about independence from handouts, from fluctuating fur prices on the world market, and from the scarcity of foxes due to natural cycles. Unfortunately, artists are now dependent on the whims of the art market, not so much a concern the first two decades of art production.

Davidialuk Alasua Amittu from Povungnituk was desperately impoverished. Johnny Pov, a friend from the same community recalls: "As Davidialuk was growing up he was poor because he was a descendant of poor people. That is the custom of Eskimos. Even when he was a grown man he had neither dogs and komatik nor kayak and he used to walk around looking for food from people."[22] Nevertheless, Davidialuk became a well-respected artist who recorded the oral history of his area in carvings, drawings, and prints—an activity that changed his life dramatically.

As a young man, Joe Talirunili, also from Povungnituk, had been accidentally wounded in the arm by his father's rifle, a mishap that severely reduced his chances of becoming a successful hunter. He became a prolific artist, despite the lifelong pain in his arm worsened by the activities of drawing, printmaking, and sculpting.

It was especially the infirm, the old, and the physically handicapped for whom making art became a welcome relief from dependence and humiliation. In a conversation with members of the Eskimo Arts Council, Donat Anawak, a Rankin Inlet ceramicist, outlines the situation of his fellow artists John Kavik and Tiktak: "Look at Kavik, he is an old, old man who cannot hunt or fish very much any more and he cannot have a regular job with the white people, but he can make money for himself and enjoy himself very much. He enjoys making what the white people also enjoy having. Without the arts and crafts project Kavik

would not be the happy man he is now."[23] About Tiktak he says, "Look at Tiktak, who was badly hurt when the mine was here, who is deaf, weak and elderly. Without the arts program he would have nothing and be nobody, but everybody knows him through his work."[24]

Although these are the more spectacular success stories, it can be safely assumed, from the interviews, that in every single case "carving helped a lot." Sometimes carving brought in the necessary cash to enable people to continue hunting. As Qaqaq Ashoona mentions in a 1996 interview, "For us older carvers we carve in order to get supplies like bullets, food and gasoline because they are necessities."[25]

At one time the Cape Dorset print shop used its press to produce a small volume titled *The Inuit World*. The authors Kananginak Pootoogook, Pia Pootoogook, and Udjualuk Etidlooie wrote about many aspects of Inuit culture. The section on caribou contains the following: "It will be understood that the great preoccupation of our people over the centuries has been simply with food. Getting enough to eat has always been a matter of concern in this land, and up until recent times actual starvation was not unknown to us. Fortunately such severe conditions of life no longer prevail and the Inuit are now free to pursue broader interests."[26]

Amazingly, fortunately, one of the first broader interests for many has been making art, be it carving, sewing, drawing, printmaking, or the weaving of tapestries.

Unconditional Acceptance and Nurturing Support

How did people have the courage to start carving without any training? Josie Papialuk from Povungnituk states, "Nobody taught me how to carve. I learned by myself. One time, I just sawed off a piece of very hard stone and started carving."[27] As astonishing as it may seem, that is how it happened for many. Thomas Sivuraq told Henry Kudluk, "I began to carve because there were no jobs then and I used to see people get money for carvings…this is when I started to carve."[28] Some artists, like Pauta Saila of Cape Dorset and Davidee Ittulu of Kimmirut, learned by watching their fathers carve, but there were no such mod-

els and teachers for those who took up drawing. Kenojuak Ashevak, Cape Dorset's famous graphic artist recalls, "I will never forget when a bearded man called Saumik [James Houston] approached me to draw on a piece of paper. My heart started to pound like a heavy rock. I took the papers to my qamak and started marking on the paper with the assistance from my love, Johnniebo. When I first started to make a few lines he smiled at me and said, 'Inumn,' which means 'I love you.' I just knew inside his heart he almost cried, knowing that I was trying my best to say something on a piece of paper that would bring food to the family. I guess I was thinking of the animals and beautiful flowers that covered our beautiful, untouched land."[29] In her poetic language Kenojuak speaks for many who, even though their heart may have pounded like a heavy rock, picked up a pencil in order to support their families.

We rarely hear about any specific instructions that may have been given to the artists along with pencils and pieces of paper. Pitseolak in her memoirs recalls vaguely, "Jim Houston told me to draw the old ways and I have been drawing the old ways ever since. We heard that Saumik told the people to draw anything, in any shape, and to put a head and a face on it."[30]

Of course Houston was not the only person giving advice or making suggestions. Paulosie Sivuak from Povungnituk remembers the Hudson's Bay manager, whom everybody called Pootinaki ("he's got hardly any meat on his rear") giving him a piece of sandpaper to finish a carving that he had brought in to sell. More advice came from a transient Southern visitor. He told Sivuak, "Before you start roughing out your carvings, please make the bottom flat first."[31]

I believe that the true secret of James Houston's success, where others before him had failed, can be found in the *Buying Guide* for Hudson's Bay managers, written by Houston himself. In it he reminds post managers, "Do not forget that a man who is considered average at present, through your encouragement and his own endeavours, may turn into the finest carver. In Eskimo carving, Canada has an art form of which it may well be proud. Its future lies not in a great quantity of carvings, or teaching on our part, but in recognition of this special art and our encouragement."[32]

An artist himself, Houston knew how vulnerable one person feels having to

submit creative work to another's judgement and scrutiny. The Hudson's Bay superintendent P. A. C. Nichols admonished post managers that "to hold and stimulate the carver's interest you must pay a fair price for his work and show by word and action that you are anxious to buy his carvings in and out of trapping season."[33] This supportive attitude was extended even to children. Houston stated in a trip report from 1950, "Handicrafts are to the Eskimo child his first step into industry and he should be encouraged as much as possible. The children's small stone carvings and sewn articles improve rapidly when they are purchased, even for a small price, and they thus start to contribute to the needs of the family…"[34] Early tentative efforts, he believed, by anyone willing to participate should be purchased "for a small amount…and ways to improve them suggested. In almost all cases where this method has been used, steady progress has been made."[35]

Norman Ross, Hudson's Bay Company manager in Inukjuak, confirmed this in a letter to the Canadian Handicrafts Guild in 1949, "It was surprising to see how readily the natives at Port Harrison (Inukjuak), under Mr. Houston's able tuition, learned to execute the fine work they turned in. It is certainly a credit to his untiring efforts among them."[36]

In a memo from a Hudson's Bay official, reference is made to "Mr. Houston of the Canadian Handicraft Guild [who] instructed our Post Manager to purchase all manner of handicraft and to refuse nothing that was brought in for sale."[37] This attitude of unconditional acceptance and nurturing support was crucial during the early period when people like Kenojuak were venturing into the unknown, struggling to overcome their natural hesitance and fear.

Mark Kalluak, Inuit historian and archivist from Arviat, relates the delightful story of watching Gabe Gely, a government-appointed arts and crafts officer, in action: "I recall an elder coming in with an object in his hand. He handed it to Gabe Gely with an expectant look. Not knowing anything about carvings I was certain he would not accept it since it was barely recognizable to me. Gabe took it, looked at it admiringly and asked: 'What is it?' Silently I preconceived the answer to be 'a newly born lemming' because that is what I thought it surely was. But he replied, 'It's a baby beluga whale.' After a few ee's and aa's Gabe wrote

out a voucher for the person, making him look a few feet taller as he disappeared through the door."[38]

In this context, mention should be made of a booklet "Eskimo Handicrafts" produced by James Houston in 1951 and published by the Canadian Handicrafts Guild. It consisted of drawings by Houston intended to give Inuit ideas for producing carvings and handicrafts. The drawings were largely copied from actual carvings he had collected from Inuit carvers.

Not surprisingly, the booklet had very little impact. In a practically non-literate culture, written material was not an effective way to communicate a message. More effective was Houston's tendency to make drawings of interesting pieces he saw in one community and show them to carvers in others. Davidee Ittulu refers to this practice in the interview by Kudluk: "When Saumik asked me to make carvings I began to make carvings. Saumik presented me with drawings and he asked me to make carvings of the pictures he gave me."[39]

In retrospect, it seems that Houston's combination of enthusiasm, encouragement and inspiration was effective in stimulating art production among people who made the odd little ivory carving for barter or personal use, but who had never produced any large-scale stone sculptures, let alone drawings on paper. While Houston's efforts together with the Canadian Guild of Crafts and the Hudson's Bay post managers were essential, none of it would have been born fruit had it not been for the Inuit themselves and a centuries-old capacity to adapt to change. What helped in equal measure, I believe, was that people were not burdened by the mystique of Art. To them carving or drawing was one step beyond sewing a beautiful parka or building a snow house. The finely honed skills were there; they just needed to be channelled into new outlets.

It was fortuitous indeed that a number of persons and agencies had the foresight and wisdom to nurture the innate talents of these remarkable people and, in the process, allowed the artists to record their unique culture in stone, prints, drawings, and textiles, just as their ancestors had done through stories and songs for future generations.

Inukjuak

The name Inukjuak means giant and comes from an old legend. A terrible giant once lived there, terrorizing the people. The giant eventually was slain by a quick-witted hunter. The giant had a fierce wife who was enraged at her husband's death. She ran after the hunter, scooping up a rock to throw at him. The nimble hunter darted behind a huge boulder and the rock hit the boulder, smashing it in two. Water began to pour forth from the split rock. So much water came that it formed a river. Thwarted and thirsty, the giant's wife stopped to drink from the water which caused her to burst. The river flows even now and it is called Inukjuak, named after the giant.

—*Estampes Inoucdjouac* 1976 Prints (Montreal: La Fédération des Coopératives du Nouveau-Québec, 1976).

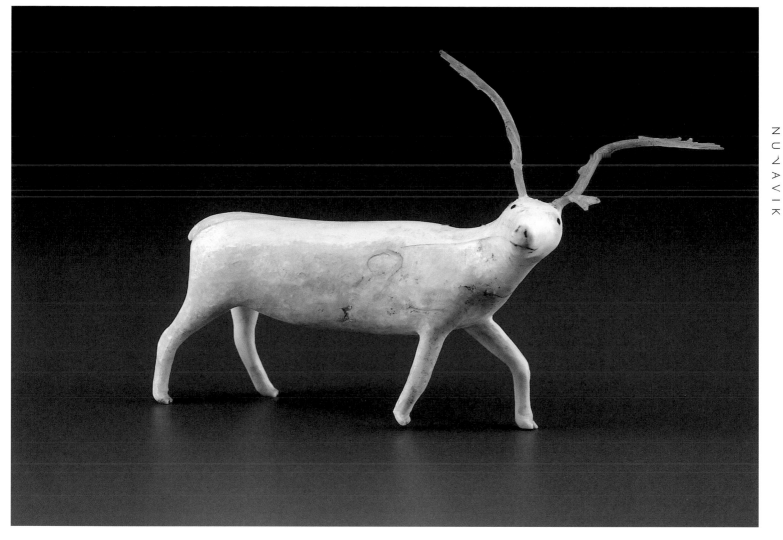

Unidentified artist

Cape Fullerton, Hudson Bay

Over the many years of contact with explorers, whalers, missionaries and traders, the Inuit learned to produce souvenirs in exchange for trade goods such as tobacco, tea and flour. However, before James Houston arrived in the North, such goods were seldom appreciated. In Inukjuak, the local traders would throw them into a bucket and reimburse the carver with five cents' worth of cigarette paper.

Caribou with Antlers 1903–1904
ivory, black colouring, muskox horn
10.2 x 2 x 2 cm
Canadian Museum of Civilization
(IV-R-799)
Provenance: Collected by A.P. Low
during Neptune expedition, received at
CMC, 1962

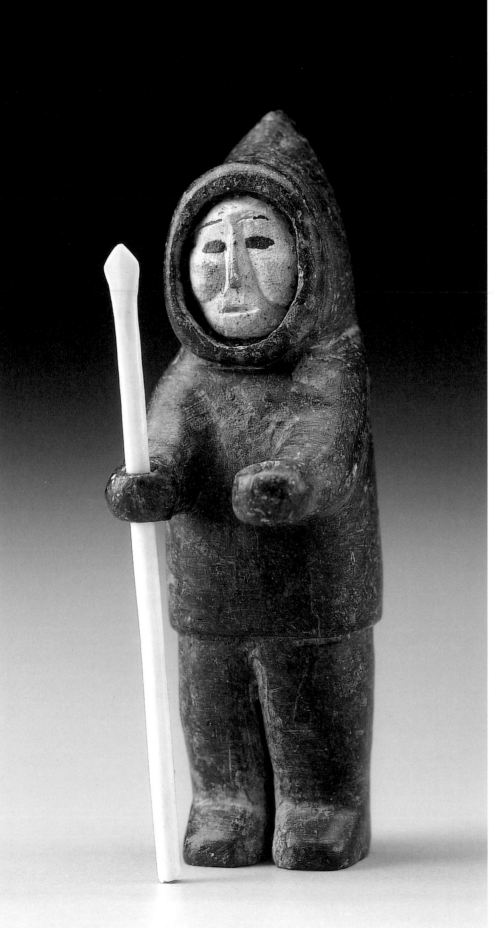

Unidentified Artist

Inukjuak

A stiff little figure reminds us that contemporary Inuit sculpture grew from a tradition of fashioning souvenirs whenever the possibility for barter existed. The explorer William Parry wrote about the Inuit meeting his ship in 1824: "They brought a little oil, some skin dresses and tusks of walrus, which they were desirous of exchanging for any trifle we chose to give them ... [They] brought with them many little canoes and paddles, sledges, figures of men and women, and other toys ..." (William E. Parry, *Journal of a Second Voyage for the Discovery of a North-West Passage* [1824; rpt. New York: Greenwood Press, 1969], 24.)

Standing Man early 1950s
black stone, ivory
9.2 x 2.8 x 3.8 cm
unsigned
Canadian Museum of Civilization, acquired with the assistance of a grant by the Government of Canada under the terms of the Cultural Property Export and Import Act, 1978 (IV-B-1705)
Provenance: Canadian Handicrafts Guild, Montreal: Samuel Welles, New York.; CMC 1978.

Unidentified Artist

Inukjuak

The implements of the man have been lost over time but would most likely have been a harpoon or knife. The woman is thinking of her husband out hunting and whether he is successful in his endeavour. An animal or person protruding from a person's head— much like a bubble in a comic strip—is a frequent device in Inuit imagery to indicate a thought.

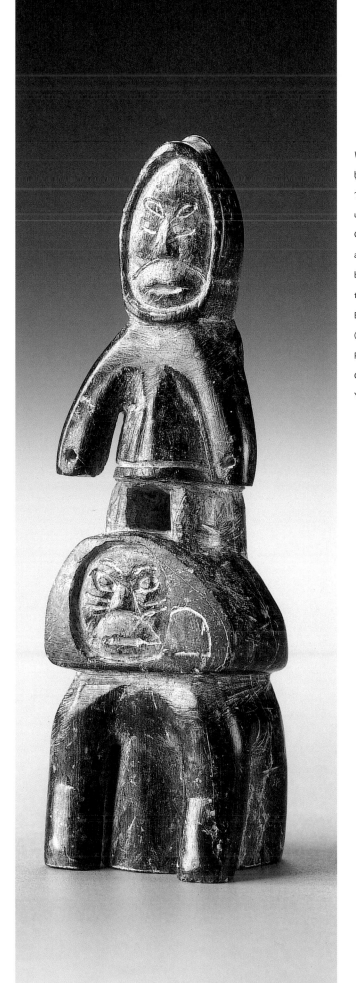

Woman Thinking of Man c.1949
black stone
11.7 x 3.5 x 2.9 cm
unsigned
Canadian Museum of Civilization, acquired with the assistance of a grant by the Government of Canada under the terms of the Cultural Property Export and Import Act, 1978
(IV-B-1720)
Provenance: Canadian Handicrafts Guild, Montreal; Samuel Welles, New York; CMC, 1978.

NUNAVIK

Akeeaktashuk

1898–1954

Inukjuak

Akeeaktashuk was killed in a hunting accident at the age of fifty-six—a walrus dragged him into freezing water. Most of his documented pieces show a hunter in action. Here, we see a hunter's prey, a bear, which was particularly dangerous to hunt. Pulsating with vitality, the animal seems very threatening. The small scale of the figure does not take away from its fierceness and menacing presence.

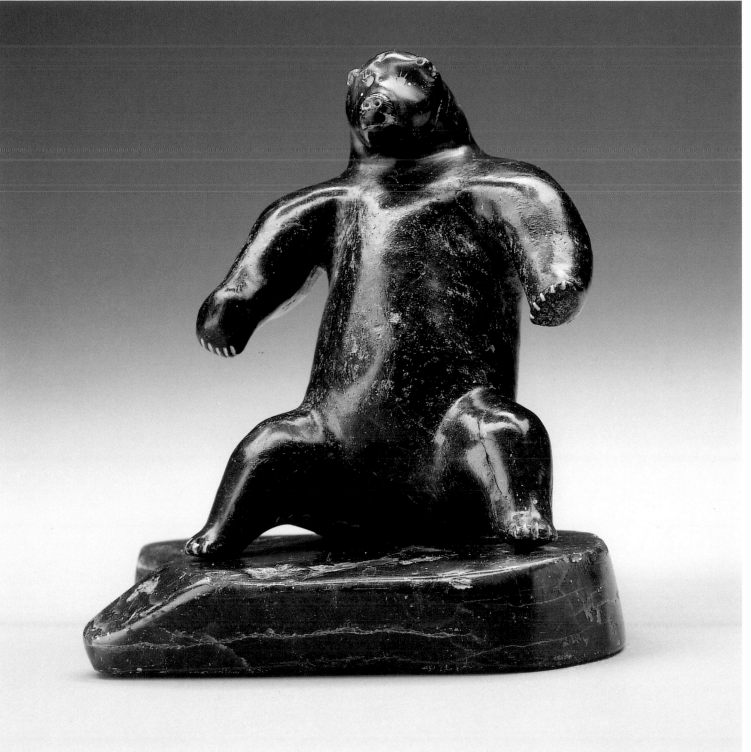

Sitting Bear 1954

grey green stone mottled with black and grey

13.2 x 7.8 x 2.5 cm

unsigned

Canadian Museum of Civilization (IV-B-1155)

Provenance: Canadian Handicrafts Guild, Montreal, 1954.

Mother and Children 1956

black stone

22.5 x 23 x 27.5 cm

unsigned

Canadian Museum of Civilization, gift
of the Department of Indian Affairs and
Northern Development, 1989 (NA 211)
Provenance: Canadian Handicrafts
Guild, Montreal, 1956.

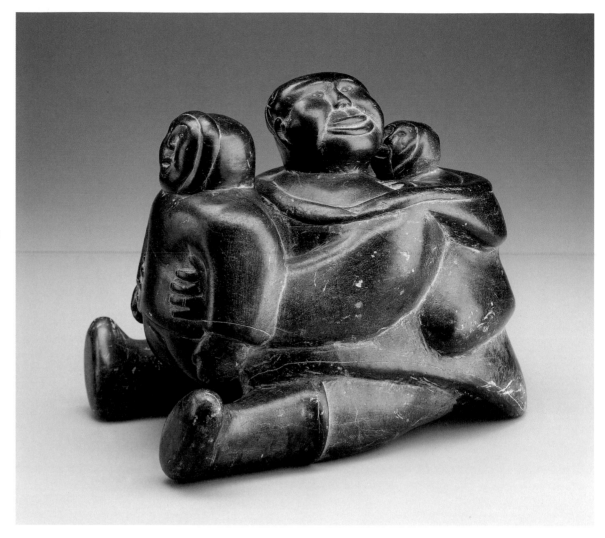

Unidentified Artist

Inukjuak

The voluptuous rounded curves and the carefully modelled
expressive faces point to Johnny Inukpuk as the creator of this
complex mother and child piece. The eyes are inlaid with material
that may well be melted phonograph records, soap, or toothbrush
handles. Inukpuk's creativity was at its height in the mid-1950s,
during which he produced some of his most powerful work.

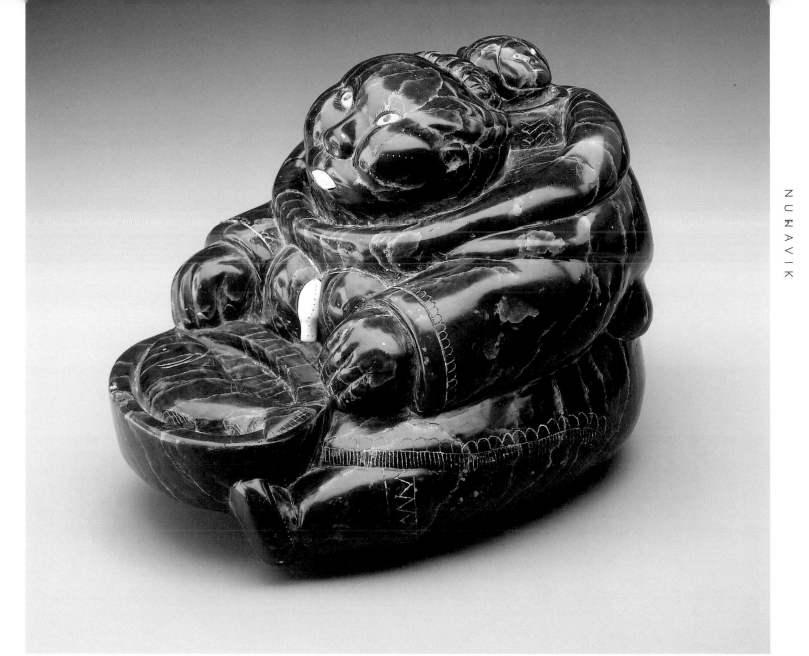

Johnny Inukpuk

1911–

Inukjuak

For a few years in the early 1950s, Inukjuak experienced an outburst of carving activity that produced some of the most memorable pieces in the whole of contemporary Inuit art. Among them is this iconic mother-and-child piece that looks like an ancient fertility goddess. This flowering resulted from the combination of luminous, jewel-like local stone and artists excited about the possibility of making a living through art. As Johnny Inukpuk stated,

Saumik [James Houston] was the one that started people to carve, so I did. Carving gave us independence that we never had before. (Henry Kudluk, "Interview with Johnny Inukpuk," unpublished ms., 1998.)

Woman and Child 1954
dark green stone, ivory
20.5 x 20 x 28 cm
signed with syllabics
Canadian Museum of Civilization (IV-B-1164)
Provenance: Canadian Handicrafts Guild, Montreal, 1954.

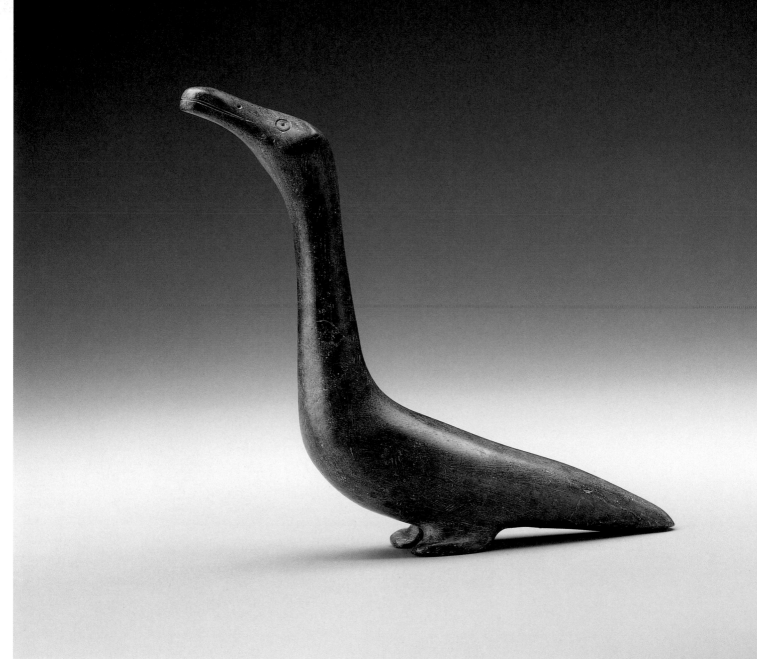

Bird 1958

grey stone

17.1 x 4.6 x 18 cm

signed with syllabics and disc number (E9-1564)

Canadian Museum of Civilization, gift of the Department of

Indian Affairs and Northern Development, 1989 (NA 707)

Provenance: Collected by William Larmour, Ottawa, 1958.

Levi Amidlak

1931–

Inukjuak

Distortion is often used as an expressive device in Inuit sculpture. Here the elongated neck of what could be a duck or a loon greatly adds to the appeal of the image. The curve of the neck is so graceful that only the clumsy feet and imperfections in the stone save the piece from being cute or slick.

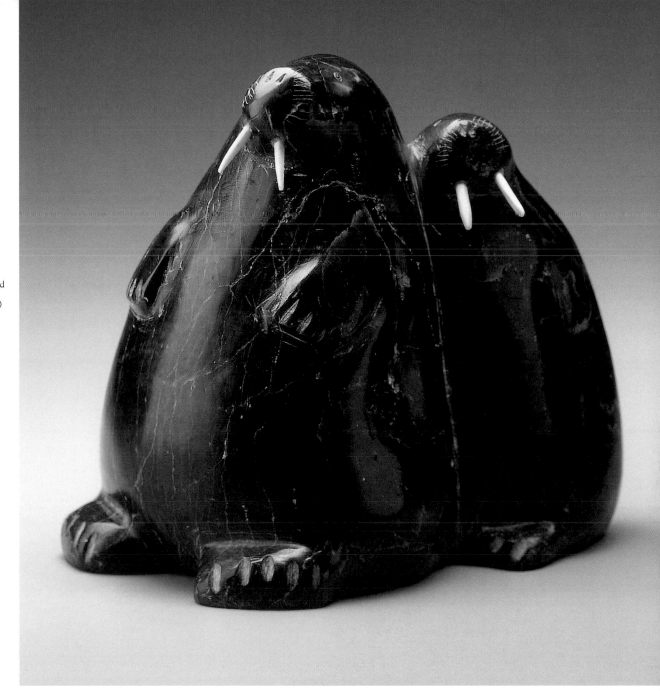

Two Walruses 1953–56

dark green stone, ivory

21 x 24 x 16 cm

unsigned

Canadian Museum of Civilization, gift
of the Department of Indian Affairs and
Northern Development, 1989 (NA 223)

Provenance: Canadian Handicrafts

Guild, Montreal, 1956.

Walrus are very gregarious animals and tend to congregate in large groups on
rocks, packed together closely, often lying half on top of one another. The artist
has captured the closeness, with the smaller animal leaning against the bigger,
as if for protection. The large one's rounded belly gives it a cuddly and
somewhat comical appearance. Like so much of Inuit sculpture, the piece is
wonderfully tactile, inviting our touch over the smooth, polished stone.

Jobie Inukpuk (attr.)

1934–1983

Inukjuak

Although it appears black, this is the same marbleized stone that other Inukjuak sculptors used during the 1950s. It looks black in contrast to the white engraving that simulates the plumage of the bird. The owl is on the verge of taking off, its wings already spread, claws drawn in. It is the implied imminent movement that gives this piece its dynamic vitality.

Owl c.1955

dark green stone

18 x 35.5 x 9 cm

unsigned

Canadian Museum of Civilization (IV-B-1212)

Provenance: Canadian Handicrafts Guild, Montreal, 1955.

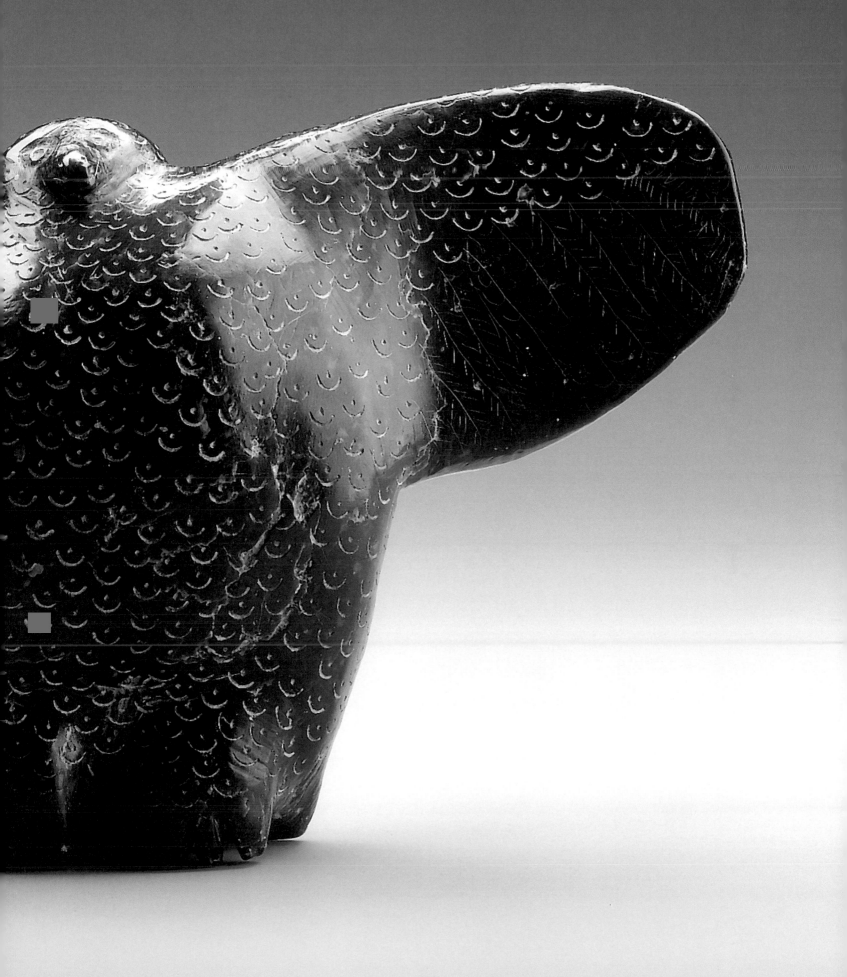

Levi Echalook (attr.)

1918–1975

Inukjuak

The focal point of this composition, which includes a seal-oil lamp, is the woman's angry face. The inlaid eyes and two rows of teeth stand in dramatic contrast to the dull grey stone. In the back, an equally angry baby tries to be heard. One of the many tasks of life in an igloo or skin tent was the tending of the oil lamp, which kept the family dwelling warm.

Mother with Child Kneeling by the Kudlik 1950s

dark grey stone, ivory

21.8 x 15.8 x 20.6 cm

signed LEVI

Canadian Museum of Civilization, gift of George J.

Rosengarten Montreal, 1983 (IV-B-1789)

Provenance: Red Petersen, former Hudson's Bay Company

manager and Co-op manager in Cape Dorset, date unknown;

George J. Rosengarten, purchased at auction Waddington's

(Toronto), June 8, 1983.

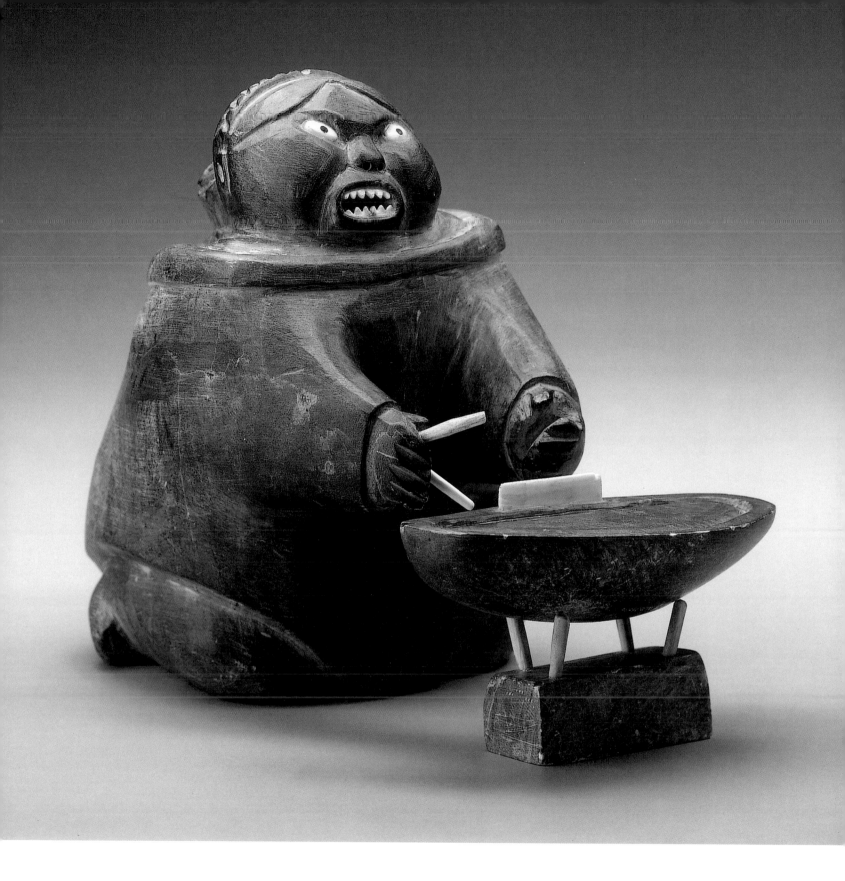

Paulosie Kasudluak

1938–

Inukjuak

NUNAVIK

After a brief and successful career as carver, Paulosie Kasudluak went on to become the president of the Federation of Co-operatives of Northern Quebec. With its smooth rounded planes, this piece follows the Inukjuak tradition of compact, sensuously curved figures of people, often carrying out a domestic task. Here the hunter is holding a fox, which most likely got caught in one of his traps.

So these carvings we make of the animals and the Inuk in traditional clothing, engaged in his work, all reveal what we were or what we are now. Nothing marvellous about it. (Paulosie Kasudluak, October 1976)

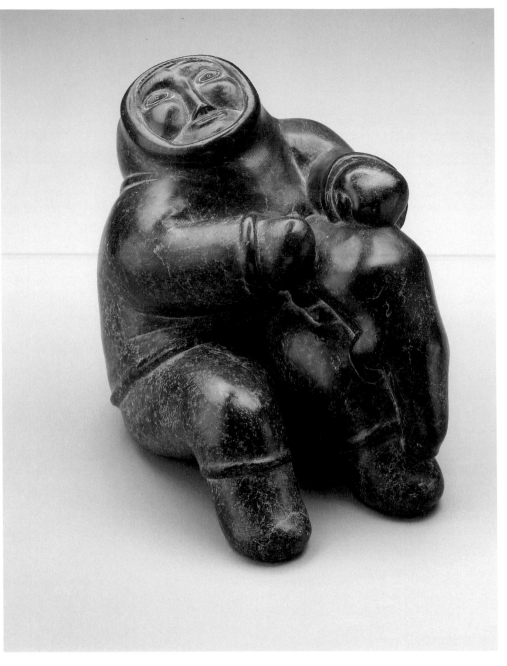

Man Holding Fox 1960

black stone, ivory

19 x 15 x 21 cm

signed with syllabics and disc number (E9-779)

Canadian Museum of Civilization, gift of the Department of Indian Affairs and Northern Development, 1989 (NA 833)

Provenance: Collected by William Larmour, Ottawa, 1960.

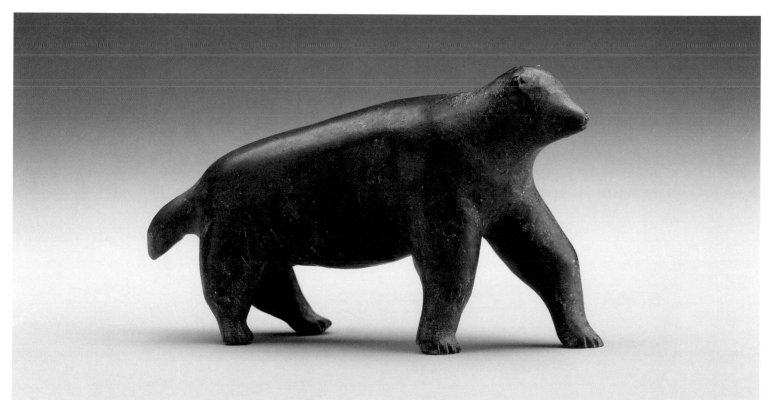

Noah Nowrakudluk

1916–

Inukjuak

Noah Nowrakudluk grew up during a time when trapping foxes was the main source of income for his family. The sculpture demonstrates his familiarity with the animal. About making art he says, *I carved so much and I didn't expect to stop. I enjoyed it so much that nights seemed long to me. I used up so much soapstone. I collected a lot of it in autumn so that I could have enough to carve over the winters.* (Personal communication with Charlie Patsauq)

Standing Fox c.1960

black stone

10 x 16 x 5 cm

signed with syllabics and disc number (–1216)

Canadian Museum of Civilization, gift of the Department of Indian Affairs and Northern Development, 1989 (NA 815)

Provenance: Collected by William Larmour, Ottawa, 1960.

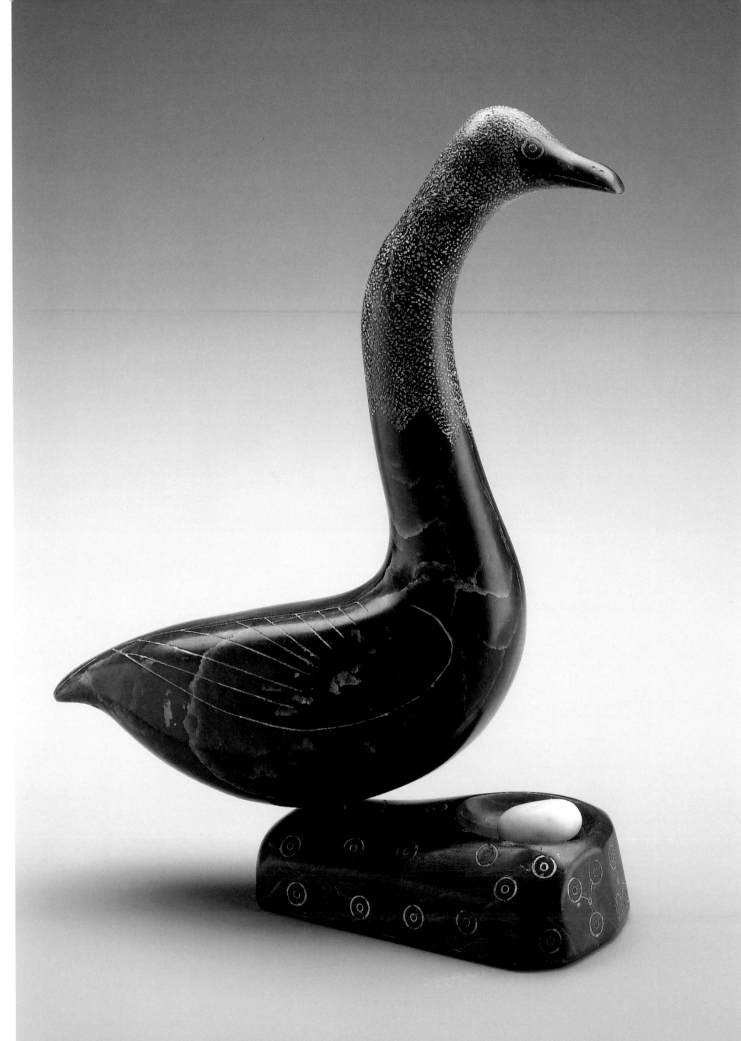

Paulosie Paulosie

1915–1979

Inukjuak

Inukjuak sculptors often peg their figures to bases for stability. Here, the artist has integrated the base into the overall image. Rather than being a support, it has become a nest in which an ivory egg lies like a jewel. The elongated neck of the loon, the delicate engraving on the neck and base, the dark green, richly textured stone all contribute to the elegance of the piece.

Loon on Nest with Egg 1950–1960

dark green stone, ivory

25.5 x 8.2 x 24.2 cm

signed with disc number (E9-1540)

Canadian Museum of Civilization, gift of Samuel and Esther

Sarick, Toronto, 1984 (IV-B-1783)

Provenance: Ron M. Woodstock, Toronto, date unknown;

Images Art Gallery, Toronto, 1984.

Sima Tukai

1911–1967

Inukjuak

Although the owl is a dangerous predator, this creature, all puffed up and comfortingly plump, does not seem very threatening. The simple incisions, probably done with some mechanical device, enliven the stone surface and simulate plumage.

Owl 1958

black stone

17.2 x 13.4 x 20.9 cm

signed SAIMA TUKI plus syllabics and disc number (E9-927)

Canadian Museum of Civilization, gift of the Department of

Indian Affairs and Northern Development, 1989 (NA 700)

Provenance: Collected by William Larmour, Ottawa.

Although unsigned, the carving may be attributed to Sima Tukai, based on some features it has in common with a signed sculpture of a seal hunter. Single figures this large are unusual in the 1950s. It takes great skill to imbue a stone of this size with life. The arresting face of the woman, with round cheeks and expressive mouth and eyes, contributes much to the success of this piece.

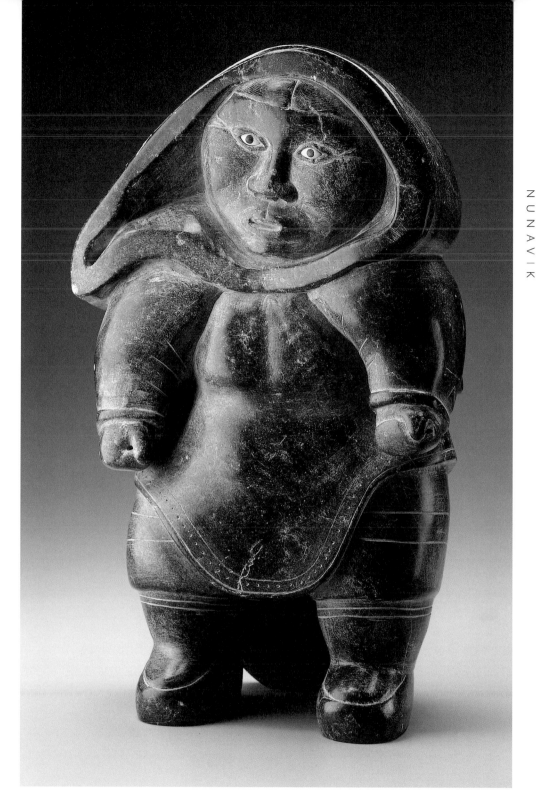

Large Woman 1956

dark grey stone, ivory

49.5 x 31.8 x 15.9 cm

unsigned

Canadian Museum of Civilization (IV-B-1219)

Provenance: Canadian Handicrafts Guild, Montreal, 1957.

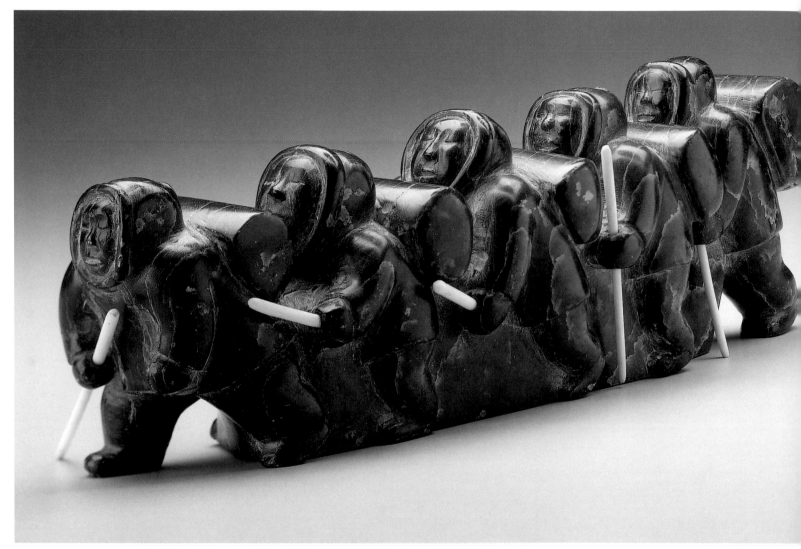

Five Men Walking 1955

dark green stone, ivory

11 x 7 x 30.2 cm

unsigned

Canadian Museum of Civilization (IV-B-1196)

Provenance: Canadian Handicrafts Guild, Montreal, 1955.

Eli Weetaluktuk (attr.)

c. 1910–1958

Inukjuak

Perhaps inspired by the shape of the stone, the artist has chosen an unusual subject. It could be a group of hunters going across thinnish ice using harpoon shafts to probe the thickness of the ice. They would not be that close unless they were caught in a blizzard and afraid to lose one another.

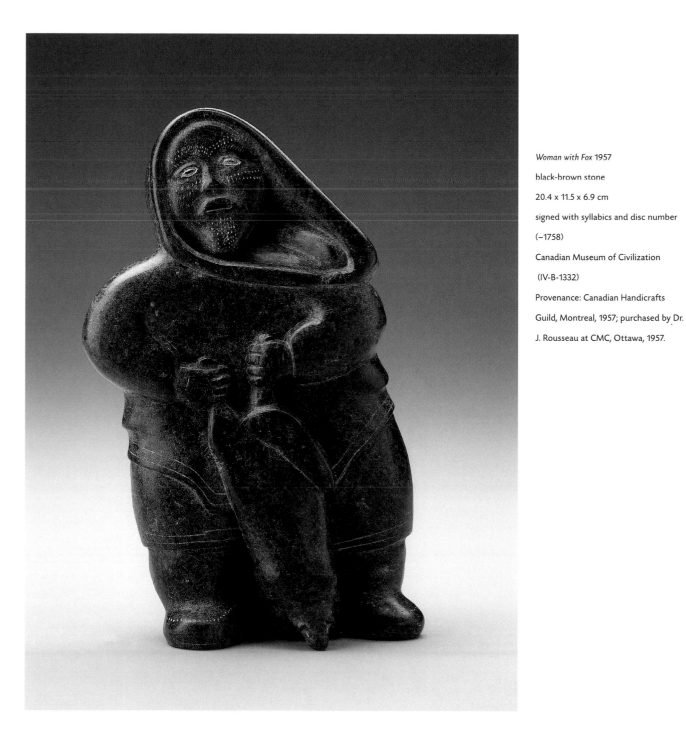

Woman with Fox 1957

black-brown stone

20.4 x 11.5 x 6.9 cm

signed with syllabics and disc number

(–1758)

Canadian Museum of Civilization

(IV-B-1332)

Provenance: Canadian Handicrafts

Guild, Montreal, 1957; purchased by Dr.

J. Rousseau at CMC, Ottawa, 1957.

Eli Weetaluktuk

c. 1910–1958

Inukjuak

The few known pieces by this artist all show the same tendency to refinement and exquisite detail. Here, the dark stone has been enlivened with infinitely fine tattooing on the woman's face and delicate stitching along her skin boots. She is holding a fox by its hind paws, its tail flipping over. Trapping foxes was an important part of the local economy in Inukjuak before prices on the world market collapsed.

Syollie Weetaluktuk

1906–1962

Inukjuak

The cameo-like faces emerging from the broad
protective hood stand in effective contrast to the
richly textured dark green stone. The artist must
have used weathered ivory. Both figures have
individual facial expressions, the baby attempting a
smile while the mother looks at us with some
concern. Her arms, lifted to pull up the hood, seem
to wave at us and increase the intensity of
interaction between the sculpture and the viewer.

Mother and Child c.1957
dark green stone, ivory
25 x 20 x 10 cm
unsigned
Canadian Museum of Civilization, gift of the Department of
Indian Affairs and Northern Development, 1989 (NA 519)
Provenance: Canadian Handicrafts Guild, Montreal, 1958.

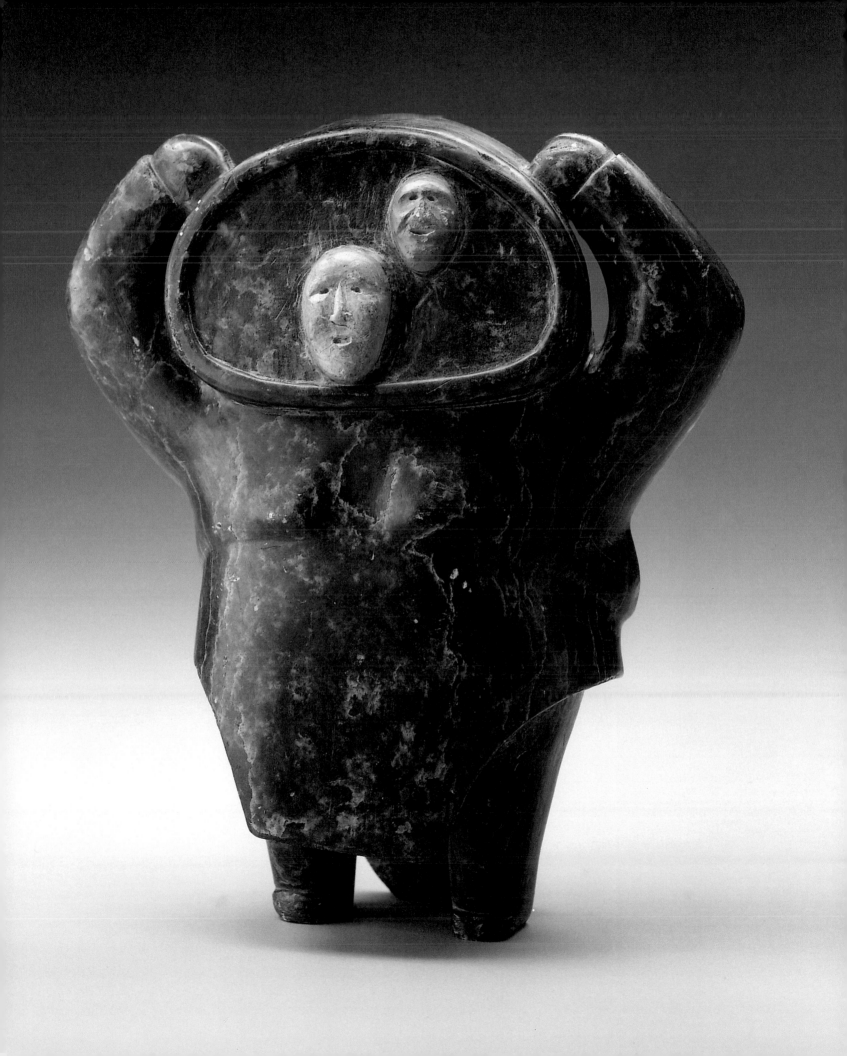

Povungnituk

The Povungnituk people liked complexity. It was almost a challenge to try and make a complex composition....I remember people would come up from Inukjuak. In those days Inukjuak people were carving quite a bit as well and they would make a big fat walrus with lots of rolls of fat on it and beautiful tusks and everything. The Povungnituk people were impressed with that...but they never tried to do the same. When they carved it was always more complex. They tried to make something that would surprise you, sort of stretch the stone a little bit, more than you thought it could be.

—Peter Murdoch, former co-op manager from Povungnituk in Marybelle Mitchell (Myers), "Making Art in Nunavik: A Brief Historical Overview," *Inuit Art Quarterly*, 13, no 3: 6.

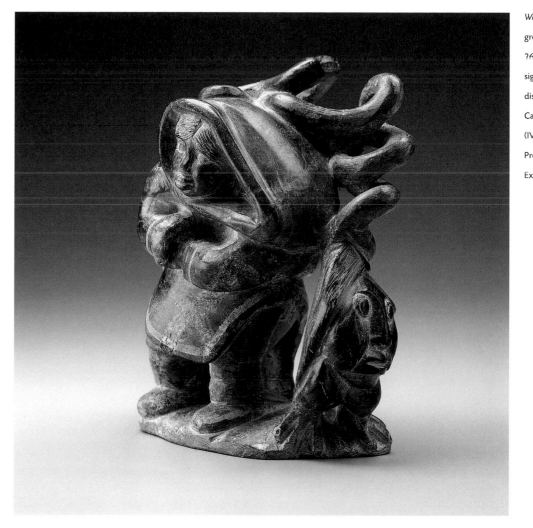

Woman with Katutayuq c.1969

grey stone

26 x 20 x 8.8 cm

signed Davidealok plus syllabics and

disc number (E9-824)

Canadian Museum of Civilization

(IV-B-1469)

Provenance: Place Bonaventure

Exhibition, Montreal, 1969.

Davidialuk Alasua Amittu

1910–1976

Povungnituk

The woman seems frightened by the sight of the monster. A frequent motif in Davidialuk Amittu's work is the snake-like spiral that is supposed to represent the northern lights. Amittu has described Katutayuq as follows: *It was a human head, tattooed and with breasts for cheeks. Its chin was a vulva, and since it had no body, its legs jutted out from the neck. It had no arms… and it had only three toes on each foot.* (Marybelle Myers [Mitchell], ed., *Davidialuk 1977* [Montreal: La Fédération des Coopératives du Nouveau-Québec, 1977], 17.)

Davidialuk Alasua Amittu

1910–1976

Povungnituk

Davidialuk Amittu has related the story for this piece:

A man was out to hunting on foot looking for driftwood along the shore. Over in the distance, while still far off, he saw a creature half-fish and half-human on the shore waving to him. As it kept waving, he went over to it. And so when he arrived, [it spoke].

"Don't come close. Don't come close; just stay nearby", said the half fish.

"Then how can I get you into the water without touching you?" said the man.

"You are looking for wood. Find some wood and try to push me out into the water. If you push me out, I will reward you," it said.

So then, looking for wood, he got some to try to push it out into the water. As it was really stuck fast in the rocks and as the half fish was very heavy, he worked a long time. When at last he pushed it out in the water, the half fish said to him, "At dawn I will place here a gramophone, a gun, and a sewing machine."

And so the half fish went off, far away out there in the water. The man simply went home. The when dawn came, the man returned to the shore to the spot where he had pushed the creature out to sea. And there on the shore the half fish had put a gramophone, a gun, and a sewing machine. But it was nowhere to be seen. The gramophone, the sewing machine, and the gun, just these were found. And all the white men are learning [to do as the half fish did] we people are thinking. That's the way the story goes; I stop because it's finished. (Z. Nungak and E. Arima, *Inuit Stories.* [Ottawa: Canadian Museum of Civilization, 1988], 93.)

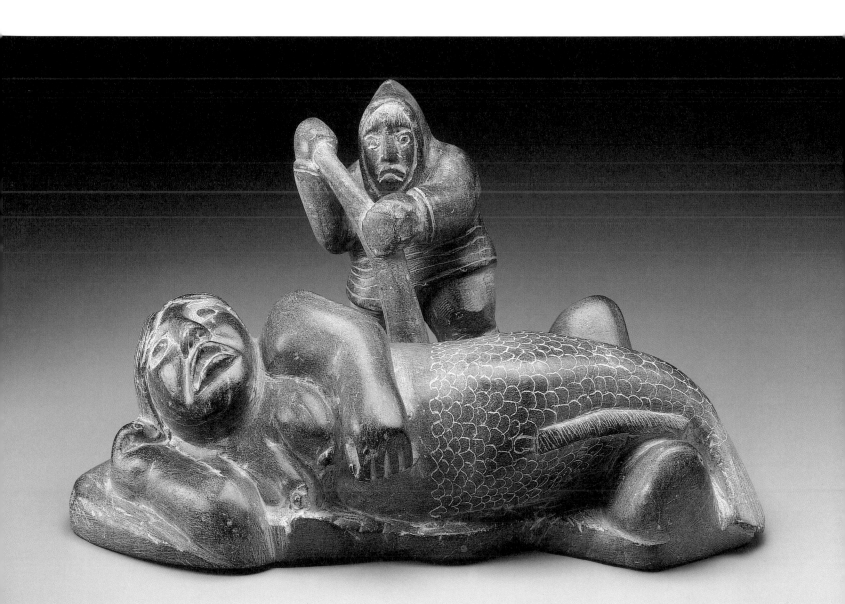

Pushing the Stranded Half Fish off the Rock 1964

grey stone

17.5 x 36 x 21 cm

signed Davidialook Alaasuik

Canadian Museum of Civilization (IV-B-1352)

Provenance: Collected by Eugene Y. Arima, of the Canadian

Museum of Man, Ottawa, 1964.

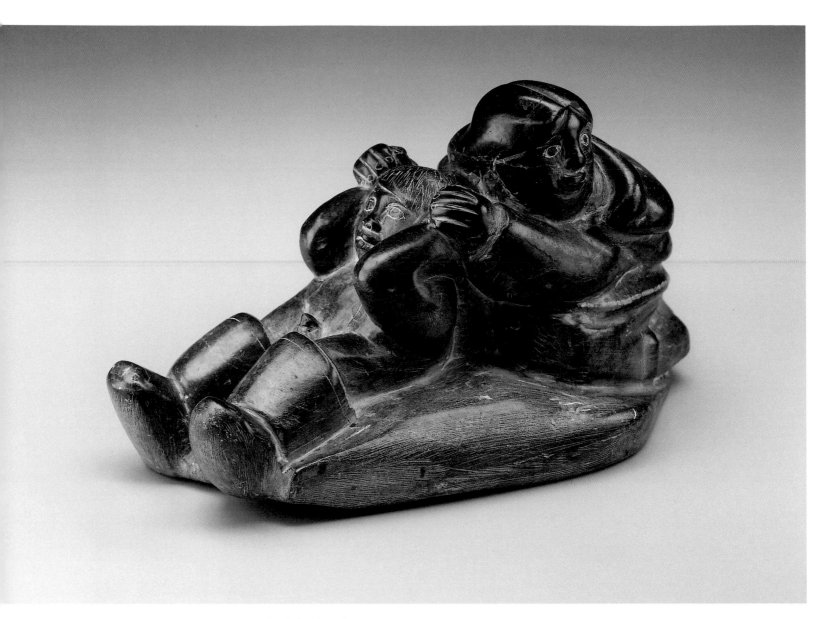

Woman with Naked Boy date unknown

grey stone

16.7 x 21.2 x 33.5 cm

signed DEVIDI

Canadian Museum of Civilization, gift of George J.

Rosengarten, Montreal, 1983 (IV-B-1788)

Provenance: George J. Rosengarten, Montreal, purchased at

auction, Waddington's (Montreal), December 1981.

Davidialuk Alasua Amittu

1910–1976

Povungnituk

Davidialuk created his very personal iconography from stories and myths he had heard as a child. Apart from telling them through prints, drawings, and sculptures, he also wrote many down, becoming a true chronicler of his people's oral history. The story behind this delightful piece is not known.

Juanisialu Irqumia

1912–1977

Povungnituk

The sculpture has been carved all around, as if it was meant to be picked up. It shows the experience of Atungak, the world traveller, blinded by the Arctic sun reflected on the snow in the spring. Before sunglasses, hunters used to wear snow goggles made out of antler with only two slits to see through.

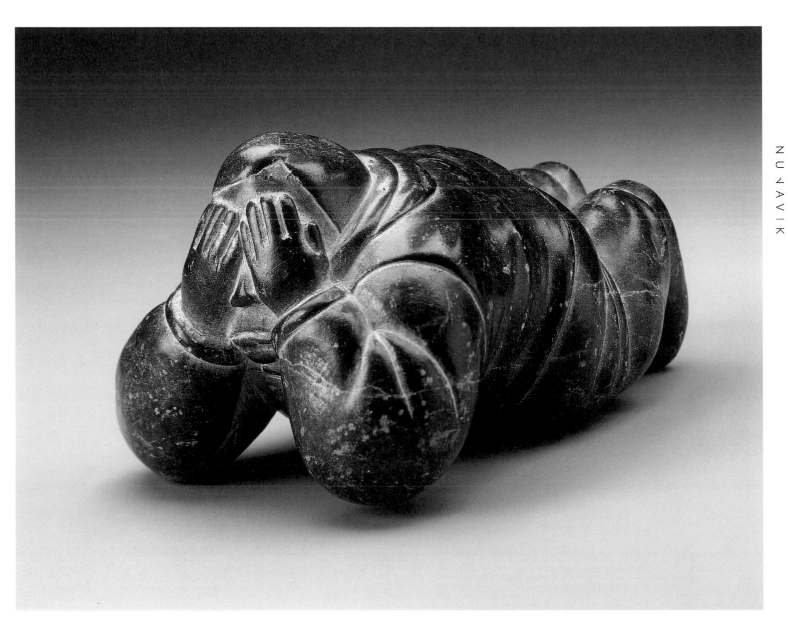

Atungak, the World Traveller, Snow-blind 1956

dark grey stone

11.5 x 13.7 x 21.4 cm

unsigned

Canadian Museum of Civilization, gift of the Department of

Indian Affairs and Northern Development, 1989 (NA 269)

Provenance: Canadian Handicrafts Guild, Montreal, 1956.

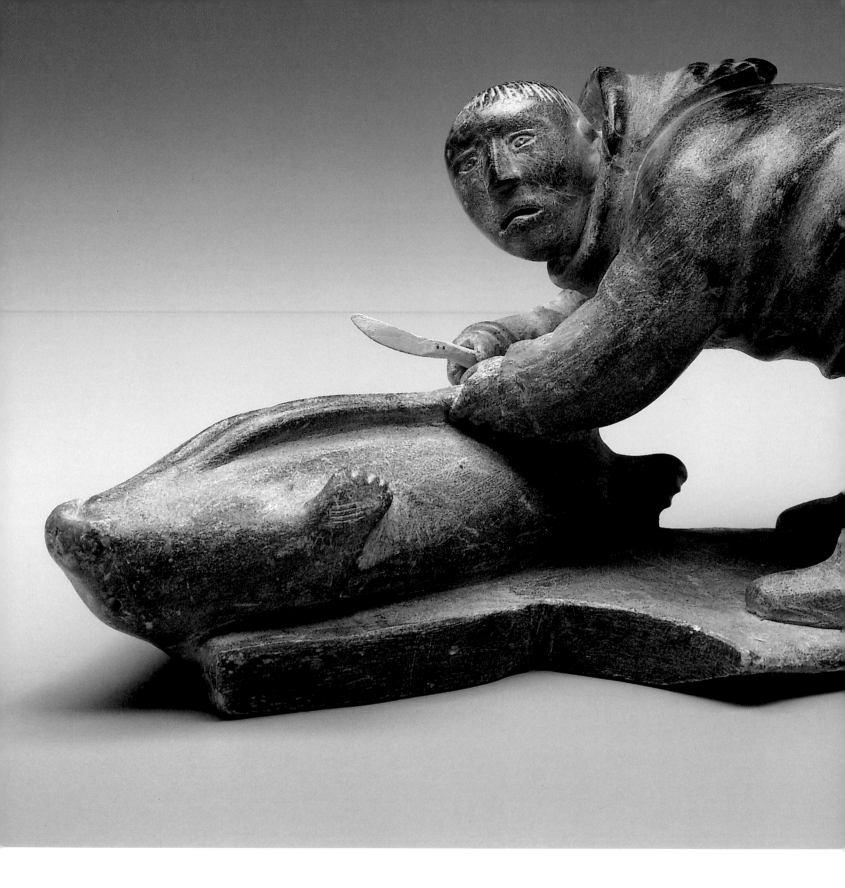

Juanisialu Irqumia (attr.)

1912–1977

Povungnituk

The attribution to Juanisialu Irqumia is based on the strong similarities between this piece and *How They Hunted Caribou Inland*. The facial features are almost identical, and in both pieces the people show strong emotions. While the travellers appear weary and tired, the seal hunter seems to be looking up from his task in surprise.

Man Cutting Seal 1957

grey stone

16.5 x 16.3 x 32 cm

unsigned

Canadian Museum of Civilization (IV-B-1279)

Provenance: Collected by Dr. J. Rousseau of the CMC, possibly

on a field trip.

Juanisialu Irqumia

1912–1977

Povungnituk

The story behind this sculpture has been told by Saali Arngnaituk: *This is the way it is traditionally. These ones are going after caribou inland on foot. They walked far away, that being the way they worked. They were courageous enough to go afar when all they had for clothing from the sea to the interior was the skins of the caribou. The man and wife had only that for clothing. They had no kayak, but some others did.* (Z. Nungak and E. Arima, *Inuit Stories* [Ottawa: Canadian Museum of Civilization, 1988], 149.)

How They Hunted Caribou Inland 1958

grey stone, caribou antler, leather

20.5 x 25.5 x 27 cm

signed SSIALUK and disc number (E9-1407)

Canadian Museum of Civilization (IV-B-1314)

Provenance: Sculptors' Society of Povungnituk, 1958; Dr. Asen Balikci, 1958.

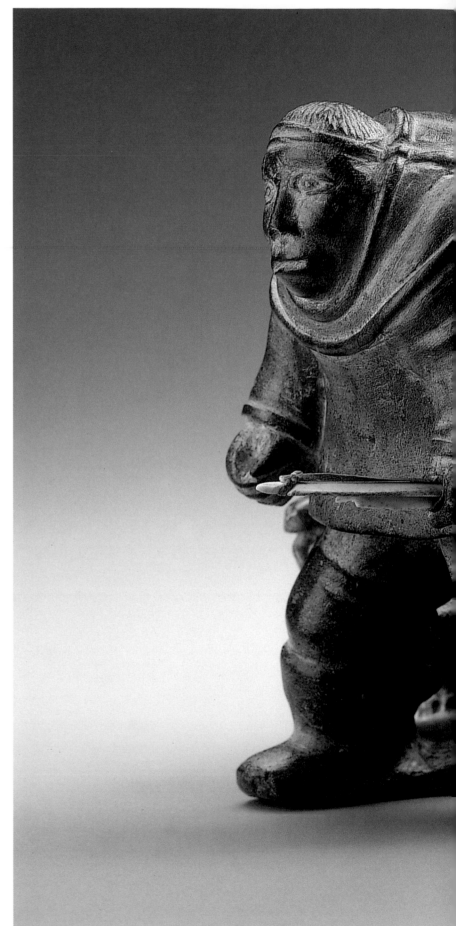

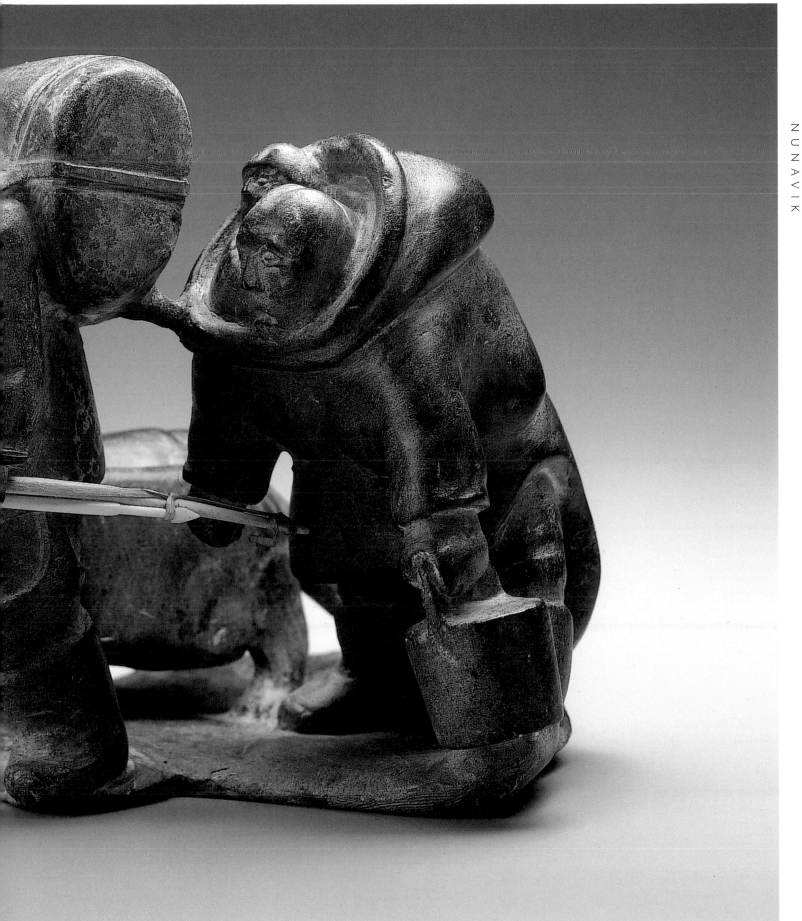

Charlie Sivuarapik

1911–1968

Povungnituk

Here the artist has set himself quite a challenge by trying to portray someone swimming underwater and from there upsetting a kayak. The story is about a woman and her fatherless child, living abandoned on an island. The child learns to swim and dive. One day two kayakers appear on the water. The boy manages to remain unseen while he punches a hole in one kayak, then upsets the other. After both men drown, mother and child now own a kayak, which enables them to move to the land.

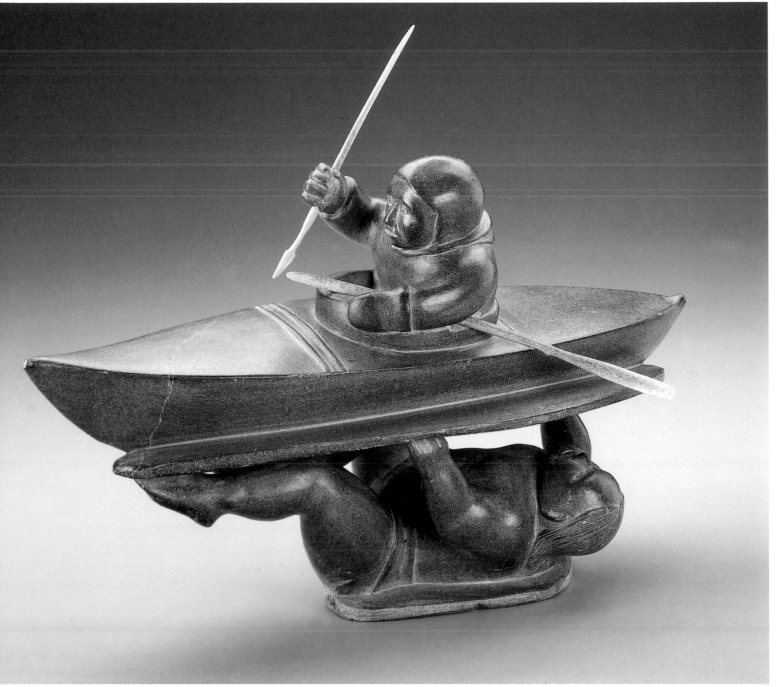

The Boy Under a Kayak 1958

grey stone, antler

27 x 14 x 36 cm

signed SHEEGUAPIK

Canadian Museum of Civilization (IV-B-1296)

Provenance: Sculptors' Society of Povungnituk, 1958; Dr. Asen

Balikci, 1958.

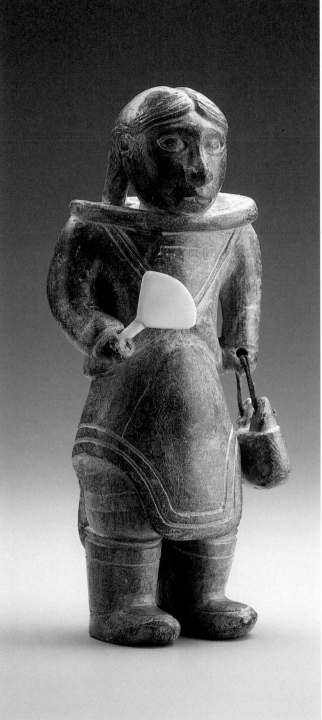

Joe Talirunili

1899–1976

Povungnituk

Apart from the migration scene, most of Joe's sculptures are single figures, frontal view, staring solemnly at the viewer. Crudely worked, and largely unpolished, they have a rustic, expressive appeal. The delicate scratchings on the woman's chest may indicate a fringe of pewter ornaments made by melting down spoons and pouring the pewter into stone moulds. They made a pleasing jingle when the woman walked.

Standing Woman with Ulu and Pail date unknown

grey stone, leather, ivory

31 x 12.8 x 9.3 cm

signed JOE

Canadian Museum of Civilization, gift of George J.

Rosengarten, Montreal, 1983 (IV-B-1785)

Provenance: George J. Rosengarten, Montreal, purchased at

auction, Waddington's (Montreal), December 1981.

Joe Talirunili, as a child, experienced a traumatic journey in an umiak—a woman's boat—during which forty people drowned. This event has been a recurring theme in his drawings, prints, and sculptures. Shortly before his death, he made another large series of "migration" pieces. The fact that this scene is one of twenty-four different versions does not diminish its power and expressive quality.

Migration c.1975

grey stone, skin, cotton thread, wood

34.5 x 29 x 20.6 cm

unsigned

Canadian Museum of Civilization (IV-B-1644)

Provenance: Innuit Gallery, Toronto, 1976.

Unidentified artist

Povungnituk

A family was moving north in a sealskin umiak. When the wind and tide caught them between heavy floes of moving ice and crushed their boat, they had to jump out onto the ice. The tide turned and they were carried far out into Hudson Bay. They had little food and would soon starve.

The men went to the edges of this floating piece of ice and waited. A large bearded seal appeared, and one of the hunters harpooned it. Now they had food for themselves and their wives and children, but still they were pushed westward by the wind. Next day the men harpooned two more bearded seals, and this gave them enough skin to cover a kayak. But they had no wood.

"We will make a kayak by splitting the seal's bones, then bending them, while the women scrape the skins and draw the long sinews out of the seal to sew the boat."

"Hurry!" whispered the hunters. "We can hardly see the shore ice now."

The women sewed as quickly as they could, and the men tied the seal's two shoulder blades, one on each end of a harpoon.

"I'll paddle," said the strongest hunter. "Some women with a baby can lie on the back of this kayak and one child can crawl inside."

He paddled them onto the main ice that was still connected to the shore, then returned to get the others. In this way, all the hunters and their families were saved.

This is an Inuit record of an event that is said to have occurred on the east coast of Hudson Bay early in the twentieth century. (Legend translated by Joni Pov.)

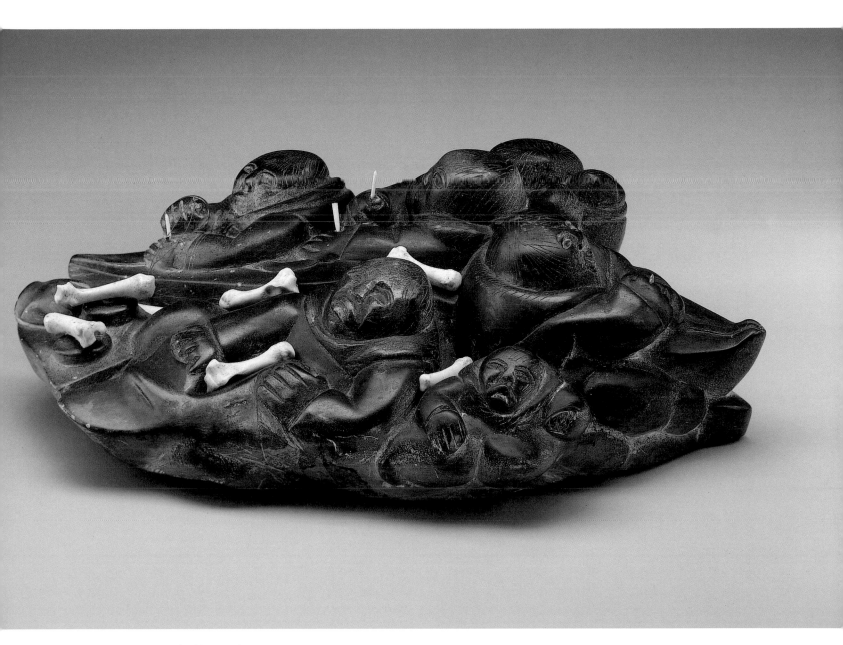

Family Sewing and Building a Kayak 1969

black stone, bone, sinew

12 x 40.5 x 27 cm

unsigned; label: Pitiaju

Collection of James Houston

Provenance: Lippel Gallery, Montreal, date unknown.

Salluit

(formerly called Sugluk)

At the place called Sugluk the endless summer days were an interlude of warmth and relative security from want. Early in July the ice covering the inlet disappeared over night as if by magic. The following morning, seals were to be seen frolicking in the open water only yards from the beach. Schools of white whales knifed their way along the shoreline, sometimes fleeing in terror from a pursuing killer whale. Deeper into the inlet arctic char in the thousands broached the mouth of the big river on their way to the spawning grounds. Whole families moved to a summer camp at the river's mouth where the harvest of fish taken by spear provided a welcome change of diet and sun-dried meat for later times.

—Barry Roberts, *The Inuit Artists of Sugluk*, P.Q. (Montreal: La Fédération des Coopératives du Nouveau-Québec, and Ottawa: Department of Indian and Northern Affairs, 1976.)

Johnny Issaja Papigatok

1923–

Salluit

This woman, proudly displaying her beautiful long braids, wears a skirt under her traditional hooded parka. Heated houses made warm caribou clothing no longer necessary, and fashions changed through increased contact with the South. Some missionaries did not like women to wear trousers and encouraged cotton skirts.

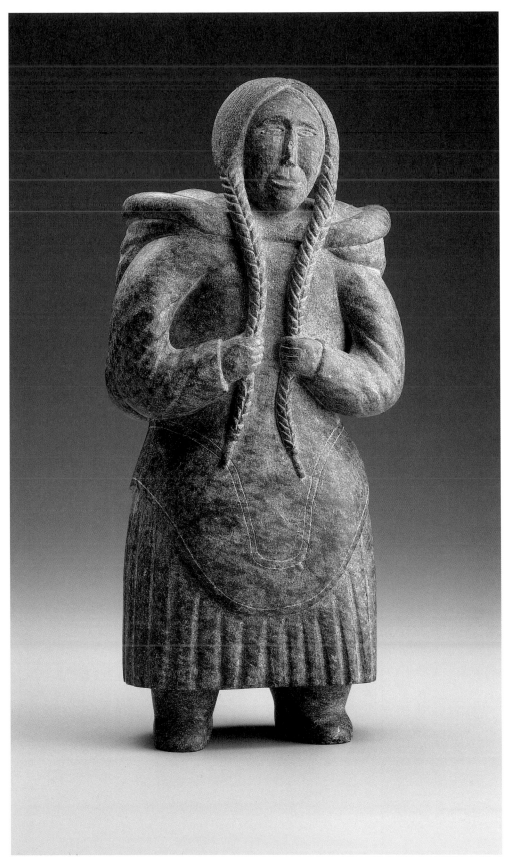

Woman with Braids 1955

grey stone

36.1 x 16.1 x 10.6 cm

signed with syllabics and disc number (E9-1111)

Canadian Museum of Civilization, gift of the Department of Indian Affairs and Northern Development, 1989 (NA 55)

Provenance: Hudson's Bay Company, Winnipeg, 1955.

Bobby Quppaapik Tarkirk

1934–date unknown

Salluit

Bobby Tarkirk was best known for his miniatures. To provide money to send his children to the movies at the Oblate Mission in Salluit, he used to carve very small pieces that could be sold locally for just enough to pay admission. Accidentally, a federal employee was looking for small-scale gifts to take to Europe. He saw one of Tarkirk's and commissioned a large group, unwittingly launching his career in small-scale carvings. The delicate rendering of hair and facial features in this piece reveal the miniaturist's interest in fine detail.

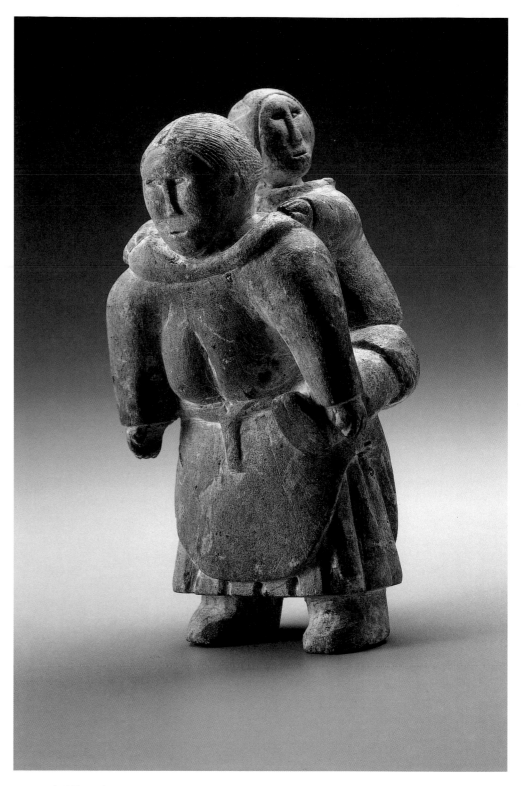

Woman with Child on Back 1958

grey stone

16.7 x 8 x 9 cm

unsigned

Canadian Museum of Civilization, gift of the Department of
Indian Affairs and Northern Development, 1989 (NA 525)

Provenance: Canadian Handicrafts Guild, Montreal, 1958.

Imadlak Tayarak

1917–1990

Salluit

Wearing a combination of traditional and modern clothing, the woman is putting a piece of meat into her mouth before she cuts the end off with an ulu (a crescent-shaped knife). Artists in Salluit during the 1950s often showed people performing simple everyday domestic tasks.

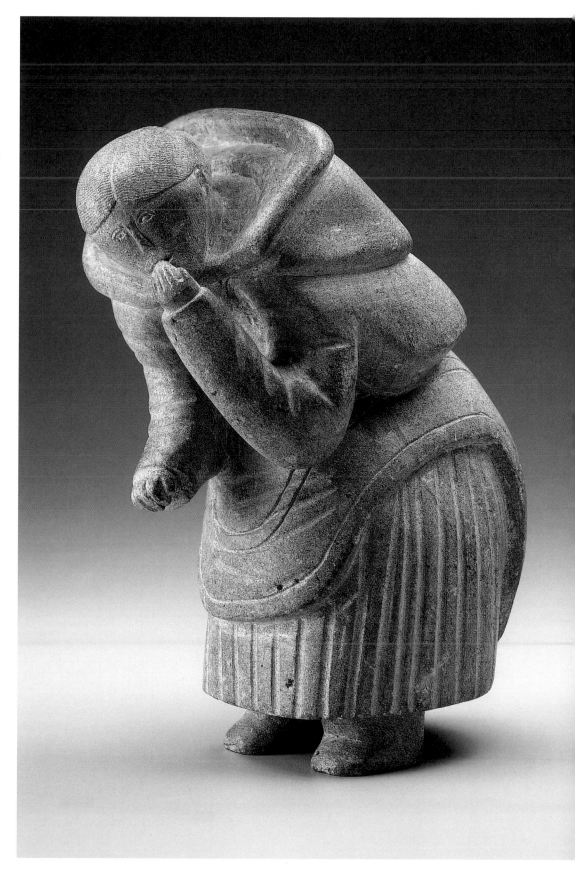

Standing Woman Eating 1956

grey stone

28.1 x 13.4 x 22.5 cm

signed with syllabics and disc number (E9-1196)

Canadian Museum of Civilization, gift of the Department of

Indian Affairs and Northern Development, 1989 (NA 251)

Provenance: Canadian Handicrafts Guild, Montreal, 1956.

Unidentified artist

Salluit

Using the protective hood as a frame for mother and child, the artist portrays a slender and graceful figure, with gentle curves emphasizing her femininity. Her stance indicates politeness and hesitance, her feet not quite touching the ground, as if she is afraid to come forward. In the pre-settlement culture, young Inuit women were encouraged to be polite and subservient to their elders.

Woman and Child 1954

grey stone, ivory

23 x 4.5 x 3.2 cm

unsigned

Canadian Museum of Civilization (IV-B-1193)

Provenance: Canadian Handicrafts Guild, Montreal, 1956.

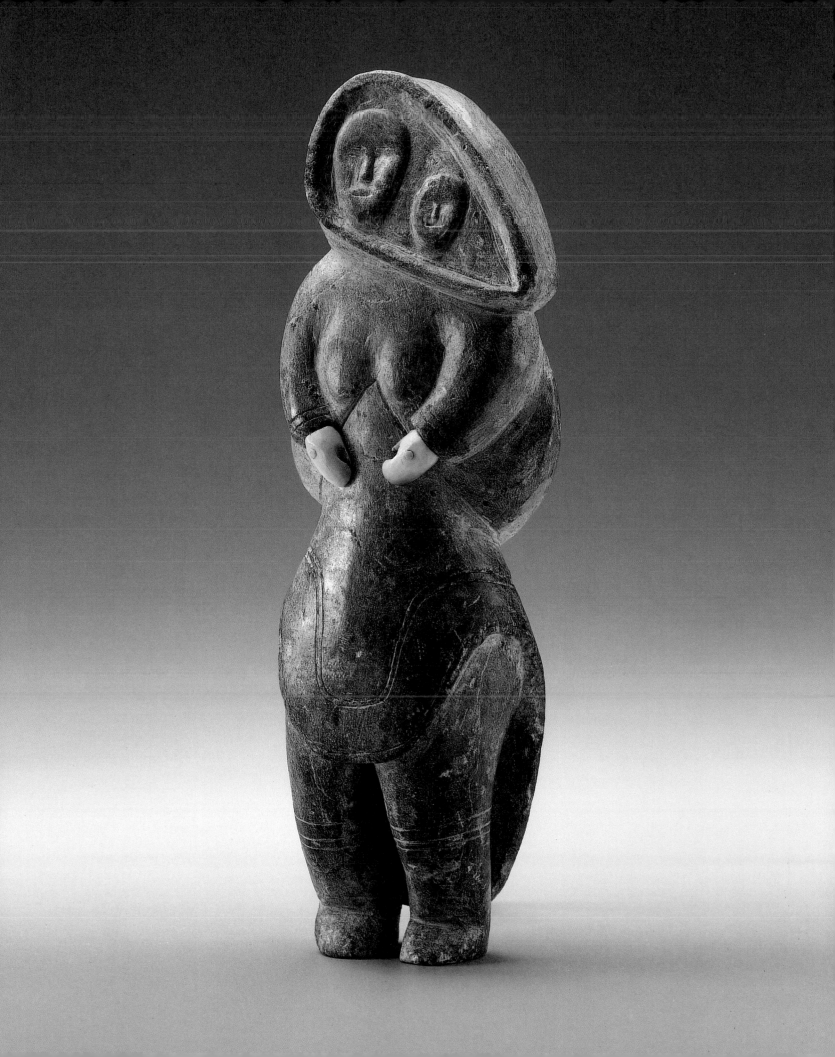

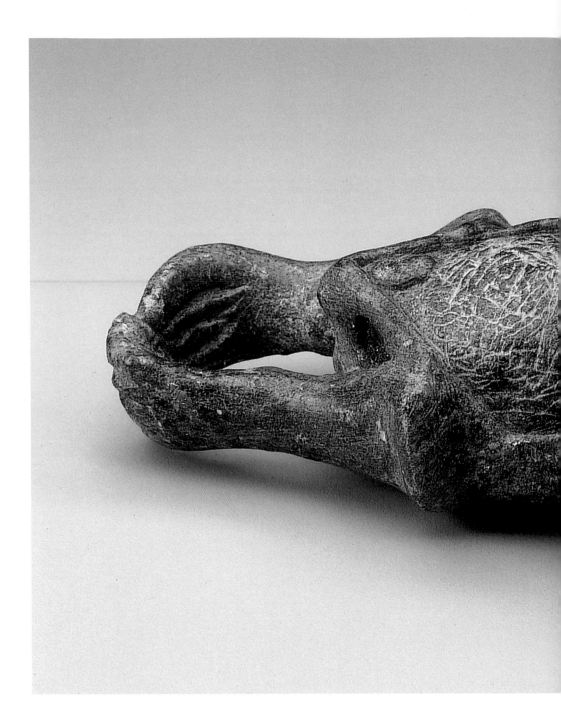

Unidentified artist

Salluit

Inuit hunters had a precise knowledge of all the animals they hunted. Walrus meat was cut into pieces before it was eaten cooked, frozen, or fermented; it was rarely consumed raw. The hide was cut into small pieces. Walrus meat was also used to feed the dogs. The tusks were used for a variety of purposes, including toggles for clothing or sled runners. One wonders whether the artist of this unique sculpture used an actual carcass as a model.

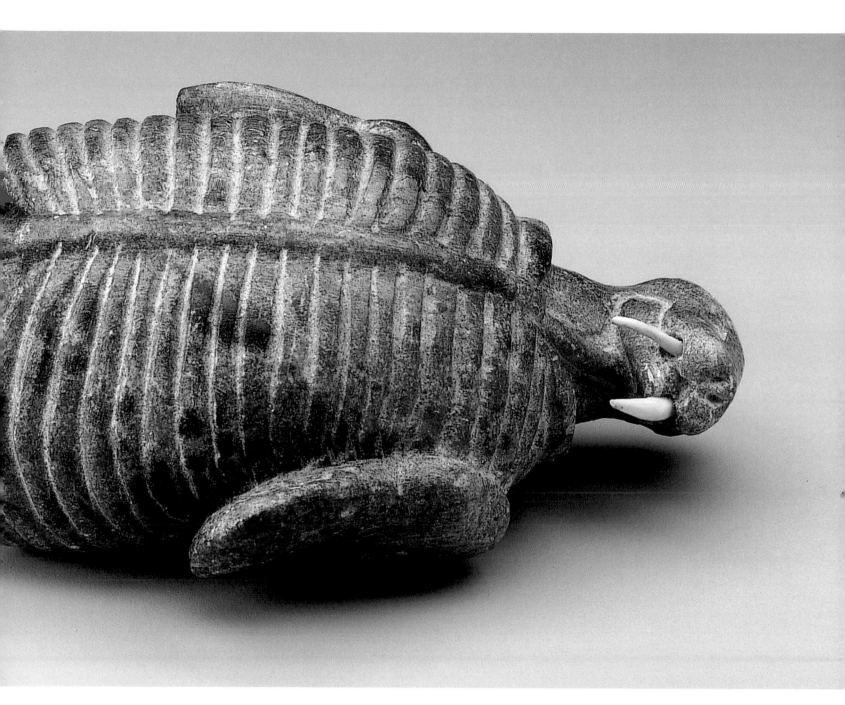

Flensed Walrus c.1951

grey green stone, ivory

6 x 7.9 x 18.9 cm

unsigned

Canadian Museum of Civilization (IV-B-1601)

Provenance: Ian G. Lindsay, Ottawa, 1951.

Sammy Kaitak

1926–

Salluit

Salluit experienced a brief period of prolific production between 1953 and 1956–57, during which this piece was produced. Unlike the usual portrayal of mother and child, this one emphasizes not the relationship between the two but the woman's absorption in the task of combing her hair. The texture of the hair is different before and after it has been combed. The delicate, heart-shaped face of the woman is in sharp contrast to her massive body, firmly grounded in a kneeling position. We are invited to share this brief domestic moment, frozen in time.

Woman Combing Her Hair c.1955

grey stone

29.5 x 15 x 24 cm

signed with syllabics and disc number (E9-1090)

Canadian Museum of Civilization, gift of the Department of

Indian Affairs and Northern Development, 1989 (NA 611)

Provenance: William Larmour, Ottawa, 1958.

Cape Dorset

When I first went there in 1951, I found a certain fiery spirit among the people of Cape Dorset, which I think drives a sense of life into their carvings.

—James Houston, "Cape Dorset 1951" in Jean Blodgett, *Cape Dorset* (Winnipeg: Winnipeg Art Gallery, 1979)

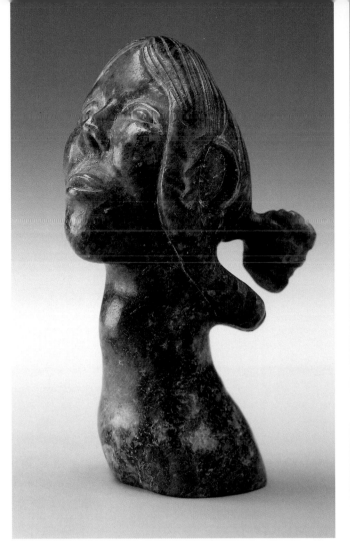

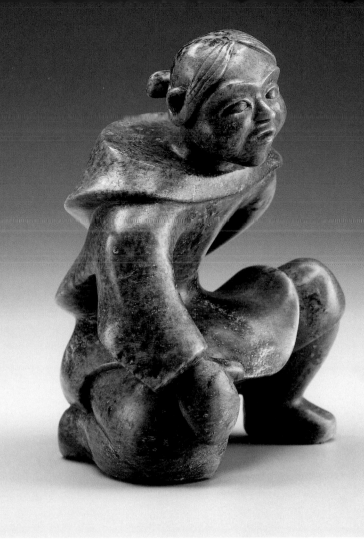

Woman's Head c.1960

green stone

13.5 x 6 x 9 cm

unsigned

Canadian Museum of Civilization, gift of the Department of

Indian Affairs and Northern Development, 1989 (NA 921)

Provenance: Collected by William Larmour, Ottawa, 1960.

Kneeling Woman 1960

green stone

19.6 x 15.8 x 15.6 cm

unsigned

Canadian Museum of Civilization, gift of the Department of

Indian Affairs and Northern Development, 1989 (NA 852)

Provenance: Collected by William Larmour, Ottawa, 1960.

Kiawak Ashoona

1933–

Cape Dorset

Kiawak Ashoona has stated that this was not the portrait of a particular person. About carving faces he has said, *When I do a face, I sort of put the chin up so it looks as if the person is smiling.... When you look at a carving and you look at a face and the face doesn't seem so well done, then the rest of the carving seems to go along with it. The main thing in a carving is the face. I think people should know that.* (Personal communication with Marion Jackson, February 1979)

The soft soapstone found on Baffin Island lends itself well to Kiawak Ashoona's graceful rendering of a young woman. The gentle rhythm of undulating lines that define the various layers of her parka make the back as aesthetically pleasing as the front view. In fact, our eyes are led around the figure by the right arm, which she hides at her back. Altogether it is an image of youth, lightness, and grace.

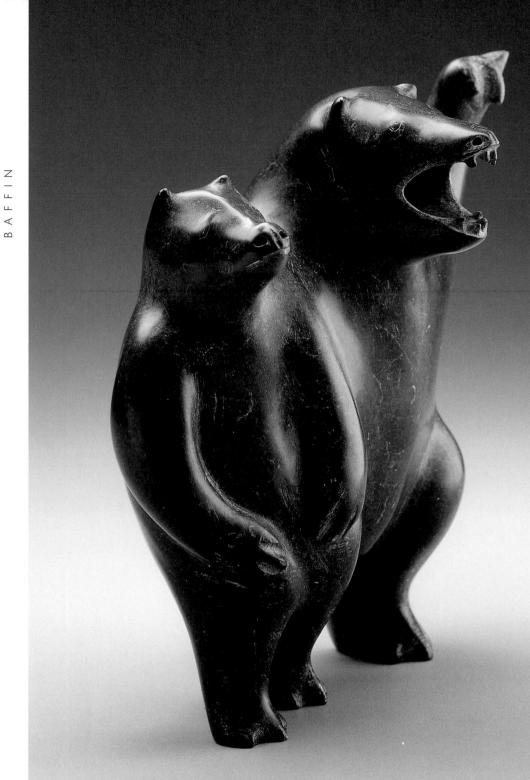

Kiawak Ashooa

1933–

Cape Dorset

Kiawak has an amazing capacity to animate stone, as in this malevolent spirit that is lifting one paw and showing its terrifing teeth. His spirit pieces from the 1960s are among the most imaginative and intriguing images in his *oeuvre*, which is impressive and spans a good fifty years. James Houston had the pleasure of encouraging Kiawak's remarkable carving talent, which he had started to display at a very young age.

Howling Spirits 1959

green stone

23.3 x 20.5 x 14 cm

unsigned

Collection of James Houston

Provenance: James Houston, trade from the artist, 1959

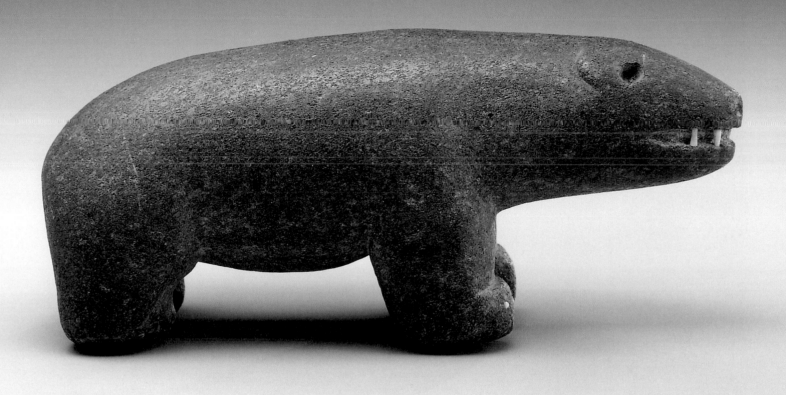

Polar Bear 1950–1952

granite, ivory

10.6 x 8.5 x 25 cm

unsigned

Canadian Museum of Civilization, acquired with the assistance of a grant by the Government of Canada under the terms of the Cultural Property Export and Import Act, 1978

(IV-C-4976)

Provenance: Canadian Handicrafts Guild, Montreal; Samuel Welles, New York.

Pootoogook (attr.)

1887–1958

Cape Dorset

According to James Houston, this piece may well be by Pootoogook, a famous camp leader and father of four prominent artists in Cape Dorset. Houston had to win Pootoogook's support for the printmaking program before he could expect it to become a success. The stone is a hard granite, which Cape Dorset artists used in the early 1950s. The porous surface does not invite detail but works perfectly to suggest the fur of the bear.

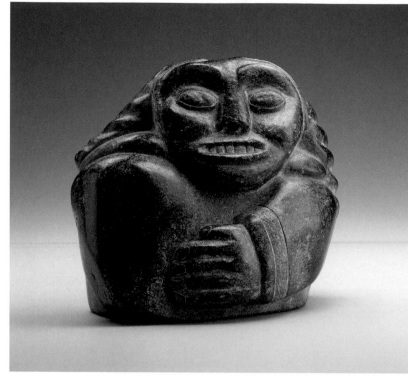

Bust of a Woman 1956

green black stone

21.3 x 24.7 x 14.8 cm

unsigned

Canadian Museum of Civilization, gift of the Department of Indian Affairs and

Northern Development, 1989 (NA 265)

Provenance: Canadian Handicrafts Guild, Montreal, 1956.

Qaqaq Ashoona

1928–1996

Cape Dorset

Qaqaq Ashoona has repeated the theme of head and torso, usually that of a woman, for many years throughout his career, which lasted more than thirty years. This is one of the earliest and much-celebrated examples. It derives its power from the precisely articulated facial features and the framing of the face by both the left arm and oversize hand and the braids on each side.

When I am carving I sort of walk around the stone just to see which way it could look better–which way it would turn out best. Yes, I get the idea for a carving from the stone. Before I start carving I just look at it for a while–sort of like draw it with my eyes to see what I will carve. (Interview with Marion Jackson, Cape Dorset, March 1979)

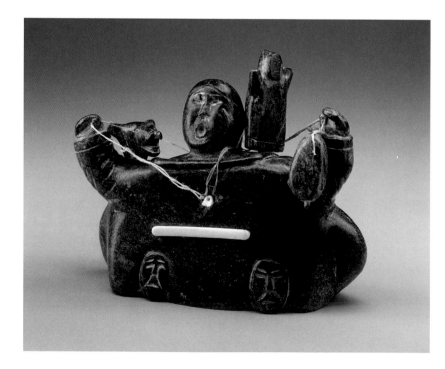

It is doubtful whether Qaqaq Ashoona himself ever experienced a shamanistic seance during which the shaman, in this case a female, harpoons herself without suffering a mortal wound. Two spirit helpers sit on her shoulder. Overt depictions of shamanistic practices are fairly rare in contemporary Inuit art; with the Inuit conversion to Christianity, shamanistic beliefs went underground and were not talked about.

Female Shaman (Medicine Woman) 1953

dark green stone, ivory, sinew, metal, wood

17.5 x 22 x 8.7 cm

unsigned

Canadian Museum of Civilization (IV-C-3362)

Provenance: Canadian Handicrafts Guild, Montreal, 1953.

This sculpture may simply be about a woman climbing on her husband's shoulders in order to get a better view into the distance. Qaqaq from the beginning developed his own distinct carving style, working more with heavy, compact forms than the delicate detail typical of his brother Kiawak.

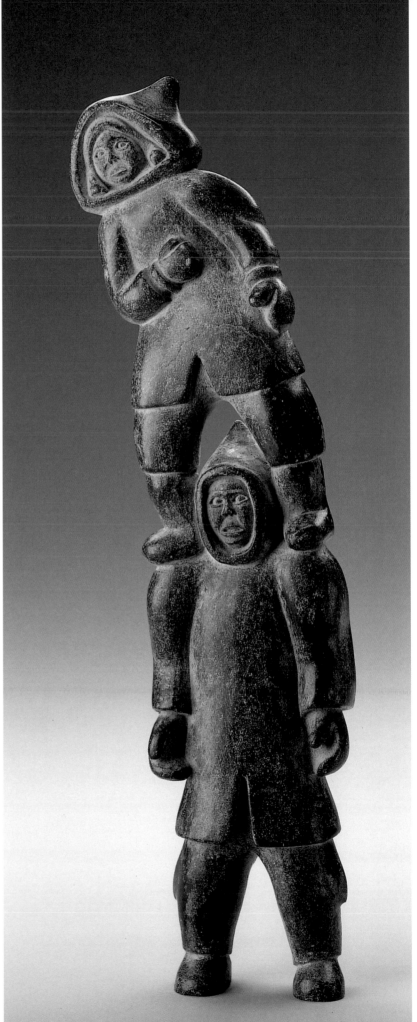

Man and Woman 1957

black stone

36.5 x 8 x 4.5 cm

unsigned

Canadian Museum of Civilization, gift of the Department of

Indian Affairs and Northern Development, 1989 (NA 403)

Provenance: Canadian Handicrafts Guild, Montreal, 1957.

Kneeling Caribou c.1969

stone, antler

36.5 x 41 x 23 cm

signed with syllabics

Canadian Museum of Civilization

(IV-C-4098)

Provenance: Canadian Arctic Producers,

Ottawa, 1970.

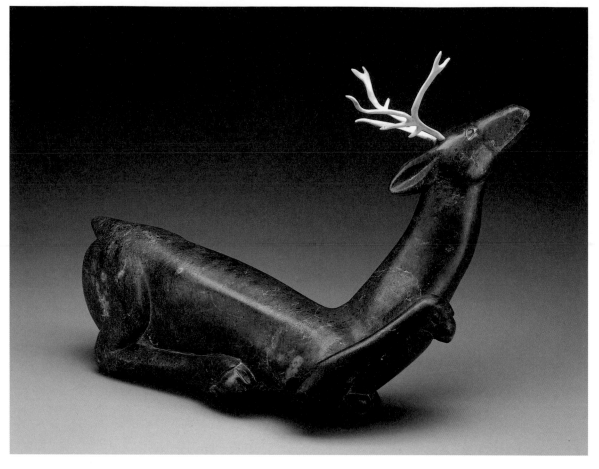

Osuitok Ipeelee

1923–

Cape Dorset

Osuitok Ipeelee is one of the most important carvers
from Cape Dorset. His career spans more than fifty
years, during which he has concentrated on the
depiction of Arctic animals, caribou in particular. The
grace, delicacy, and elegance of his caribou
sculptures, as evidenced in this early piece, are
admired the world over.

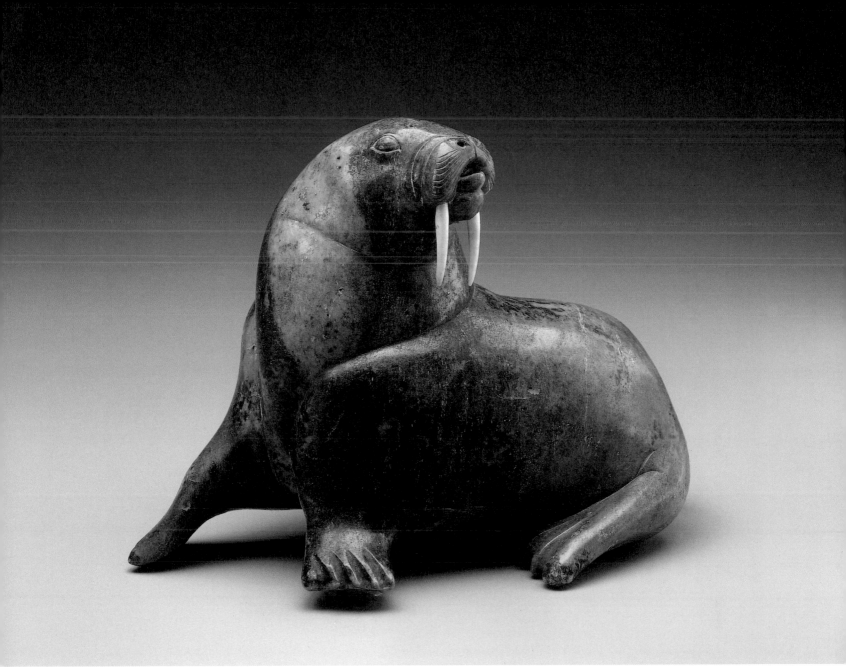

Walrus 1962

stone, ivory

19.5 x 26 x 14 cm

unsigned

Collection of James Houston

Provenance: James Houston, gift from

the artist, 1962.

James Houston received this piece from Osuitok Ipeelee as a parting gift when he left Cape Dorset in 1962. It marked the end of a long and mutually rewarding collaboration. Houston fondly remembers Osuitok's wife, Nepeesha, surrounded by her children, carrying the wrapped carving in the hood of her amautik down to the police plane that was waiting on the ice to take him south.

Osuitok desribes his work habits:

Nowadays, I generally begin work on something I'm going to carve in the early morning when it's nice, just beginning to get light. I carve at it all day, the next day and even into a third day. I won't get tired of it. I won't get bored. (personal communication with Dorothy Harley Eber)

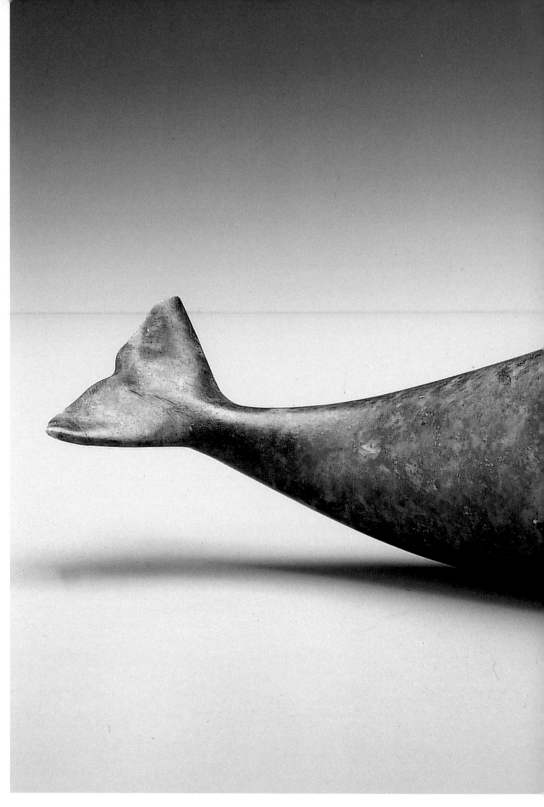

Taleelajuq c.1960

green stone

12.5 x 7.8 x 34 cm

unsigned

Canadian Museum of Civilization, gift of the Department of

Indian Affairs and Northern Development, 1989 (NA 955)

Iyola Kingwatsiak

1933–

Cape Dorset

According to the artist, the sculpture shows
Taleelajuq, who is half human and half beluga whale,
holding her child. While the sea goddess had

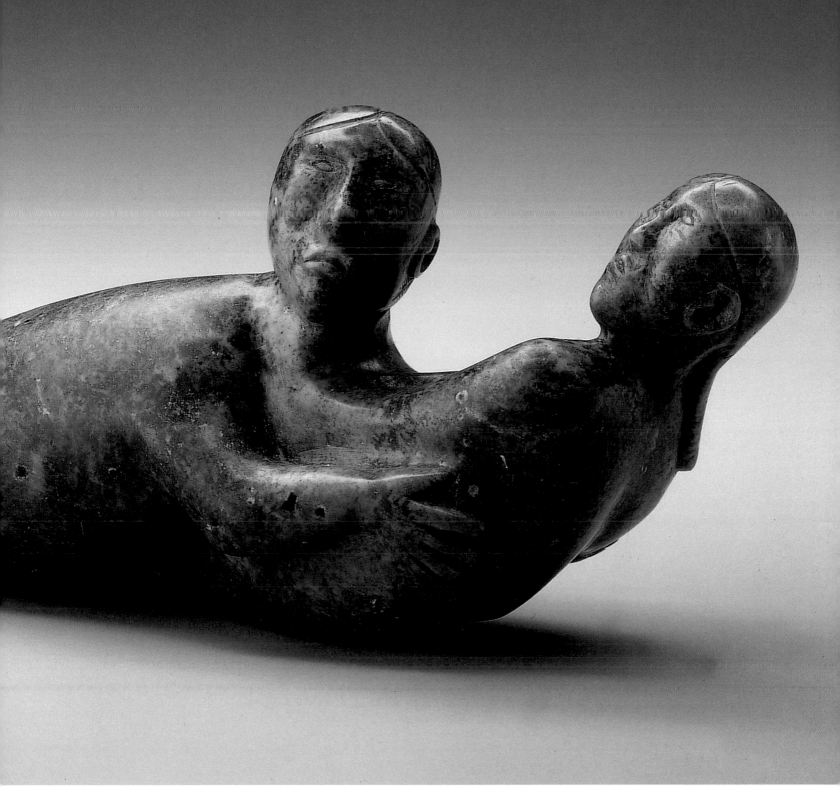

terrifying aspects in Inuit mythology, here she is shown in a mellow maternal mood. The gentle rhythm of the two figures evokes the splashing of the waves of the ocean where they are swimming.

Looking back to life in nomadic camps, Kingwatsiak said, *Yes, there were some hardships, but sometimes*

as I look back, what may have seemed hard, in retrospect were happy times, even when we were poor. Now we live only on bought food, which makes it much harder. (Personal communication with Henry Kudluk, August 1998)

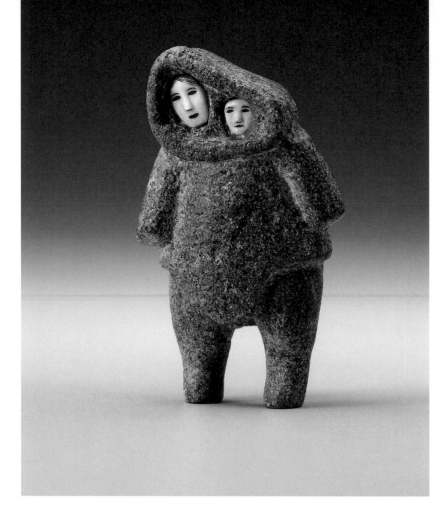

Mother and Child c.1951

granite, ivory, black ink

10.5 x 5.8 x 3.4 cm

unsigned

Canadian Museum of Civilization,
acquired with the assistance of a grant
by the Government of Canada under
the terms of the Cultural Property
Export and Import Act, 1978 (IV-C-
4984)

Provenance: Canadian Handicrafts
Guild, Montreal; Samuel Welles, New
York; CMC, 1978.

Unidentified artist

Cape Dorset

Although the original documentation lists "Peesee Oshuitoq" as the
artist, the piece strongly resembles a clearly documented sculpture
by Sheokjuk in the collection of the Canadian Guild of Crafts,
Quebec. Both Peesee Oshuitoq and Sheokjuk Oqutaq produced
exquisite works in ivory.

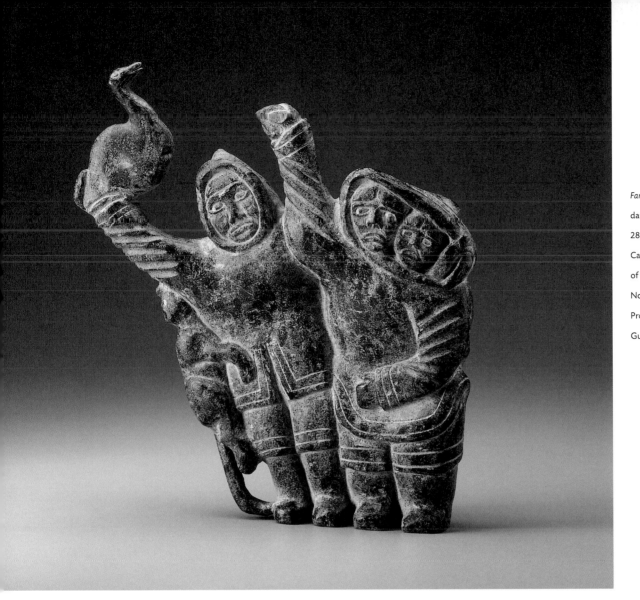

Family with Fox and Bird c.1957

dark green stone

28.1 x 22.9 x 5.2 cm

Canadian Museum of Civilization, gift

of the Department of Indian Affairs and

Northern Development, 1989 (NA 402)

Provenance: Canadian Handicrafts

Guild, Montreal, 1957.

Timothy Ottokie

1904–1982

Cape Dorset

The original sales slip from the Canadian Handicrafts Guild says
"Ottokie," hence the carving can be attributed to Timothy Ottokie,
one of the long-time printmakers at the Cape Dorset printshop. The
sculpture was created a year before the first collection of prints was
issued, yet this piece is definitely very graphic. The dramatic overall
contour, the incised lines demarcating the parka decorations, and
the sharp ridges indicating folds all could easily be translated into a
printed image.

Eegyvudluk Pootoogook

1931–

Cape Dorset

Eegyvudluk Pootoogook, brother of Pudlat, Paulassie, and Kananginak Pootoogook, is best known for his work as a printmaker at the Cape Dorset printshop. This "muskox" looks more like a bull. With one leg in front, the powerful animal seems to be in the process of charging forward. An inert piece of stone in the skilful hands of an experienced hunter and stonecutter has become animated with movement and life.

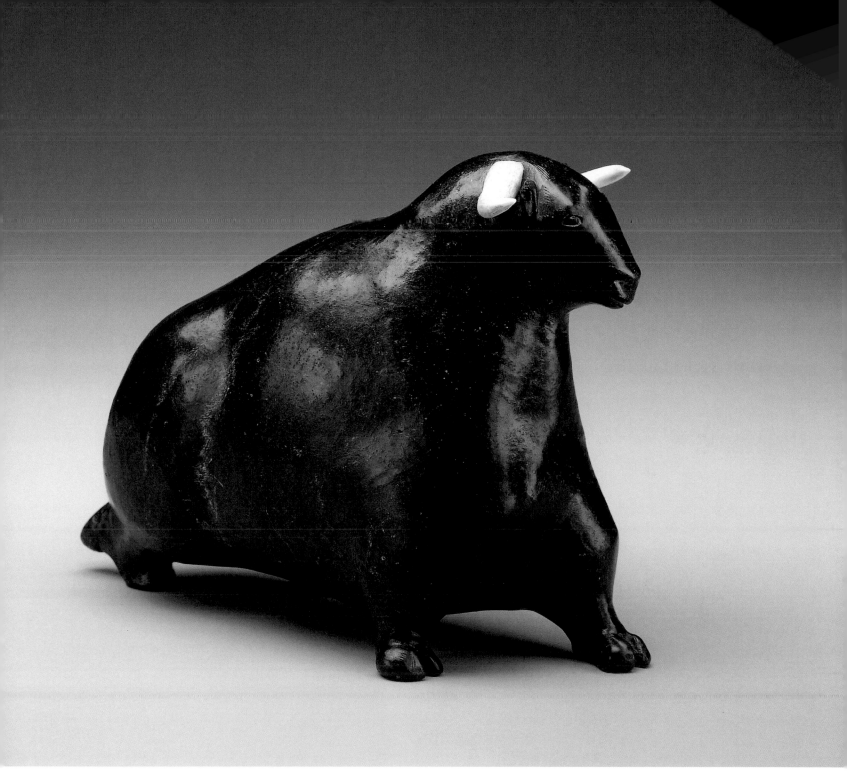

Muskox c.1960

black stone with red striations, ivory, wood

16 x 8.5 x 19.5 cm

unsigned

Canadian Museum of Civilization, gift of the Department of

Indian Affairs and Northern Development, 1989 (NA 956)

Provenance: Collected by William Larmour, Ottawa.

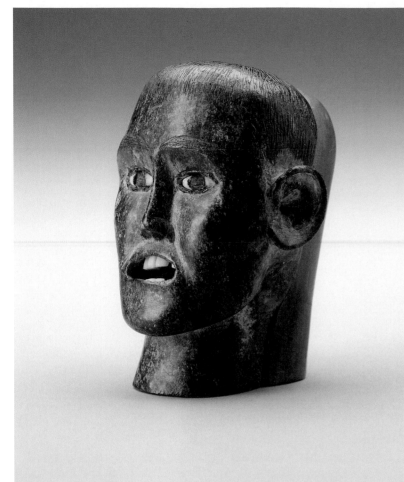

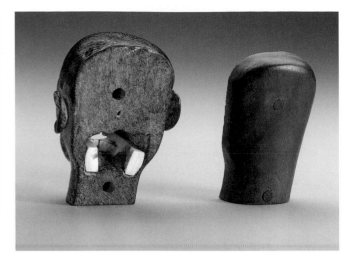

Houston's Portrait 1954

black stone, ivory, wood

10.2 x 7 x 7 cm

unsigned

Collection of James Houston

Provenance: James Houston, gift and trade from the artist,

1954.

Pudlat Pootoogook

1919–1985

Cape Dorset

This is a caricature in stone and wood of the head of James
Houston. At this time, Houston was trying to learn to speak
Inuktitut. To visualize his attempt, Pudlat Pootoogook, his
sometime teacher, as a joke carved Houston's likeness, his face in
stone, teeth and eyes in ivory, and the back of his head in wood.
These two pieces are separate. The artist then hollowed out the
stone and inserted ivory teeth, which move when the carving is
shaken. Some Inuit artists portray their neighbours or local traders
with features that are recognizable. Houston, still young, has a
large chin and leftover army haircut. Inuit called him Tadlo (Chin)
on the east coast of Hudson Bay, and Saumik (Left-Handed) on
Baffin Island.

Pudlat Pootoogook was known for his sense of humour, expressed in this carving. The young child is trying to climb out of its mother's hood, against the mother's will. In the process, the boy seems to push the mother out of his way quite forcefully, symbolizing the pain of separation that every mother has to go through when the offspring wants to leave her protective environment.

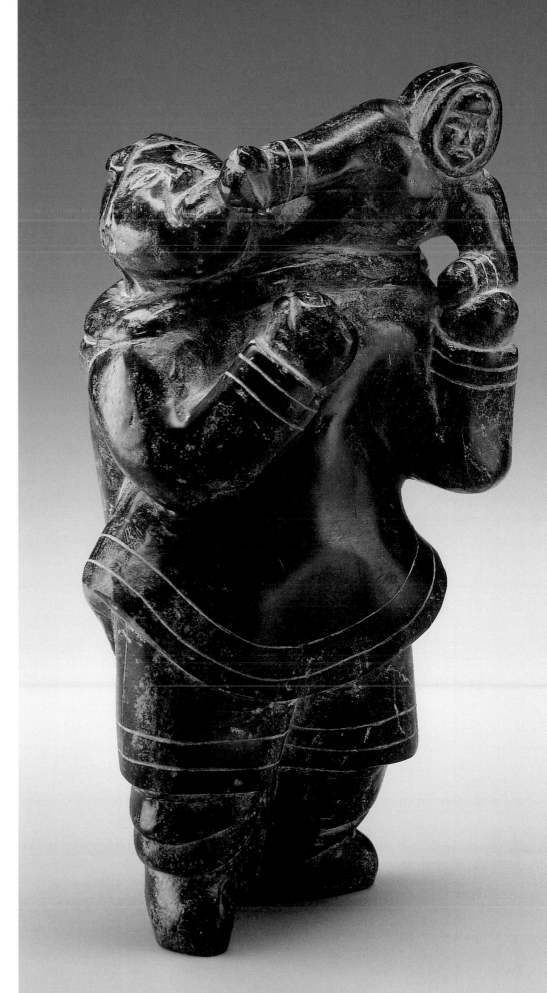

Mother and Child 1954

dark grey stone

30.5 x 16.6 x 8.5 cm

Canadian Museum of Civilization (IV-C-3372)

Provenance: Canadian Handicrafts Guild, Montreal, 1954.

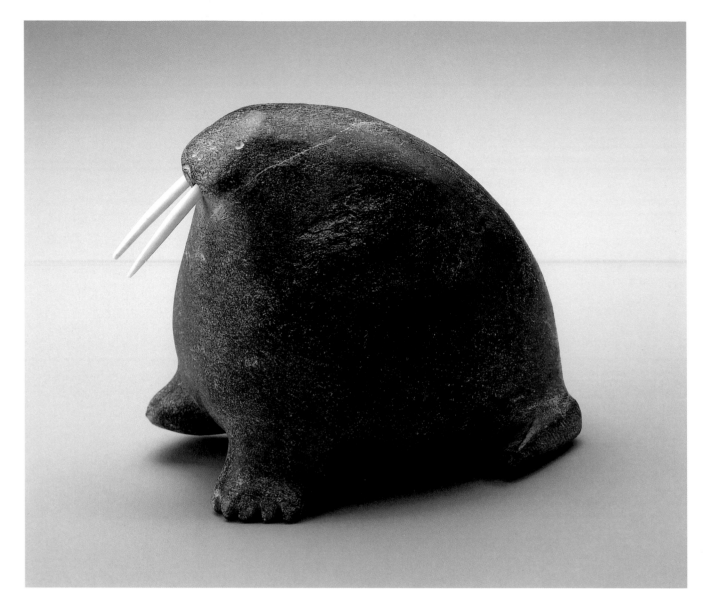

Walrus 1965

dark grey stone, ivory

14.5 x 12 19 cm

unsigned

Canadian Mueum of Civilization, gift of the Department of

Indian Affairs and Northern Development, 1989 (NA 1085)

Pauta Saila (attr.)

1916–

Cape Dorset

The original sales slip says "Sila," which may refer to Pauta Saila, who was already an accomplished carver by 1965. The use of volume that is massive without being bulky is very much Pauta's trademark. The animal has humour and grace, two qualities that are characteristic of Pauta's dancing bears. Pauta experimented with other Arctic animals, such as walrus, before he settled on bears as his mayor theme.

Bear 1963

green stone

25.5 x 15.3 x 6.9 cm

unsigned

Canadian Museum of Civilization, gift of the Department of Indian Affairs and Northern Development, 1989 (NA 1092)

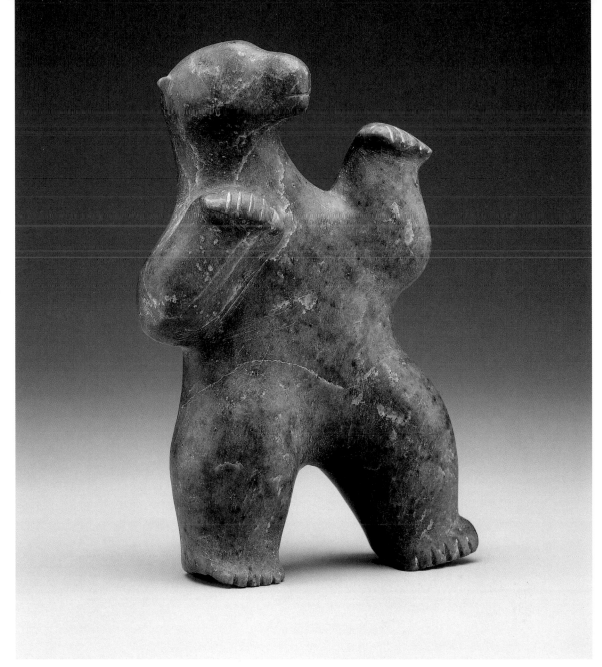

Pauta Saila

1916–

Cape Dorset

Saila's bears frequently assume human postures and attitudes. Here the bear, front paws lifted up, seems to approach the viewer with curiosity. This early piece exemplifies Saila's ability to evoke the animal's presence with a few simplified shapes. The big, oversize claws, the heavy thighs, the thick neck suggest the very essence of a bear. *Before the white men, the Inuit did not seem as if they had leaders. Inuit were very responsible for their actions. They were working as a team. If other Inuit were hungry or when they were lacking something, they helped each other. They kept an eye on sick people as a team. In wintertime, we had the most hardship. But we were making sure that the community had enough oil to last. We handled the food and oil as a team.* (Personal communication with Simionie Kunnuk, July 1994)

Unidentified artist

Cape Dorset

This figure of a woman with a dog emerging from her body may well be an illustration of Taleelajuq, in legend half seal and half woman, giving birth to one of her dog children. (See also *Human Dog Spirit in Slipper* in the Pangnirtung section.) The origin of this title, referring to a bear, is unknown.

Woman and bear 1958

dark grey stone

38.3 x 20.5 x 11 cm

unsigned

Canadian Museum of Civilization, gift of the Department of

Indian Affairs and Northern Development, 1989 (NA 790)

Provenance: William Larmour, Ottawa, 1958.

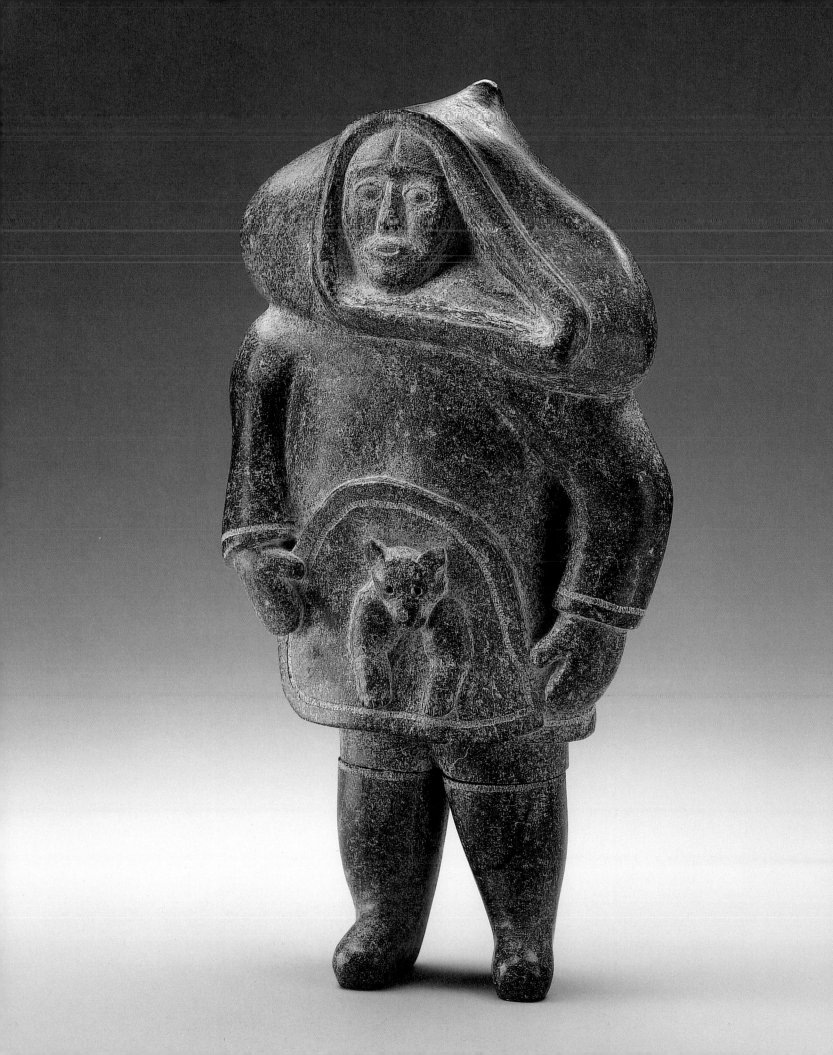

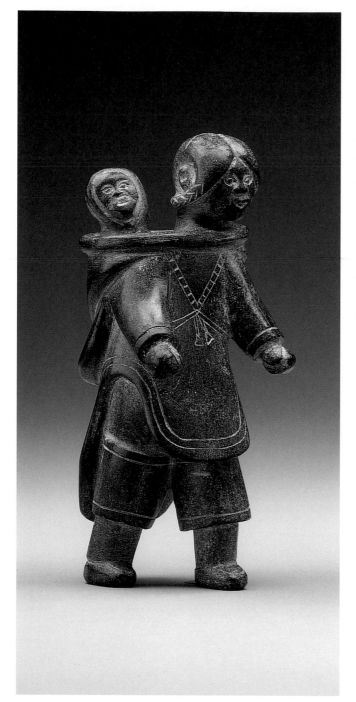

Munamee's Wife and Baby c.1951

grey stone

15.7 x 6.2 x 7.6 cm

unsigned

Canadian Museum of Civilization, acquired with the assistance of a grant by the Government of Canada under the terms of the Cultural Property Export and Import Act, 1978 (IV-C-4966)

Provenance: Canadian Handicrafts Guild, Montreal, 1951; Samuel Welles, New York, 1951; CMC, 1978.

Munamee Shaqu

1917–

Cape Dorset

The little figure of a young mother with her child in her hood—Shaqu's wife and child—has been carved with loving detail. The woman's features are carefully defined and so is her elaborate hairdo. The artist has chosen to show her walking. This was a much greater challenge than the stiff frontal pose in which many of the early pieces are rendered.

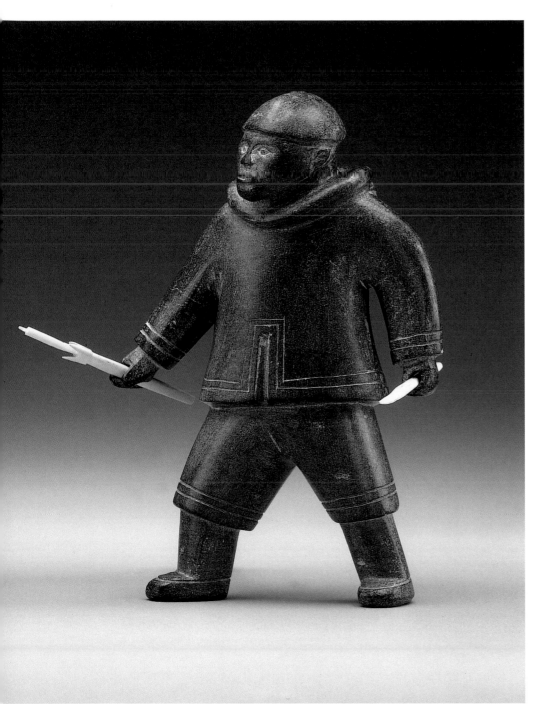

Self-Portrait as a Hunter c.1951

grey stone, ivory

16.9 x 13.1 x 10 cm

unsigned

Canadian Museum of Civilization, acquired with the assistance

of a grant by the Government of Canada under the terms of

the Cultural Property Export and Import Act, 1978 (IV-C-

4989)

Provenance: Canadian Handicrafts Guild, Montreal, 1951;

Samuel Welles, New York, 1951; CMC, 1978.

This is one of the few documented self-portraits in Inuit art. We do not know how the collector, Samuel Welles, obtained the information that this portrait of a hunter and its companion of a mother and child (IV-C-4966) were of Shaqu himself and his wife and child. Most likely, James Houston provided this information when he brought both pieces to Ottawa, plus another sculpture by Shaqu that was given to Princess (now Queen) Elizabeth in November 1951.

Kimmirut

(formerly called Lake Harbour)

With a population of about 365 people, Kimmirut is one of the smallest villages on Baffin Island. Inuit in the area were used to large-scale commercial trading of souvenirs much earlier than in other areas. Lake Harbour, now Kimmirut, was basically founded by whalers. Whalers stationing at the Upper Savage Islands not only provided seasonal employment but were also the first serious trading partners. As early as 1914, the Hudson's Bay Company trading post in Kimmirut (then called Lake Harbour) imported ivory tusks from other areas to meet the demand. During World War II, the U.S. Army base in Frobisher Bay, now Iqaluit—provided another market for ivory carvings. The trading post would receive 500 to 1000 pounds of ivory per year from other posts—raw material that was turned into cribbage boards and scrimshaw by local carvers. The Hudson's Bay manager Tinling remembers that one shipment of fifteen cases to the army base was sold in less than 24 hours.

—Helga Goetz, "Inuit Art: A History of Government Involvement," in *In the Shadow of the Sun: Perspectives on Contemporary Native Art* (Hull: Canadian Museum of Civilization, 1993).

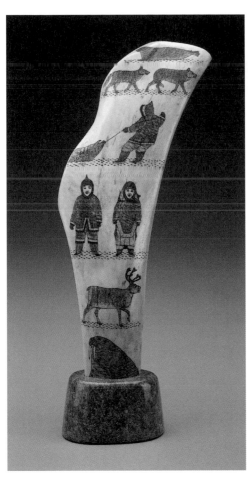

Engraved Antler c.1965

antler, stone, black ink

42 x 10 x 7.9 cm

signed DAVIDEE plus syllabics and disc

number (E7-1042)

Canadian Museum of Civilization

IV-C-5746

Gift of Jack Greenwald, Montreal, 1996

Provenance: Jack Greenwald, Montreal.

Commissioned directly from the artist

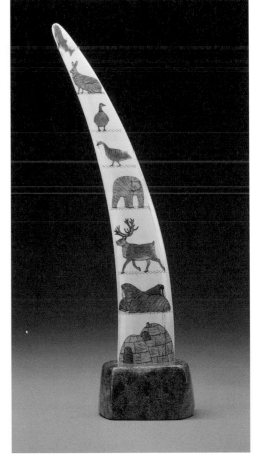

Davidee Itulu

1929–

Kimmirut

Itulu grew up in Cape Dorset and moved to Kimmirut in his early twenties in order to build a boat. He was encouraged by James Houston to carve. He had watched his father carving as a boy. Although he does commissioned work, he prefers to carry out his own ideas.

I always try to carve what I think about. This is our way of making a carving. I find it's much easier to make a carving of your own ideas.... Trying to make what you have been requested to do is not always good, because you do not have the freedom to make what you want to make. (Interview with Henry Kudluk, August 1998)

Engraved Walrus Tusk c.1965

stone, ivory, black ink

32 x 8.5 x 6.3 cm

signed DAVIDEE, plus syllabics and disc number (E7-1042)

Canadian Museum of Civilization, gift of Jack Greenwald, Montreal, 1996 (IV-C-5745)

Provenance: Jack Greenwald, Montreal, commissioned from the artist, 1965.

Itulu is very much a graphic artist, although he has never worked as a printmaker largely due to the fact that there has never been a printmaking program in Kimmirut. His delicate engravings on ivory and antler show sensitive modelling and tonal gradations in the rendering of animal furs and other textures.

I am always happy when a carving is completed; even though the carving cannot move on its own, it seems to have a life of its own. (Davidee Itulu, August 1998)

Nuvaliaq Qimirqpik

1937–

Kimmirut

Qimirqpik says this figure is half human and half polar bear, with antlers, depicting a shaman. To add further to the confusion, one leg is in the process of turning into a claw. When asked how he feels about the new Inuit way of life, the artist says wistfully,

To remember the old days I say that we were doing okay with what we had. But today we have a warm place to stay all the time now in the community ... but I always think about the old days. (Interview with Henry Kudluk, August 1998)

Shaman Holding a Figure 1966

green stone, ivory

43 x 26.7 x 18.1 cm

unsigned

Canadian Museum of Civilization (IV-C-4503)

Provenance: Christie, Manson and Woods auction, May 1975.

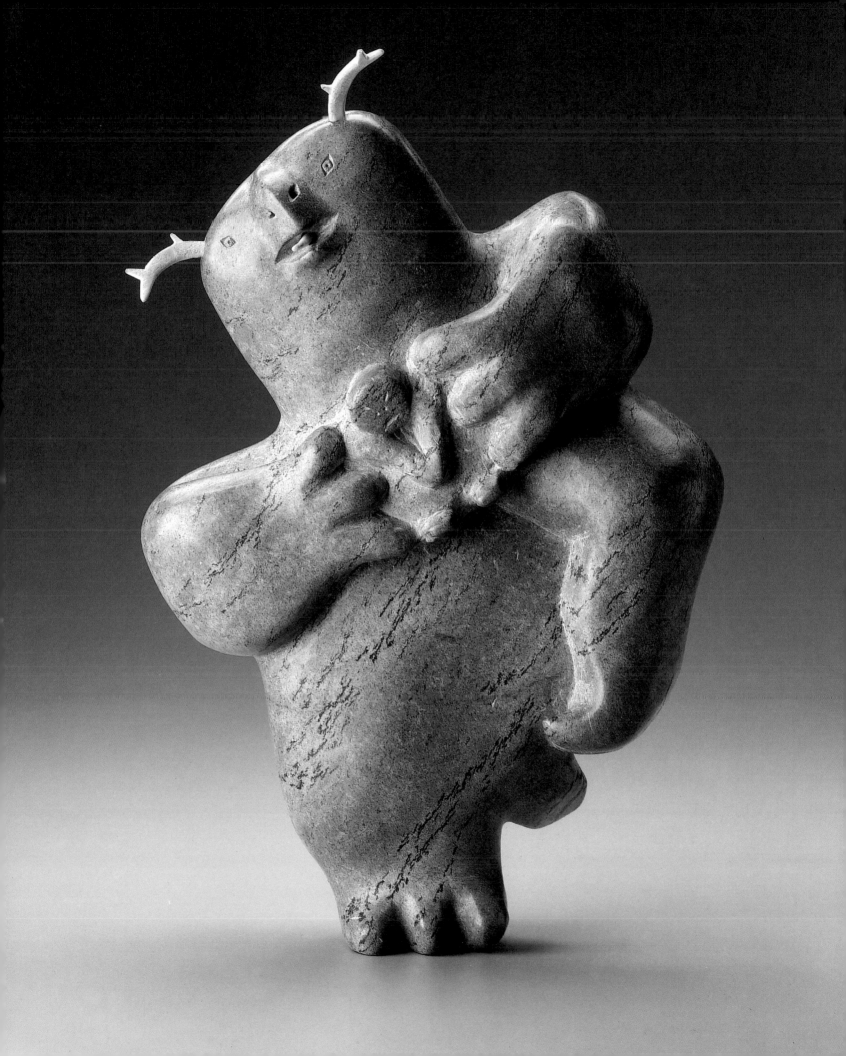

Iqaluit

(formerly called Frobisher Bay)

In 1942, during the Second World War, the U.S. Air Force, with the blessing of the Canadian government, selected Iqaluit as an ideal site to build an airstrip. It was to be long enough to handle large aircraft transporting war materials from the United States to its European allies. During this time, many Inuit from surrounding hunting camps were recruited to help construct the airstrip, aircraft hangars and related buildings.

These hunters and their families had no choice but to begin building year-round huts on the beaches of Koojesse Island, using wood discarded from the airbase and the local dump. The Inuit referred to the little village that grew here as Iqaluit, meaning "fish."

—*Nunavut Handbook* 1999 (Iqaluit: Nortext Multimedia Inc. 1998), 359.

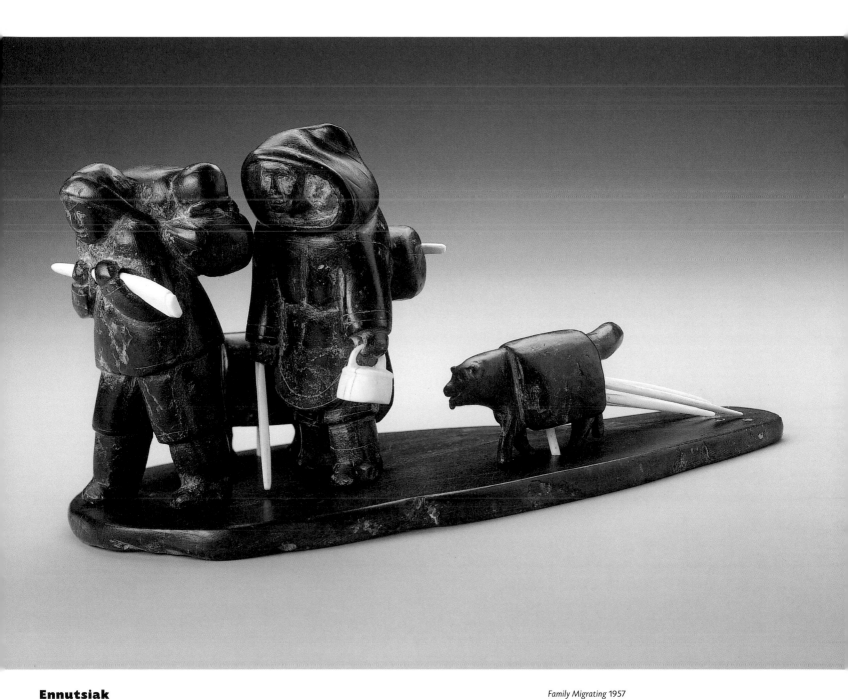

Ennutsiak

1896–1967

Iqaluit

During summer and fall, families and their dogs would travel overland, carrying all their belongings on their backs. In Ennutsiak's piece, the older child is lying on top of the father's pack, while the mother is carrying the baby in her hood. The dogs are also doing their share, one transporting the tent poles.

Family Migrating 1957

black stone, ivory

17.9 x 35.8 x 16 cm

unsigned

Canadian Museum of Civilization (IV-C-4828)

Provenance: Robertson Gallery, Ottawa, 1978.

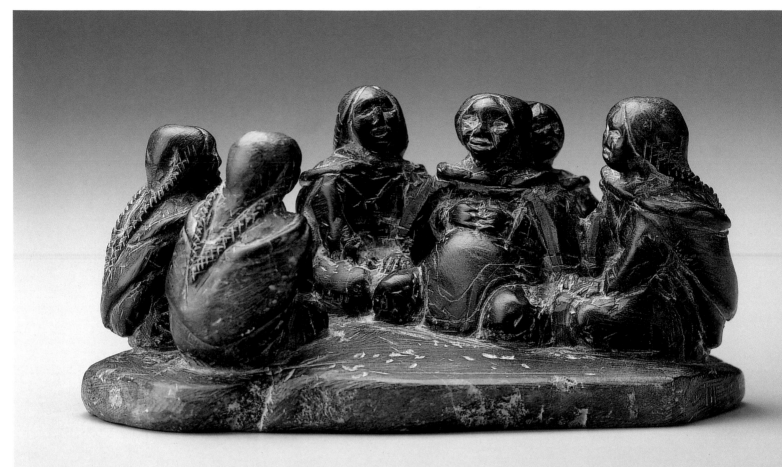

Childbirth 1963

grey stone

8.2 x 17.5 x 10 cm

unsigned

Canadian Museum of Civilization, gift of the Department of

Indian Affairs and Northern Development, 1989 (NA 1048)

Provenance: Collected by Robert Hume, Ottawa.

Ennutsiak

1896–1967

Iqaluit

Within the pre-settlement culture where Ennutsiak spent most of his life, childbirth took place in a separate tent or igloo. The mother or an elderly woman assisting would utter a series of names of deceased relatives. The name that was spoken as the child was born would be the baby's. It was hoped that the deceased person's soul would protect the newborn child.

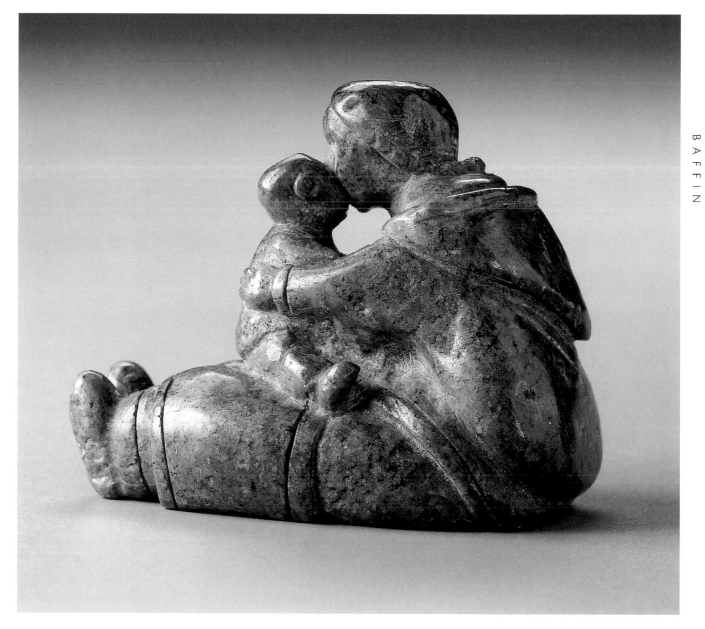

This little sculpture has been attributed to Ennutsiak because both subject matter and style reveal his unmistakable touch. The mother has taken her baby out of her hood and kisses the child affectionately. Both the spontaneity of the gesture and the sketchy, confident manner in which the scene has been brought to life are typical of Ennutsiak, whose style is very distinct and recognizable.

Mother and Child date unknown

green stone, red colouring

6.4 x 8.3 x 4.4 cm

unsigned

Canadian Museum of Civilization (IV-X-750)

Provenance: Little Museum, Toronto, date unknown; purchased by Dr. William Taylor, director at CMC, 1973.

Henry Evaluardjuk

1923–

Iqaluit

Portraiture is not of much interest to Inuit artists. In their culture, it is not considered appropriate to stand out or want to be noticed. Faces on human figures are often mask-like and are not supposed to represent any person in particular. This bust is clearly an exception. The aquiline nose, the wrinkles around the eyes, the protruding ears seem to depict a particular individual, in all likelihood a white person such as a missionary.

Head 1963

grey stone

28.5 x 21 x 15.5 cm

signed HENRY and syllabics

Canadian Museum of Civilization, gift of the Department of

Indian Affairs and Northern Development, 1989 (NA 1056)

Provenance: Collected by Robert Hume, Ottawa, 1963.

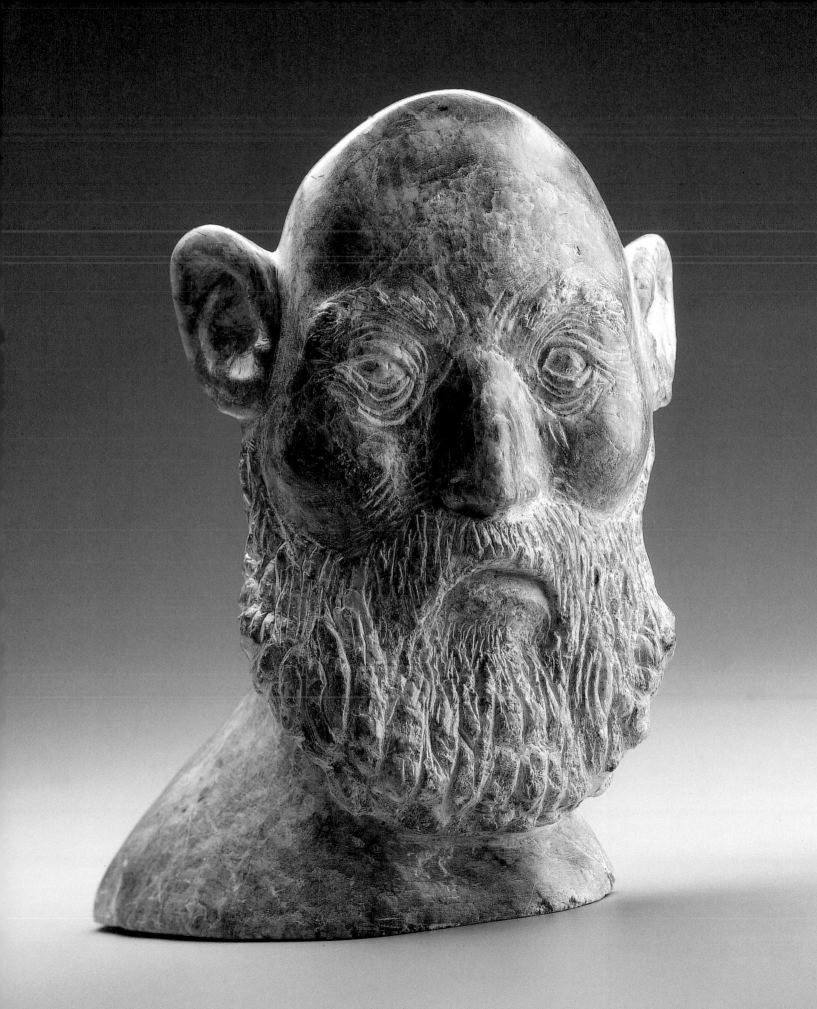

Pangnirtung

I came to Pangnirtung when I was sixteen, when my parents got a job, from the place beyond Iqaluit, what is that, Lake Harbour (Kimmirut)? That was the only Hudson's Bay Company post. That winter the H.B.C. manager and five Inuit travelled by dog team to different camps: Blacklead Island, Kekerten Island, Usualuk. At Usualuk, a ship came in summer, looking for people to work, and we sailed to Pangnirtung. No houses at that time. Inuit just came here because the area had many bull caribou, and so it was called Pangnirtung.

—Pauloosie Karpik, a graphic artist from Pangnirtung, quoted in *Pangnirtung 1987* (Pangnirtung: Pangnirtung Eskimo Cooperative, 1987).

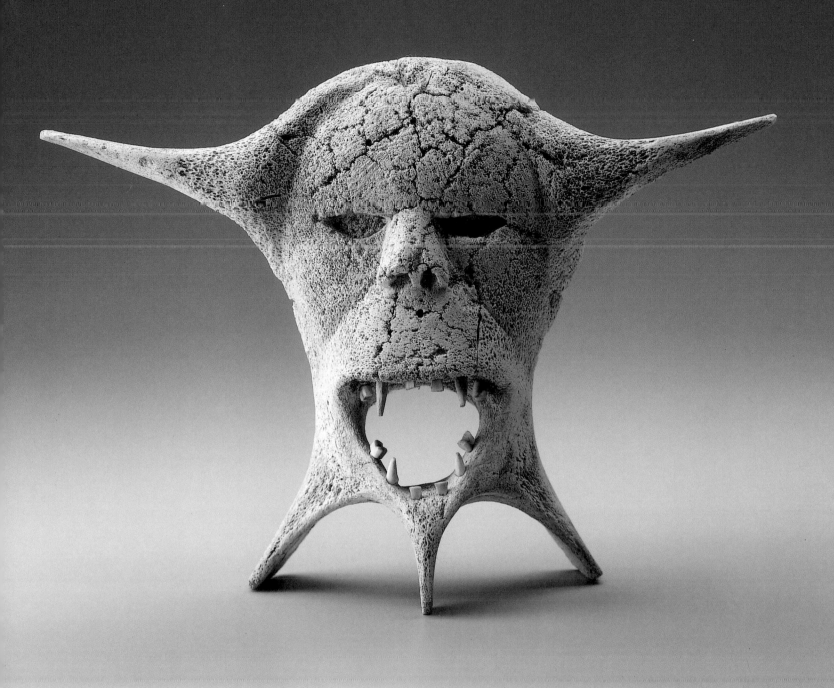

Unidentified Artist

Pangnirtung

Ancient weathered whalebone is a familiar material used by Pangnirtung artists. The natural cracks in the bone add to the sinister, threatening appearance of this malevolent spirit. As usual, the artist has worked very much with natural shape, turning a vertebra into a *tornaqaluq*, a demonic spirit figure.

Spirit Head 1965

whalebone, antler, teeth

25 x 36 x 13 cm

unsigned

Collection of James Houston

Provenance: Ross Peyton, Pangnirtung, 1965.

Unidentified artist

Pangnirtung

The story of Sedna, half seal and half woman, is one of the greatest Arctic myths. In some dialects she is called Taliilajuq or Tikanakamsalik.

One night, during a blizzard, her family heard a dog team arrive, and into their igloo came a handsome young man. He wore beautifully fitted skin clothing, and a curious amulet around his neck bore two large white canine teeth. After Sedna's father had shared their food with this bright-eyed stranger, they made space for him in the family bed. In the morning, the stranger was gone, leaving no sign that he had been there.

The father went outside, but found no sled tracks. He was angry. "I believe that was no human who slept here. It was my lead dog. He's just sly enough to try a trick like that."

Moons passed, summer came, and Sedna was pregnant.

"My lead dog did that," said the angry father. "Lie on the back of my kayak, daughter, and I'll paddle you out to that small rock island. You can give birth there. Who knows whether you will produce Inuit children or perhaps a litter of pups?"

Sedna would surely have died of hunger, but the lead dog swam to the island, bringing meat to her every second day. When Sedna did give birth, she had four young. Two were humans and the other two had big ears, long snouts, and they whined instead of crying.

Sedna had no wood to build a proper kayak, but when the lead dog brought her three sealskins, she sewed these into one large, boat-like slipper. Sorrowfully, she placed her two dog-like children in it and, when the tide was running out, she pushed them southward, crying, "Goodbye."

Later, when Inuit first saw *kallunait*, whites, they cried out, "Welcome, cousins! You return." (Written by James Houston)

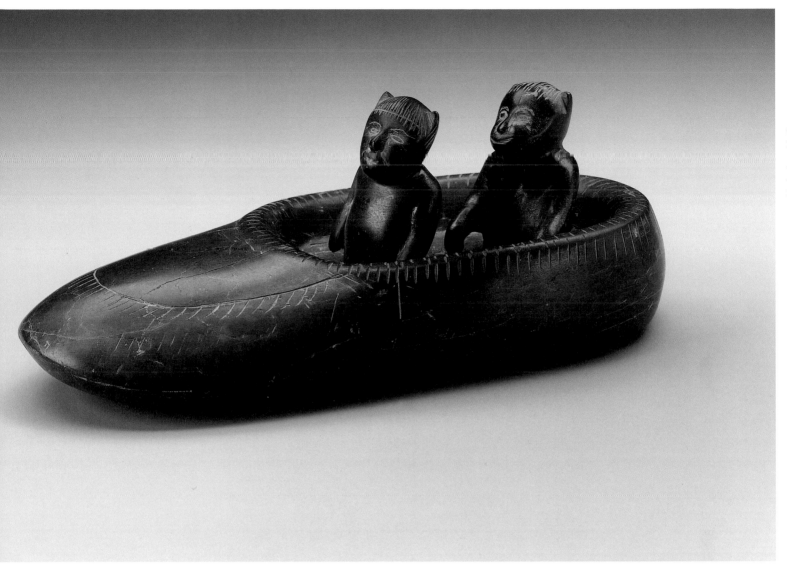

Human Dog Spirits in Slipper 1955

dark green stone

10 x 26 x 7.7 cm

signed AKPALIAPIK

Collection of James Houston

Provenance: Hudson's Bay Company post, Pangnirtung, 1955.

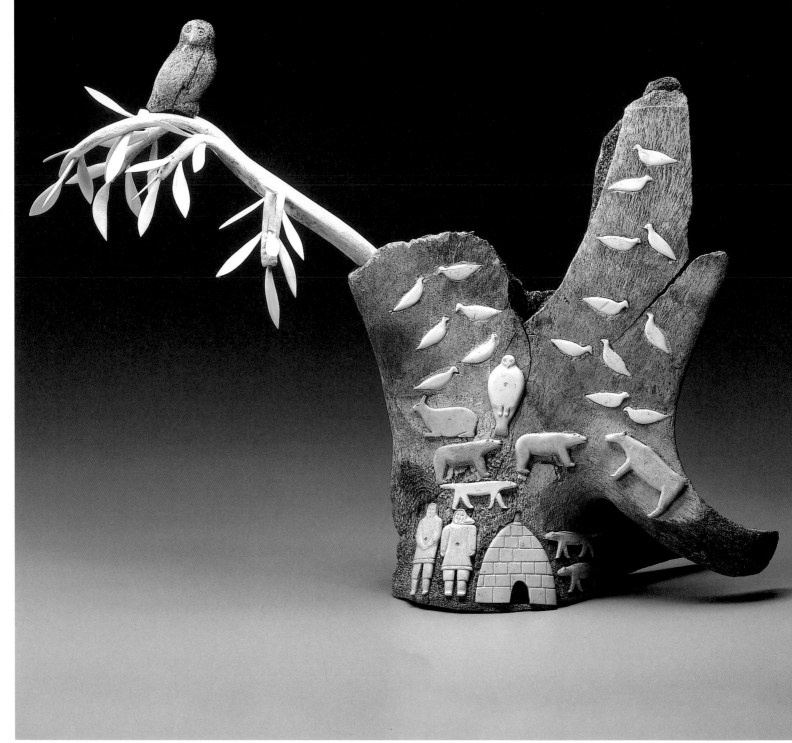

Composition No. 2 1968

whalebone

49.5 x 58.5 x 23.5 cm

unsigned

Canadian Museum of Civilization (IV-C-3756)

Provenance: Canadian Arctic Producers, Ottawa, 1968.

Josephee Kakee

1911–1977

Pangnirtung

On one side we see a couple with their igloo, surrounded by the animals that sustain their lives, and the other shows the sea goddess and the sea animals over which she reigns. The artist has used a weathered piece of whalebone as his canvas, on which he has applied cut-out images of the various animals. A caribou antler decorated with leaves balances this highly unusual composition.

I know that down on the left-hand side of Cumberland Sound there are many, many walrus. It can be very frightening to find oneself far from shore among the walrus. I wouldn't use a kayak to travel long distances, as a walrus could come up and tip the boat at any time. My cousin was killed in just that way. The walrus were hunted in this manner by real men, by hunters who would not give in to fear. (Josephee Kakee in John Houston, ed. Pangnirtung 1976 (annual print catalogue) [Toronto: Herzig Somerville Ltd., n.p., 1976.])

Qaqasiralaq Kullualik

1913–1983

Pangnirtung

The contrast between massive feet and small hands and a finely chiselled face draws all our attention to the man's intense expression; he looks as if he is scanning the horizon anxiously. A hunt meant life or death, and the sculptor has succeeded in conveying the total concentration required.

Walking Man c.1970

green stone, leather

26.8 x 13.5 x 17.2 cm

signed with syllabics and disc number (E6-227)

Canadian Museum of Civilization (IV-C-4116)

Provenance: Canadian Arctic Producers, Ottawa, 1970.

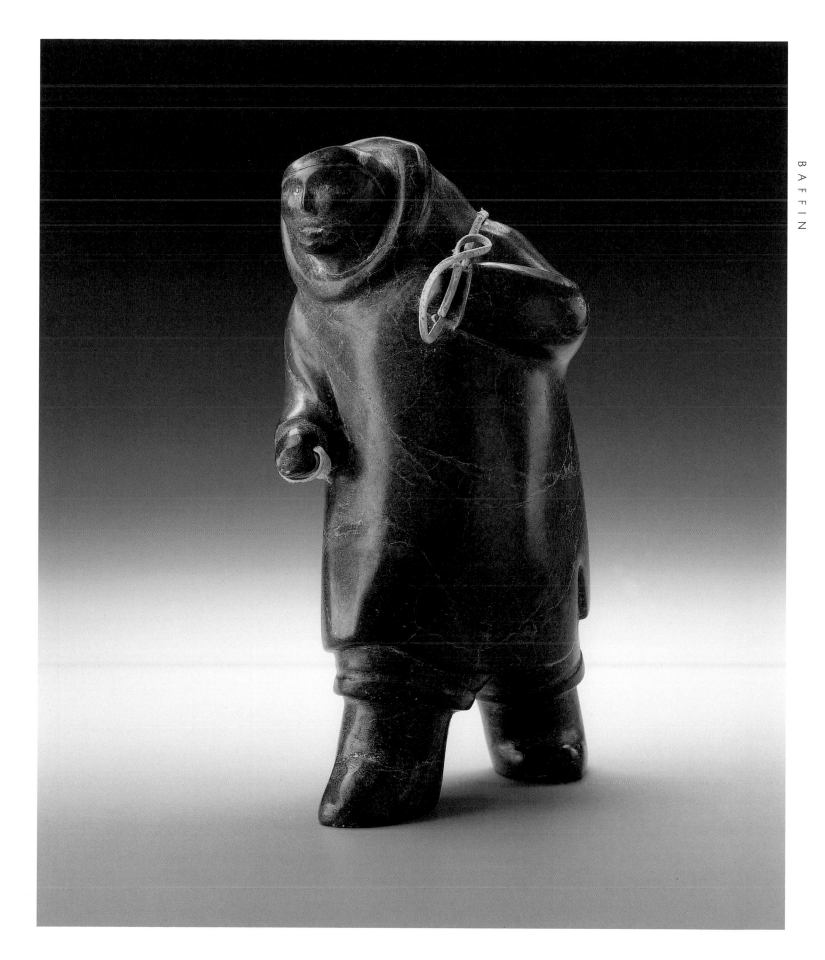

Peterosee Anilniliak (attr.)

1923–

Pangnirtung

Pangnirtung is located on the shores of the Cumberland Sound, which was a major whaling site during the mid-nineteenth century. A century later, artists are using the weathered whalebone left behind from those days as carving material. The porous surface does not encourage any detail. The carver has concentrated on the overall sculptural form of the woman with her face effectively framed by the parka hood.

Woman with Water Pail c.1967

whalebone, sinew, antler

24.8 x 14.6 x 12.4 cm

unsigned

Canadian Museum of Civilization (IV-C-3792)

Provenance: Canadian Arctic Producers, Ottawa, 1967.

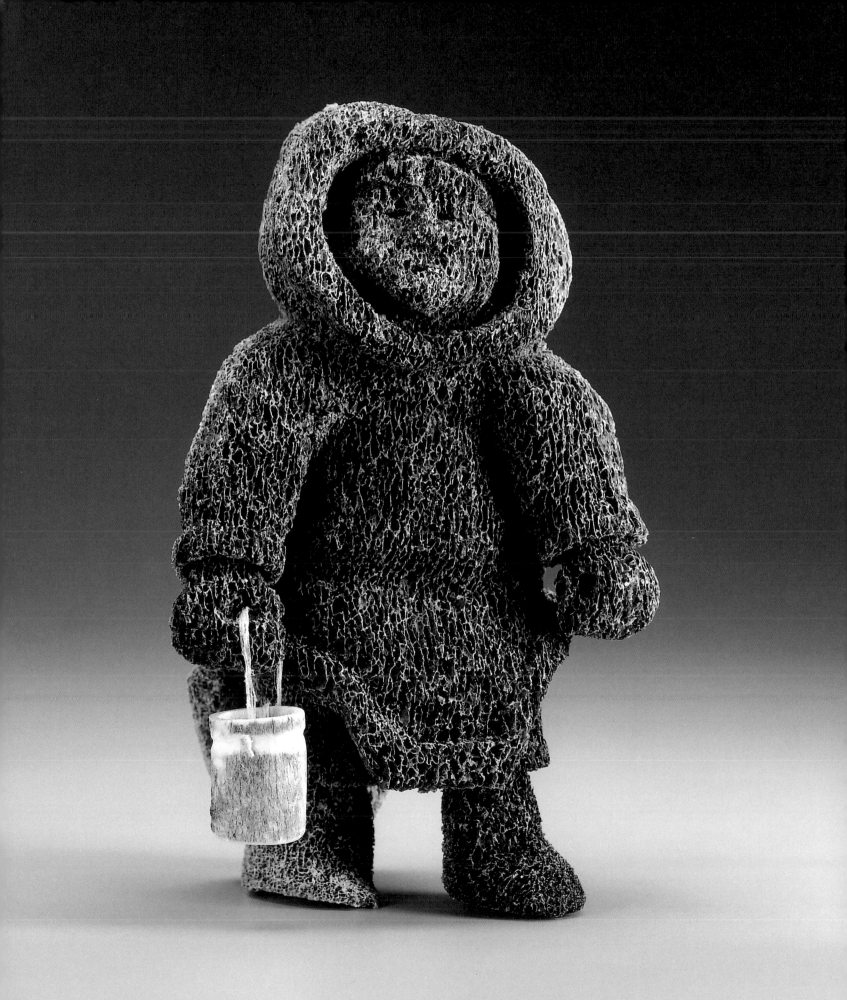

Arviat

I recall an elder coming in with an object in his hand. He handed it to Gabe Gely (the arts and crafts officer) with an expectant look. Not knowing anything about carvings I was certain he would not accept it, since it was hardly recognizable to me. Gabe took it, looked at it admiringly and asked: "What is it?" Silently I preconceived the answer to be "a newly born lemming" because that is what I thought it surely was. But he replied, "It's a baby beluga whale." After a few ee's and aa's Gabe wrote out a voucher for the person, making him look a few feet taller as he disappeared through the door.

—Mark Kalluak, *Pelts to Stone: A History of Arts and Crafts Production in Arviat* (Ottawa: Indian and Northern Affairs Canada, 1993).

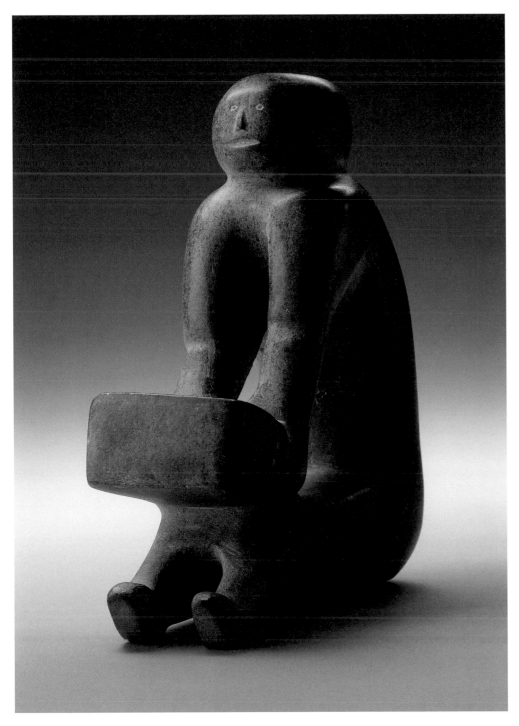

Monique Kopanuak

1913 1987

Arviat

Only the pot that the figure is holding on her knees gives us an indication of the subject's sex. In the best minimalist tradition of Arviat, the figure is stripped of any detail. The beautifully rounded shoulders and the cylindrical head have been stylized into pure form, and only the disproportionately small feet add a human touch to the otherwise remote, archetypal image.

Woman with Pot on her Lap c.1968

grey-green stone

20 x 5 x 15 cm

signed with syllabics and disc number (E1-194)

Canadian Museum of Civilization (IV-C-3720)

Provenance: Canadian Arctic Producers, 1968.

Henry Isluanik

1925–

Arviat

Rarely has a carver achieved so much expression in the difficult medium of antler. The caribou especially, struggling to get up after having been wounded, is very moving. The artist has used a natural piece of stone as the base, to provide a setting for the dramatic scene.

Henry Isluanik started carving in 1958 in Brandon, Manitoba, where he was hospitalized with tuberculosis for five years. When he came back to the North, he settled in Arviat and earned his living as a carver until 1969, when he became community health worker. Now in retirement, he is carving again.

Back then our life on the land was simple; there was much less crime than today. . . . I look back and envy the old way of life, but we are moving forward. It cannot be helped. (Personal communication with Henry Kudluk, August 1998)

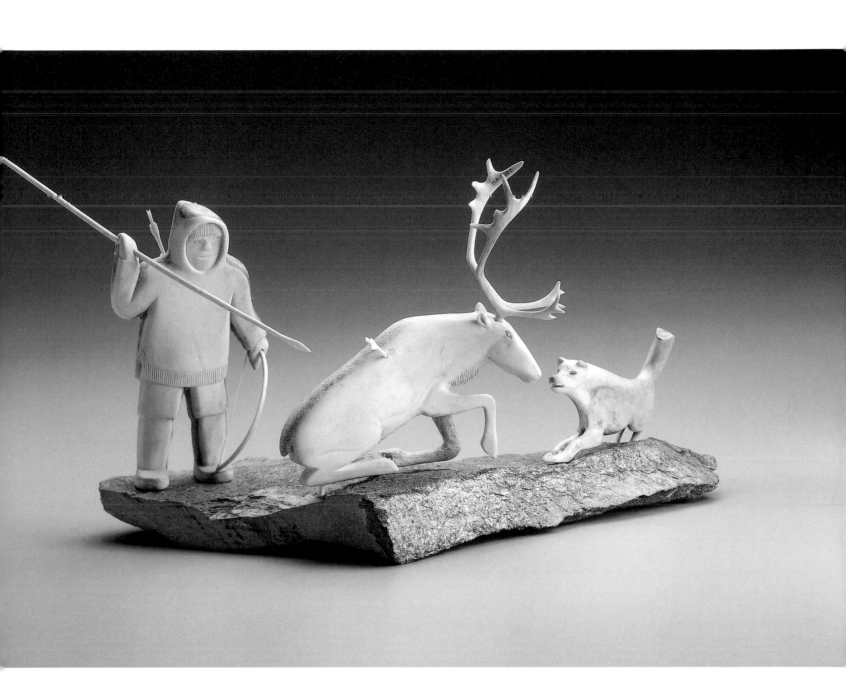

Hunting Caribou 1964

antler, stone, sinew

16.5 x 16 x 32 cm

signed with syllabics and disc number (E1-489)

Canadian Museum of Civilization, gift of the Department of

Indian Affairs and Northern Development, 1989 (NA 1232 a-d)

Andy Mamgark

1930–1997

Arviat

Andy Mamgark first worked at the nickel mine in Rankin Inlet. He would pick up stone around the mine and carve for the white employees there. When he returned to Arviat in 1965, he continued to carve and had this story to tell.

I had a dream once, Mamgark said, *of a powerful shawoman. She would lift up her flaming oil lamp, but no oil or fire would run out. This shawoman would sing three magic words again and again, calling her helpers, the owls. She had the power to make these owls bring the caribou close to us, but also her owls could make craziness happen in some people.* (Personal communication with James Houston, April 1970, travelling for the Canadian Eskimo Arts Council)

Kneeling Woman with Owls c.1967

grey stone

35 x 18.5 x 30 cm

signed with syllabics and disc number (E1-164)

Collection of James Houston

Provenance: Hudson Bay Company post, Arviat, 1967.

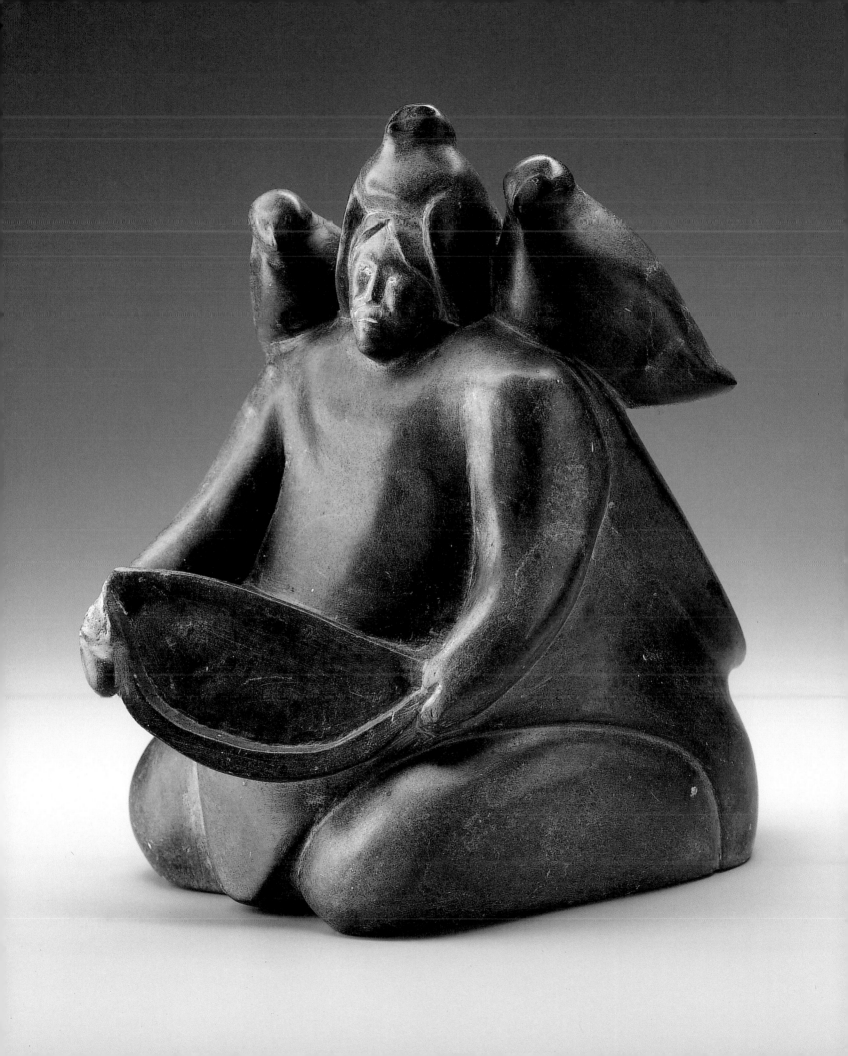

Andy Miki

1918–1983

Arviat

Andy Miki is the first to admit that his cartoon caricatures have no origin in nature. They're visual puns that emerge from his knowledge of animals and his own whimsical imagination. A prospective buyer will often try to second-guess his source:

"What's this?" the carver is asked. "A caribou? A rabbit?" Never committing himself, Miki simply shrugs. When questioned why people seem so intrigued by his carvings, Miki answers, "Probably because they expect everything to be real." (Bernadette Driscoll. *Eskimo Point/Arviat.* Winnipeg: The Winnipeg Art Gallery, 1982, page 31)

Dog, c.1958
light grey stone
7.1 x 3.7 x 16.1 cm
unsigned
Canadian Museum of Civilization, gift of the Department of
Indian Affairs and Northern Development, 1989 (NA 1251)

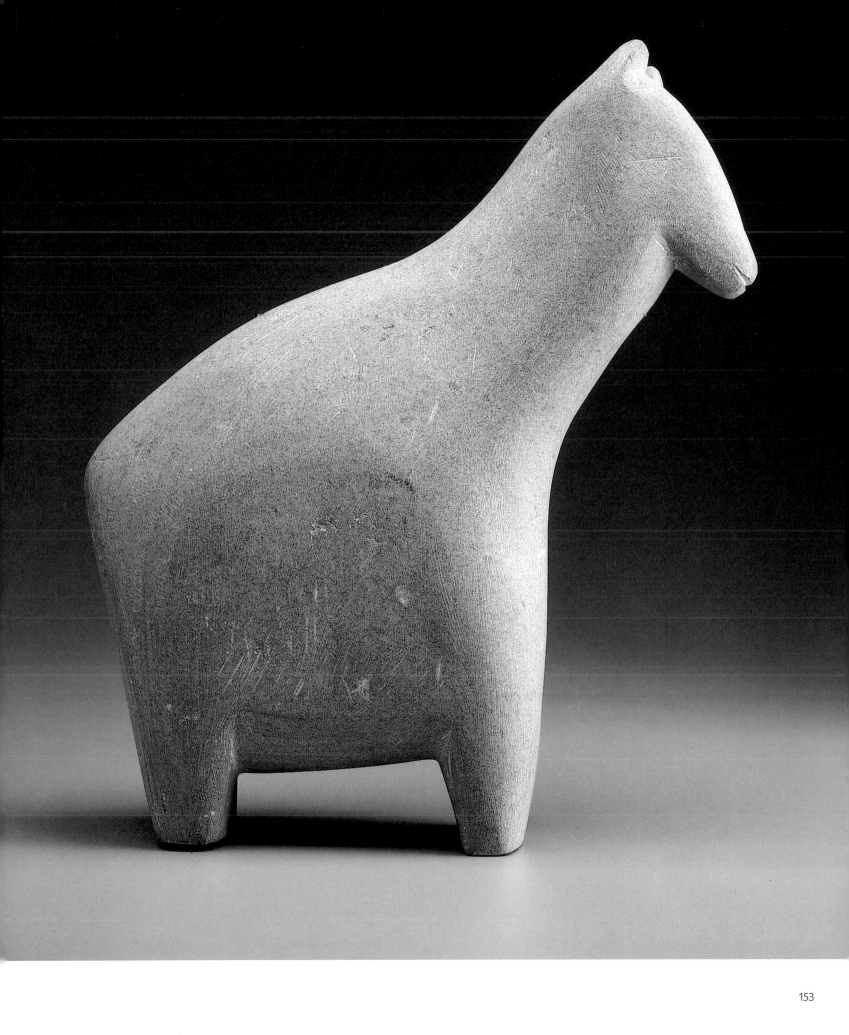

John Pangnark

1920–1980

Arviat

John Pangnark's highly stylized, nearly abstract carvings were appreciated by critics and collectors alike, much to the puzzlement of his Inuit colleagues. Lucy Tasseor remembers that, *John Pangnark and I were told that our carving was the best. We used to laugh and joke with each other that we should just make funny carvings because they were more desired than naturalistic ones.* (Personal communication with Bernadette Driscoll, May 1982)

Woman 1970

grey stone

14.2 x 15.1 x 6.8 cm

signed with syllabics

Canadian Museum of Civilization (IV-C-4131)

Provenance: Canadian Arctic Producers, Ottawa, 1970.

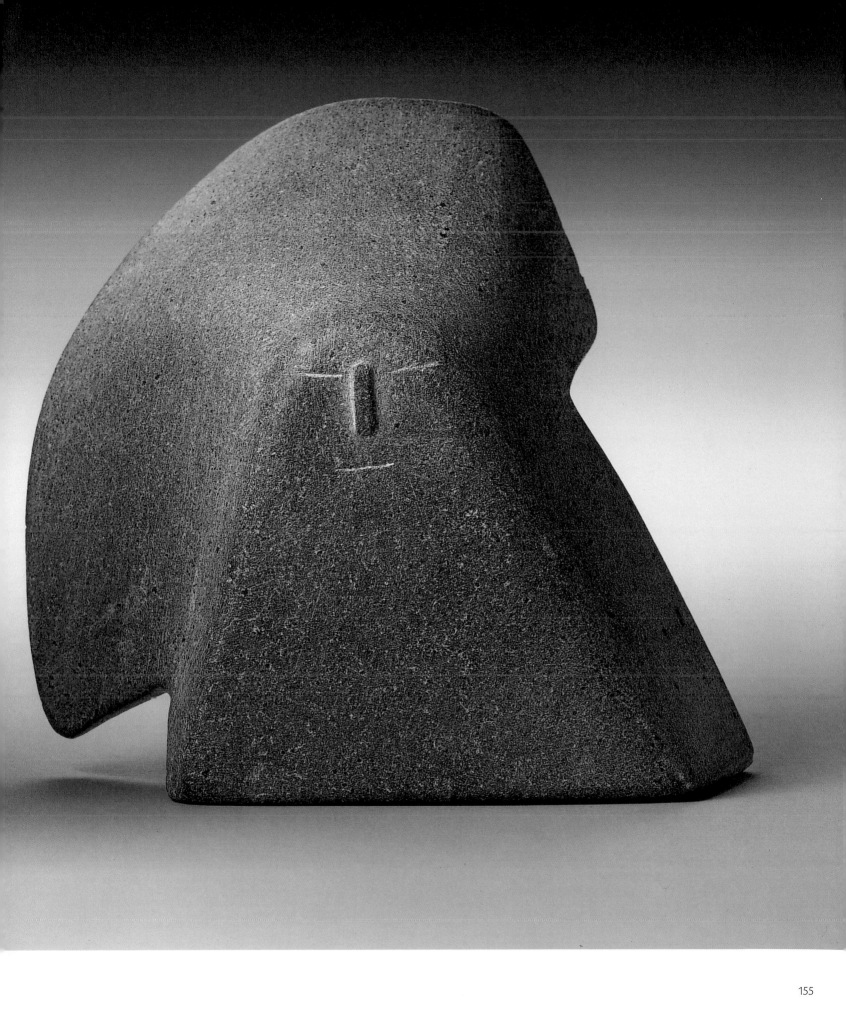

John Pangnark

Arviat

Pangnark allowed himself to be largely guided by the original shape of the stone, polishing or rounding what was already there. Here, this process led to the figure of a man, one arm outstretched, legs rather undefined. The arts and crafts officer in Arviat at the time recalls that, *his carvings are meant to stand, but he seldom smooths the bottom enough. If people comment on this, Pangnark moves the carving all over the table till he finds a place where it will stand, or he bends over and squints at the level of the table or floor, saying the building is crooked. Inevitably, he has to give in and file a flatter spot on the bottom of the carving.*

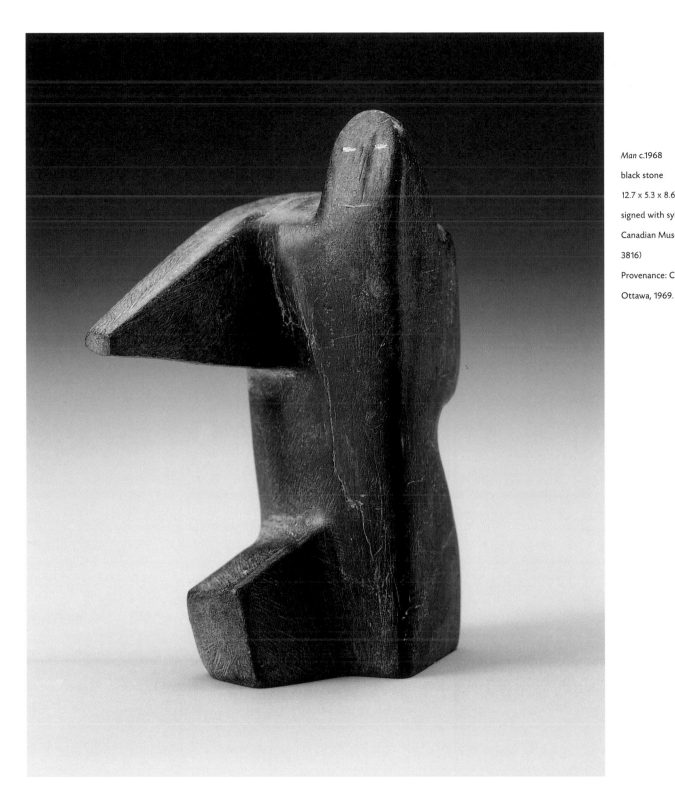

Man c.1968

black stone

12.7 x 5.3 x 8.6 cm

signed with syllabics

Canadian Museum of Civilization (IV-C-3816)

Provenance: Canadian Arctic Producers, Ottawa, 1969.

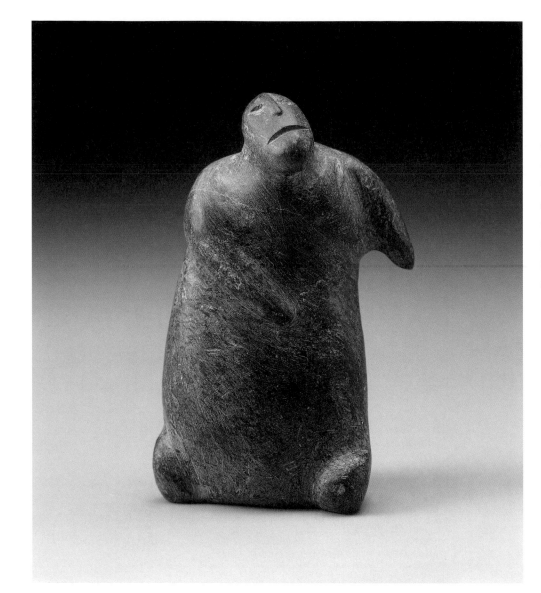

Standing Man c.1968

dark grey stone

10 x 5.8 x 3.9 cm

signed with syllabics

Canadian Museum of Civilization (IV-C-3931)

Provenance: Canadian Arctic Producers, Ottawa, 1969.

Lucy Tasseor Tutsweetok

1934–

Arviat

Lucy Tasseor Tutsweetok is one of Arviat's most renowned and exhibited artists. As is typical of her style, the figure is shown with most of the stone surface unarticulated. All the expressive emphasis is on the head, which is tilted upward. She has described what it felt like to be an artist: *One time a group of singers came to the community. My daughter was watching me while I was carving. She asked me if carving a sculpture was the same as singing. I replied, "Yes, it is."* (Personal communication with Ingo Hessel, 1990)

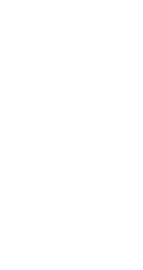

Heads Emerging from Stone 1969
black stone
13.5 x 13.5 x 7 cm
signed with syllabics
Canadian Museum of Civilization (IV-C-4075)
Provenance: Canadian Arctic Producers, Ottawa, 1969.

The theme of heads growing out of an unarticulated piece of rock is Lucy Tasseor's main theme. She recalls how she was first inspired:

When I first started carving, no one was interested in buying my work. Finally my grandfather advised me. He showed me what to carve by drawing in the sand. He drew a figure with many heads. It was only then that people became interested and started to buy my carvings. (Personal communication with Bernadette Driscoll, May 1982)

Silas Sikikau Paopa

1911–1982

Arviat

The long, distorted body with two small heads is reminiscent of contemporary Western sculpture, especially by Henry Moore. Unlike other Arviat sculpture, this figure is actually engaged in an activity, indicated by the two instruments used to beat off the snow from clothing whenever one entered an igloo. This narrative element is reinforced by both figures' smiling. There is little known about this artist. Like many Inuit during the 1950s and '60s, he may have tried carving for a while and then gone on to other activities.

Woman and Child c.1968

grey stone, antler

28 x 12 x 12 cm

unsigned

Canadian Museum of Civilization (IV-C-3747)

Provenance: Canadian Arctic Producers, Ottawa, 1969.

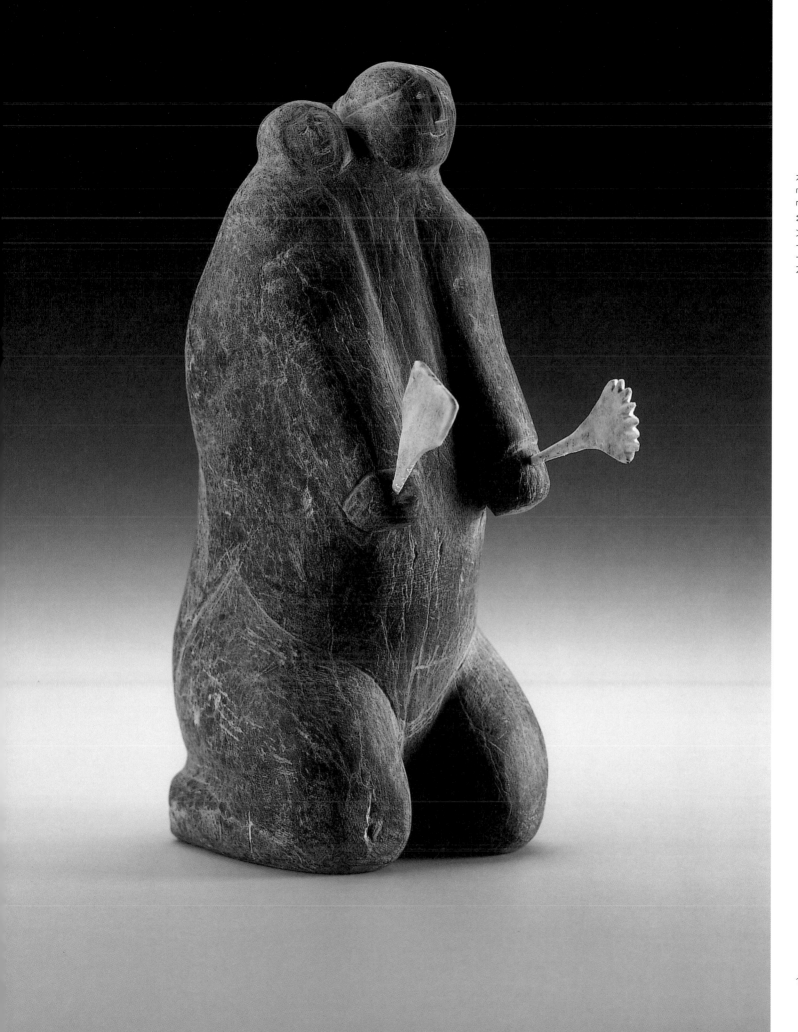

Margaret Uyauperq Aniksak

1905–1993

Arviat

It appears that Margaret Uyauperq Aniksak was quite unaware of the beauty and power of her work. She tended to be very shy about it. She preferred to work out of doors, but if anyone came to look, she would quickly wrap up the stone in a piece of canvas and run inside.

When I began carving, I used to think of my children, how they were going to get food and clothing… but I do not carve only for money. I want my children to be proud of me, of what I did, and I want them to be happy about the carvings. (Personal communication with Ingo Hessel, 1990)

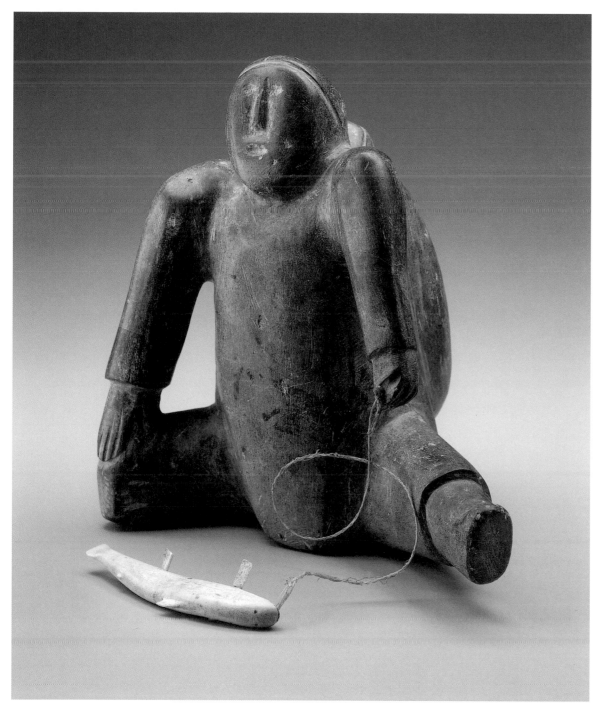

Woman Fishing 1967

grey stone, antler

25 x 26 x 18 cm

unsigned

Collection of James Houston

Provenance: Hudson's Bay Company post, Arviat, 1967.

Qamanittuaq

(formerly called Baker Lake)

I didn't want to live in Baker Lake at first, but I settled down and it became my hometown when I was 13 years of age. I did not like it at first because the young men and even the grown men would gang up on me. Secondly, there was no place to go eat country food, nobody to hunt or fish for us. Almost every day we were half-starving, but when we learned to work we were able to survive. We went to school with empty stomachs, went to church with no food in our stomachs because no one was permitted to stay home unless they were really sick.

Every single one of the people went to church when it was time to go. The Minister, Reverend Canon James, would go after you if you missed one service, and you'd better have some good explanations for him … The Bay manager was also strict. And the Anglican minister was strict. I don't know too much about the R.C. Mission priests. They were very kind, that's all. The teachers were very strict too. We had to run to school, not be a minute late. No chewing gum in school. Speak English only. Even if we couldn't speak English, we had to try hard!

—William Noah, "Starvation on the Land and my Experience in Baker Lake" in *Qamanittuaq: Where the River Widens* (Guelph: Macdonald Stewart Art Centre, 1995.)

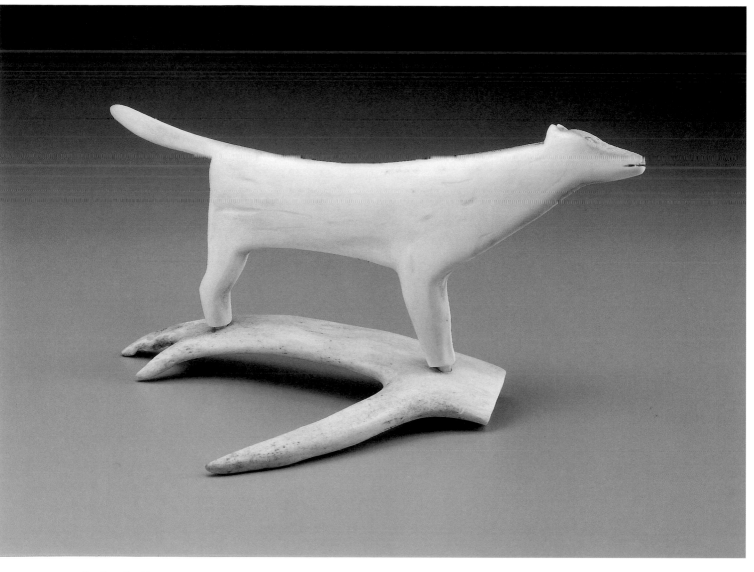

Luke Iksiktaaryuk

1909–1977

Baker Lake

Luke Iksiktaaryuk captures the dog in a state of alertness with a minimum of detail. The animal is attached with a peg to a piece of unworked antler. Its lifted tail, the tension in the neck thrust forward, and the raised ears imbue it with life. In its understated simplicity, this sculpture is a marvel of refinement and minimalism achieved in a very limiting and difficult medium.

Dog 1963

antler

13.2 x 26.8 x 16 cm

unsigned

Canadian Museum of Civilization, gift of the Department of Indian Affairs and Northern Development, 1989 (NA 1334)

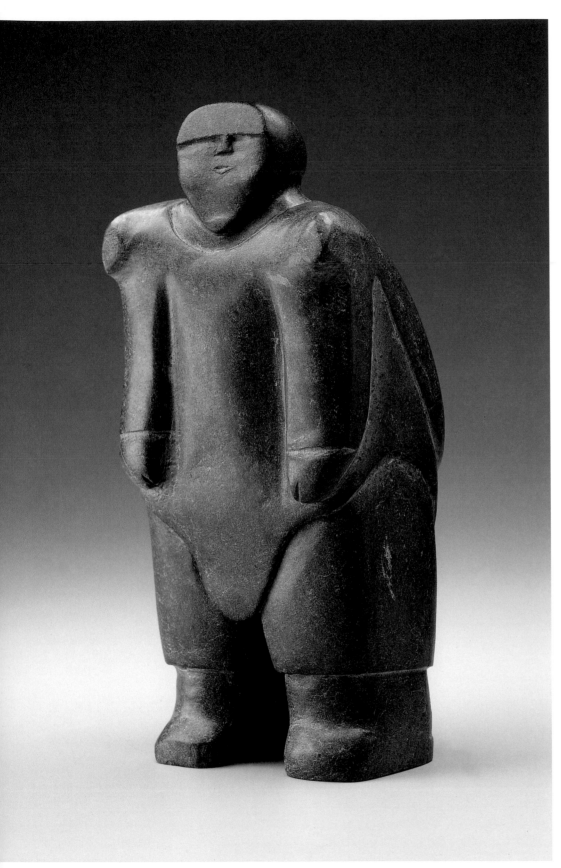

Woman c.1964

dark grey stone

31.9 x 13.5 x 11.5 cm

signed with syllabics

Canadian Museum of Civilization, gift of the Department of

Indian Affairs and Northern Development, 1989 (NA 1322)

Francis Kaluraq

1931–1990

Baker Lake

The hood in the back and the apron in front are the
only indications that this is the representation of a
woman. Firmly planted on two massive feet, she
seems to face the world in a defiant, challenging
pose. The emphasized shoulders add a touch of
elegance and femininity to an otherwise stern and
forbidding figure. There are only few of Kaluraq's
pieces known in public collections, each as
impressive and memorable as this one.

Thomas Sivuraq

1940–

Baker Lake

Thomas Sivuraq lived on the land as long as he could, even after his siblings had been evacuated by plane because they were starving. His parents died and he stayed alone running his trapline.

When I came here, I was at my wits' end. I was going through a hard time for a while. My dogs were on the verge of starvation. I met up with another dog team on the way back to Baker with a canoe they had picked up in the spring. My dogs were so weak that the whole team was put in the canoe with me to go back to Baker Lake. My dogs had no strength because they were starving.

(Personal communication with Henry Kudluk, August 1998)

Mother and Child c.1968

black stone

35 x 24.5 x 37 cm

signed with syllabics and disc number

(E2-236)

Canadian Museum of Civilization

(IV-C-3665)

Provenance: Canadian Arctic Producers,

Ottawa, 1968.

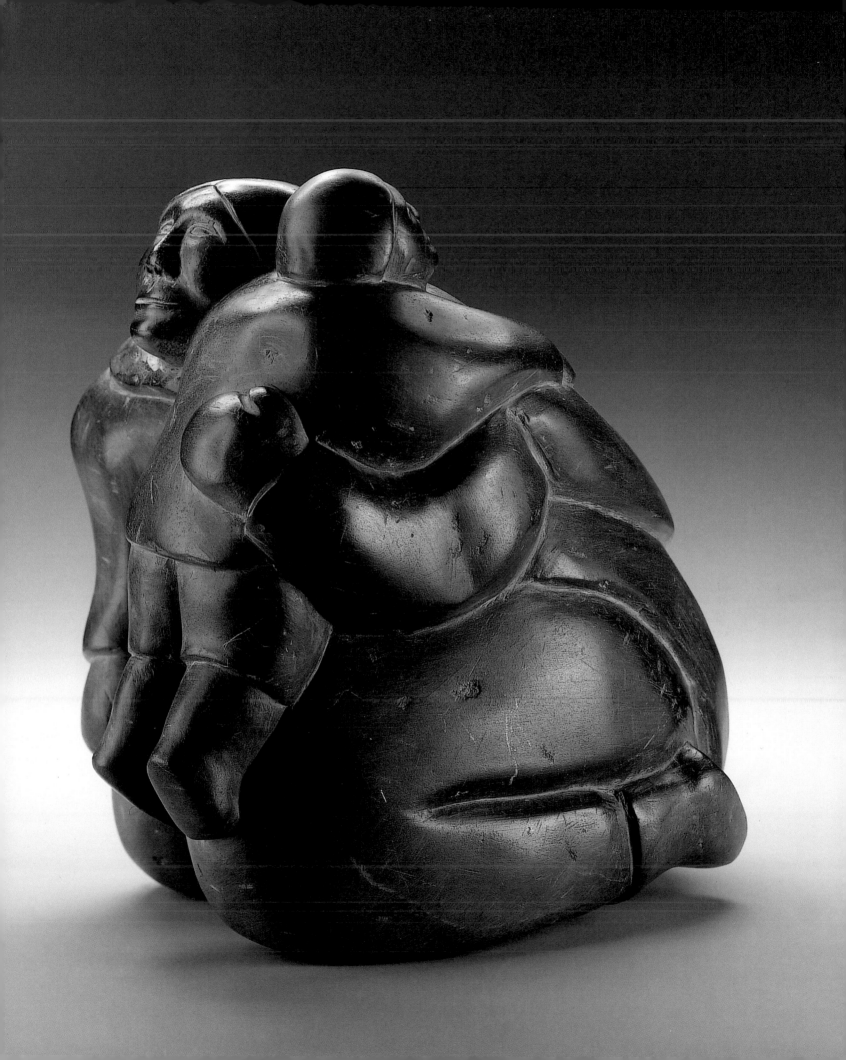

Yvonne Kanayuq Arnakyuinak

1920–

Baker Lake

Depicting a close-knit family scene, this piece already shows all the features characteristic of a group of women sculptors in Baker Lake: the relatively small, intimate size and the depiction of a family group. The lively, playful interaction between the mother and her four children, all clustered around her, makes this early piece especially appealing.

In the past, Inuit living in the Keewatin area west of Hudson Bay had experienced the death of whole families due to starvation when the caribou migration failed. These memories, Houston believes, have made Inuit there especially eager to portray mother and child or children, a sign that hunting families are successfully surviving again.

Mother and Four Children 1957

greenish black stone

11.3 x 7 x. 9 cm

signed with disc number (E2-24)

Collection of James Houston

Provenance: Hudson's Bay Company post, Churchill, 1957.

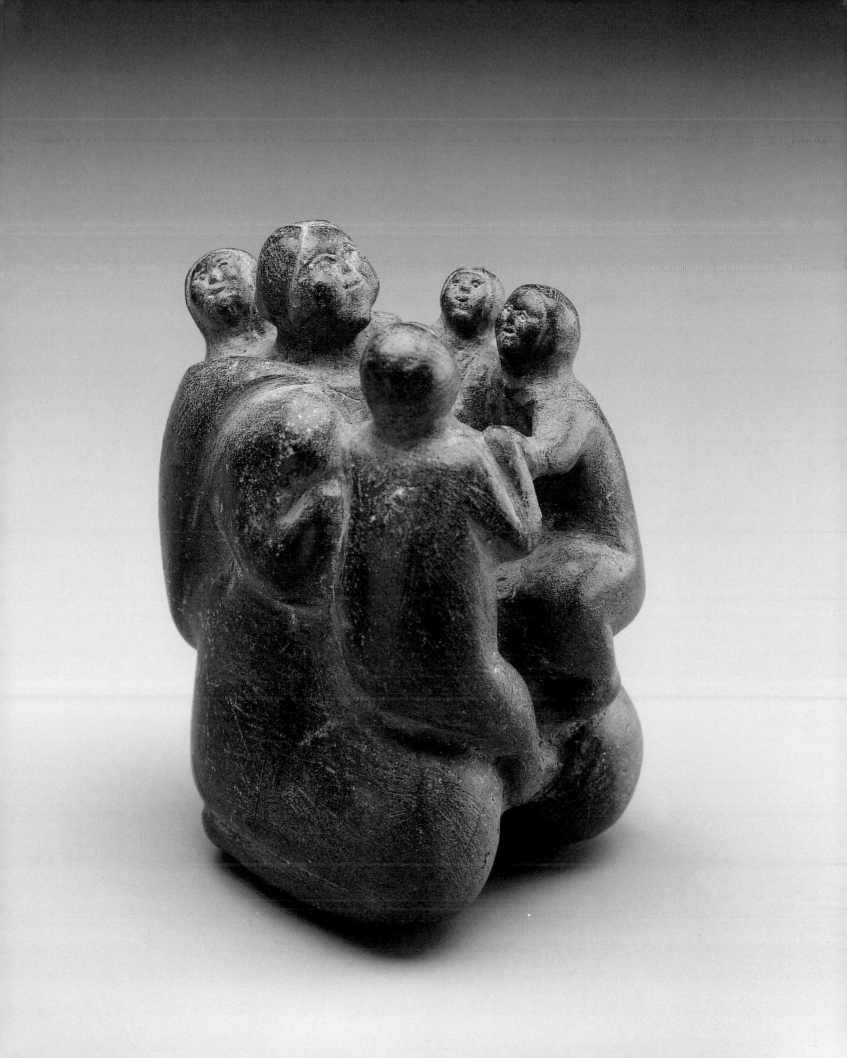

Rankin Inlet

The social and economic environment [in Rankin Inlet] is distinct from that of any other Inuit community. The typically Inuit subjects of animals, hunting, and daily activities associated with the hunt are seldom represented in Rankin Inlet art. Instead the recurring subject is the human figure. Would it be an exaggeration to say that [as the people are] caught up in a lifestyle which bears little resemblance to traditional Inuit life, there emerges among Rankin Inlet artists a preoccupation with the human form and the human condition?

—Bernadette Driscoll, *Rankin Inlet/Kangirlliniq* (Winnipeg: Winnipeg Art Gallery, 1981).

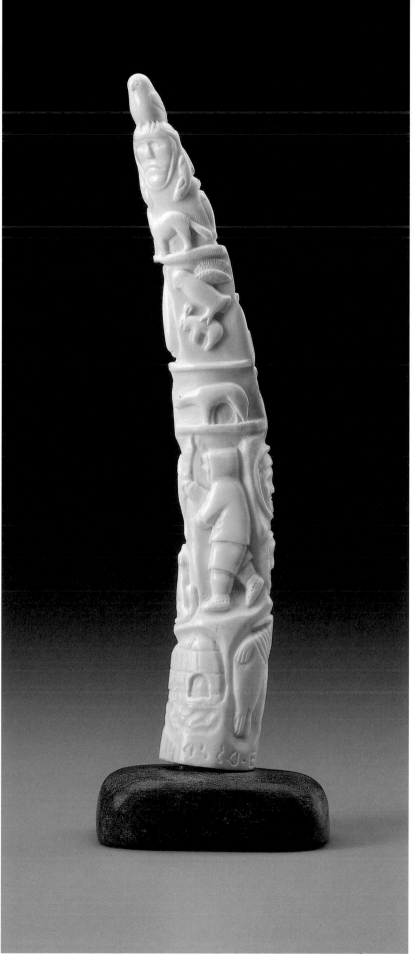

Laurent Aksadjuak

1935

Rankin Inlet

Rather than engrave linear designs in the tradition of scrimshaw, Laurent Aksadjuak has chosen to sculpt images into the tusk. The artist participated in a government-sponsored ceramics project, learning to decorate pots with scenes made out of clay, which then were applied to the surface of the container. This may have inspired his more sculptural approach to the ivory tusk.

Carved Walrus Tusk 1964

ivory, stone

29.5 x 5.1 x 8.9 cm

signed with syllabics and disc number (E1-17)

Canadian Museum of Civilization, gift of the Department of

Indian Affairs and Northern Development, 1989 (NA 1225)

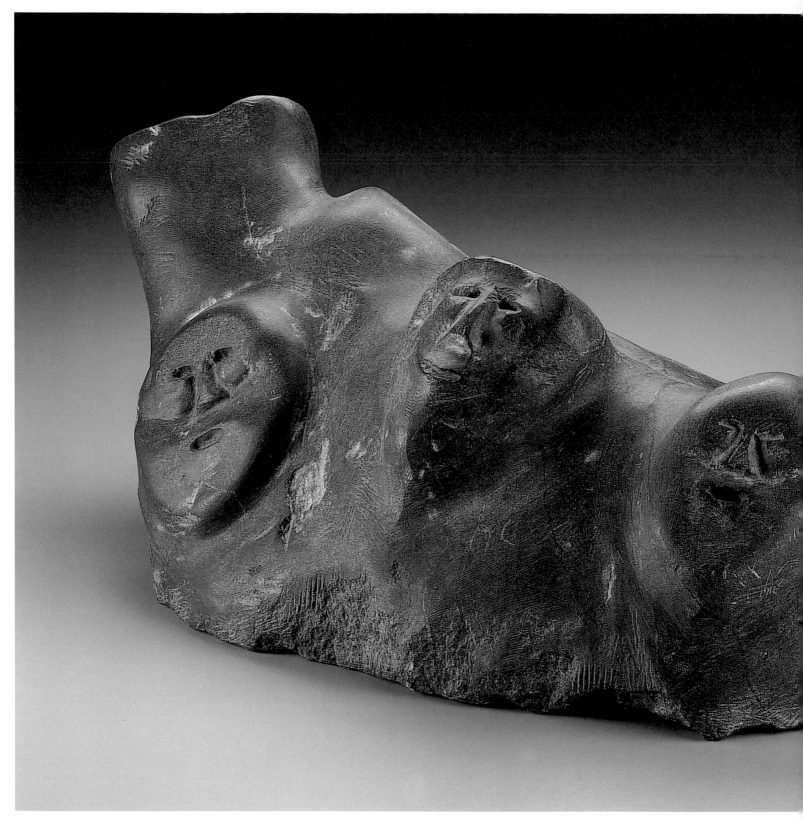

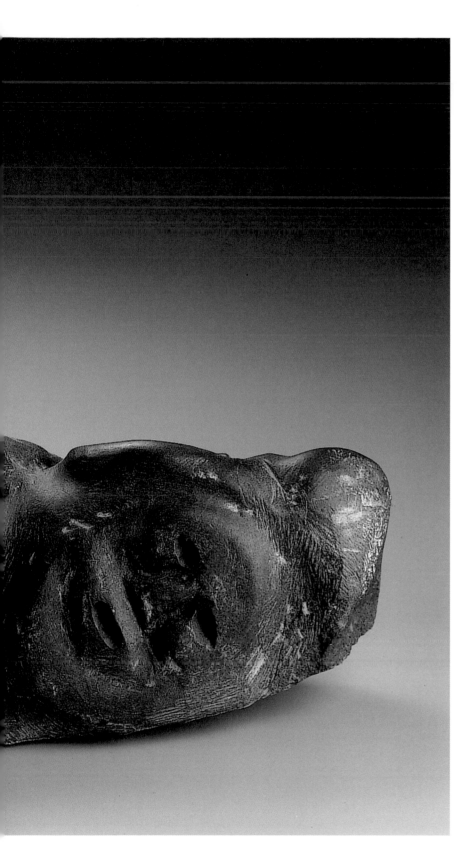

John Tiktak

1916–1981

Rankin Inlet

The motif of multiple heads emerging from a background is a popular one in the Keewatin and can be found in stone, prints, and wall hangings. In Tiktak's piece, the heads seem to be still part of the rock, almost like fossils. The rough surface and the natural untouched contour of the stone reinforce the sense of something organic, made by nature rather than man.

Heads Emerging from Stone c.1967

grey stone

25 x 68.1 31.5 cm

unsigned

Canadian Museum of Civilization (IV-C-3771)

Provenance: Lippel Gallery, Montreal, 1968.

John Tiktak

1916–1981

Rankin Inlet

John Tiktak emphasizes the heaviness of his medium. Large volumes of stone are unadorned, with only the two openings that separate the arms from the figure's torso breaking up the massive planes. And yet there is nothing clumsy or crude about this figure. Arms and shoulders are sensuously rounded, and the head and encircling arms form a pleasing rhythm of two concentric shapes. Donat Anawak said about his colleague: *Tiktak was badly hurt when the mine was here; he is deaf, weak, and elderly. Without the arts program he would have nothing and be nobody, but everybody knows him through his work.* (Personal communication with George Swinton, August 1971)

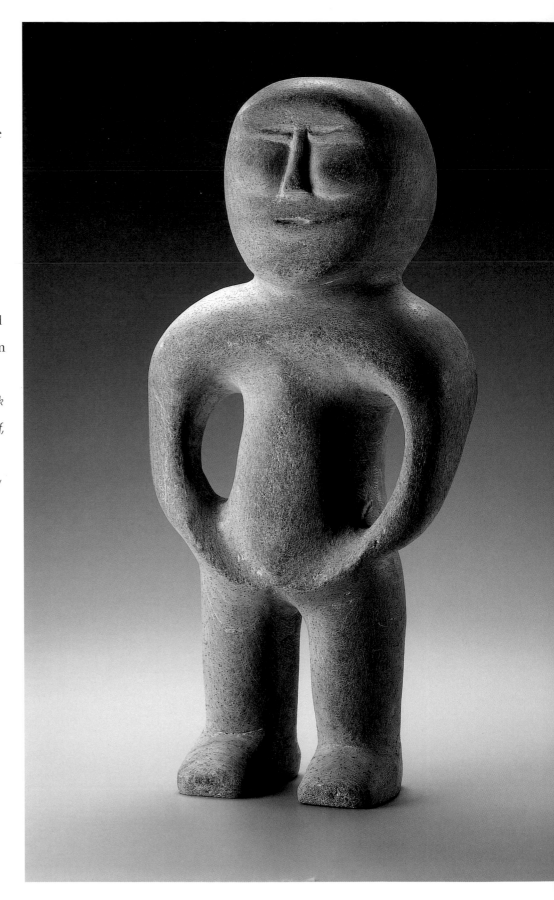

Man 1965

grey stone

62.5 x 30 x 15 cm

signed with syllabics and disc number (E1-266)

Canadian Museum of Civilization, gift of the Department of

Indian Affairs and Northern Development, 1989 (NA 1329)

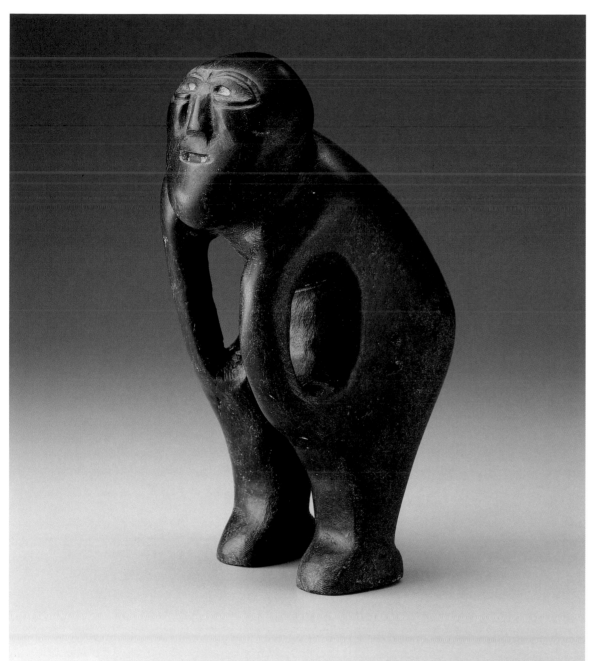

Standing Stone Figure 1967
black stone
32 x 12.5 x 16 cm
signed with syllabics
Collection of James Houston
Provenance: James Houston, purchased
from the artist, 1967.

In Tiktak's figures, arms grow out of the shoulder and into the torso in one graceful sweep. This figure of a hunter or perhaps an old person, hand on his hip, stoops forward, which gives movement to the highly stylized figure. Tiktak claimed that he worked without premeditation, that he took a piece of stone and let the shape that was inside emerge.

I enjoy carving best of all the things I do. I have a son who lives here. I hope that he will grow up to be a carver. It's a good life changing dreams into stone. (Personal communication with James Houston, April 1970, travelling for the Canadian Eskimo Arts Council)

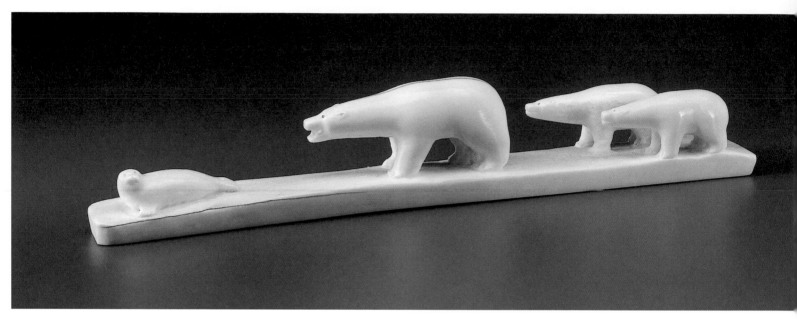

Pierre Karlik

1931–

Rankin Inlet

Pierre Karlik was taught how to carve by a mission helper while he was hospitalized in Chesterfield Inlet in the mid-1950s. Unlike his contemporaries, he grew up in the settlement because his caretakers, his grandparents, lived near the Catholic mission that supported them. His work is often on a much larger scale than this little scene of a mother bear stalking a seal. Because of the monumental nature of his work, he has carried out several commissions for large-scale sculptures, among them *Inuit Ublumi* for the Canadian Museum of Civilization.

Bear, Cubs, and Seal 1965

ivory

4.5 x 3.3. x 24 cm

signed KARLIK plus syllabics and disc number (E3-145)

Canadian Museum of Civilization, gift of the Department of Indian Affairs and Northern Development, 1989 (NA 1220)

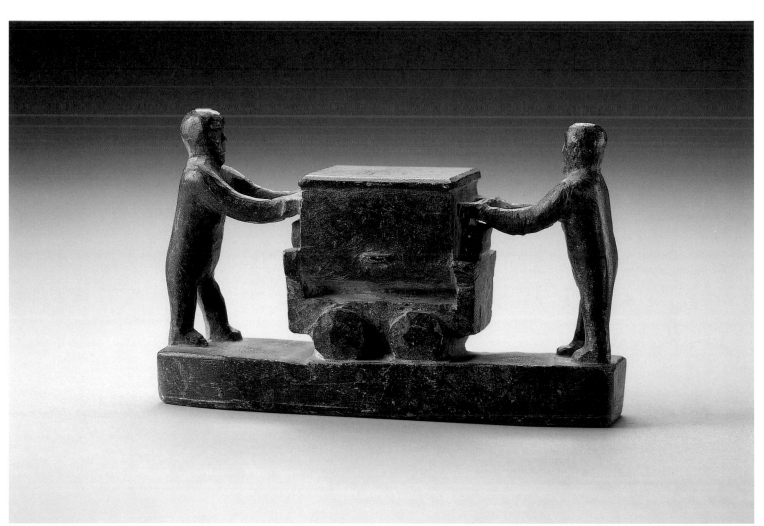

Vital Okoktok

1912–c.1981

Rankin Inlet

Rankin Inlet owes its existence to the opening of a nickel mine in 1957, which attracted many Inuit from surrounding camps who were going through severe hardship. This piece documents the particular experience of working in a mine, a dramatic change from camp life. When the mine closed in 1962, many Inuit were left without employment. In response, the federal government initiated the ceramics project in 1964.

Nickel Miners c.1960

black stone

7.8 x 4 x 12.2 cm

unsigned

Canadian Museum of Civilization (IV-C-4713)

Provenance: Innuit Gallery, Toronto, 1979.

Collected by Dr. William Taylor, Ottawa, purchased 1979.

John Kavik

1897–1993

Rankin Inlet

John Kavik started carving in his early sixties, after working for three years in the local nickel mine. His work is stark and roughly hewn, with chisel marks and deeply cut gouges adding to its expressive force. His fellow carver Donat Anawak said about him: *Look at Kavik, an old, old man who cannot hunt or fish very much any more and he cannot have a regular job with the white people, but he can make money for himself and enjoy himself very much. He enjoys making what the white people also enjoy having. Without the arts and crafts project, Kavik would not be the happy man he is now.* (Personal communication with George Swinton, 1971)

Mother and Child c.1967

grey stone

52.5 x 17 x 22 cm

unsigned

Canadian Museum of Civilization (IV-C-3797)

Provenance: Canadian Arctic Producers, Ottawa, 1968.

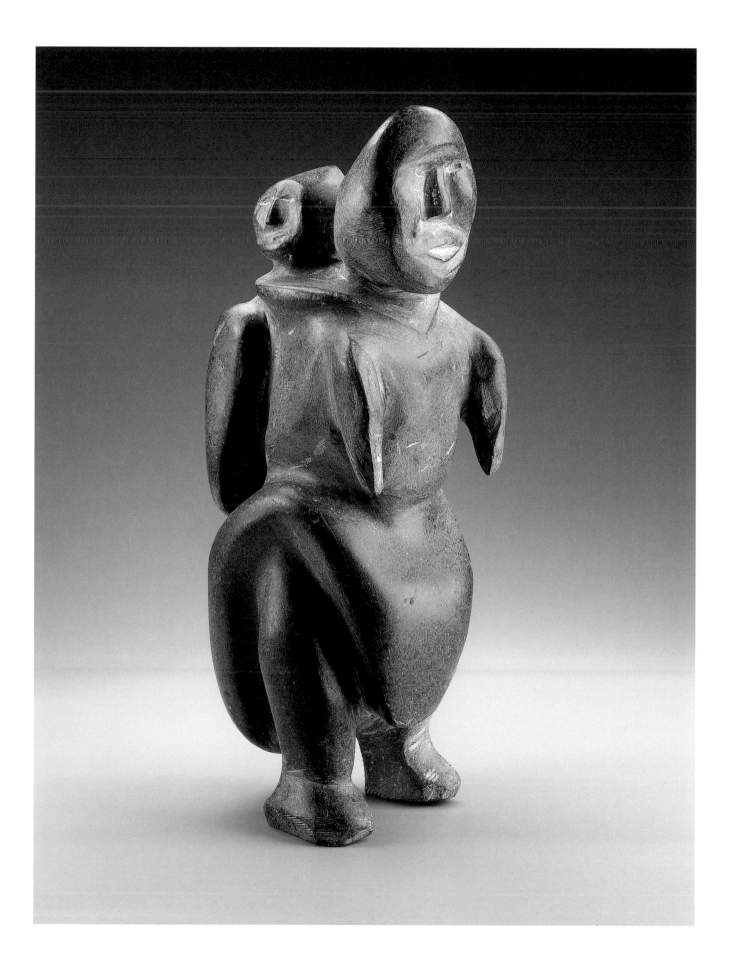

Taloyoak

(formerly Spence Bay)

The traditional inhabitants of the Taloyoak area were the Nattilik Inuit, the Nattilingmiut, a people largely sustained by the abundance of seals in the region, which provided their main source of food and clothing.

The search for the Northwest Passage has played an important role in the contemporary history of the Taloyoak region. The first significant European exploration here occurred between 1829 and 1833, when Sir John Ross and his crew combed the area after their ship became trapped in ice. Between 1848 and 1860, the area was visited extensively by British and American sailors searching for the lost Franklin Expedition.

The foundation of the modern community began in 1948 when poor ice conditions forced the Hudson's Bay Co. to close its trading post at Fort Ross on the south coast of Somerset Island, some 250 kilometres north of Taloyoak. The post was relocated to its present location at Stanners Harbour, and Taloyoak— then known as Spence bay—was born.

—*Nunavut Handbook 1999* (Iqaluit: Nortext Multimedia Inc., 1998), 268.

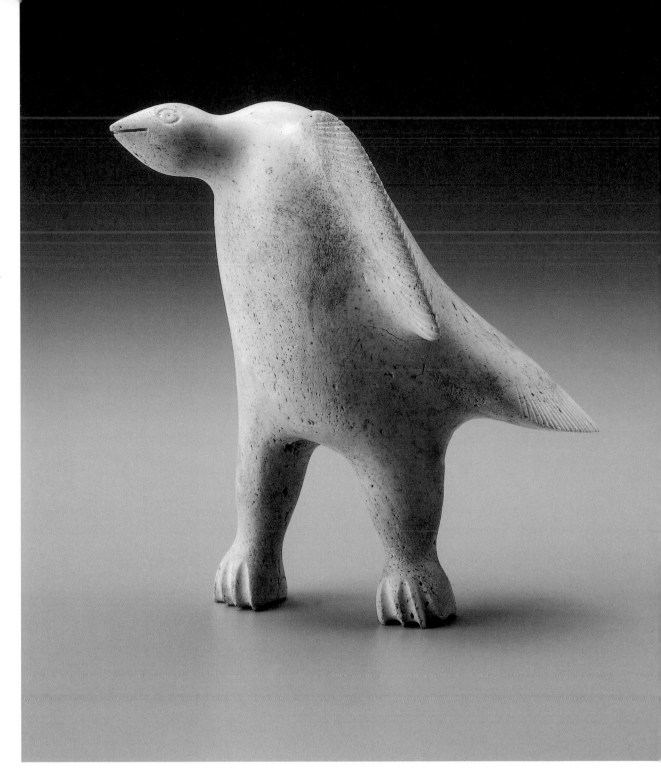

Bird 1970

whalebone

16.7 x 16.3 x 10.3 cm

unsigned

Canadian Museum of Civilization (IV-C-4397)

Provenance: Government of the Northwest Territories, Iqaluit, 1970.

Karoo Ashevak

1940–1974

Taloyoak

This piece won third prize in a competition organized by the Canadian Eskimo Arts Council in 1970. Although it does not display the features that Karoo Ashevak's work has become famous for, it certainly shows his enormous talent and brought his work for the first time to the attention of art critics and dealers.

Karoo Ashevak

1940–1974

Taloyoak

Whalebone is the material most associated with sculpture from Taloyoak. To encourage carving production, the federal government in 1965 decided to fly in by charter a shipment of whalebone from Somerset Island, where great quantities had been left by the prehistoric Thule Eskimos and subsequent European whalers. Ashevak was the first to exploit the inherent expressive possibilities of this unusual carving material.

Drum Dancer 1972

whalebone, ivory, stone

44.6 x 17.3 x 18 cm

signed with syllabics

Canadian Museum of Civilization (IV-C-4293)

Provenance: Innuit Gallery, 1972; purchased by Helga Goetz at CMC, 1972.

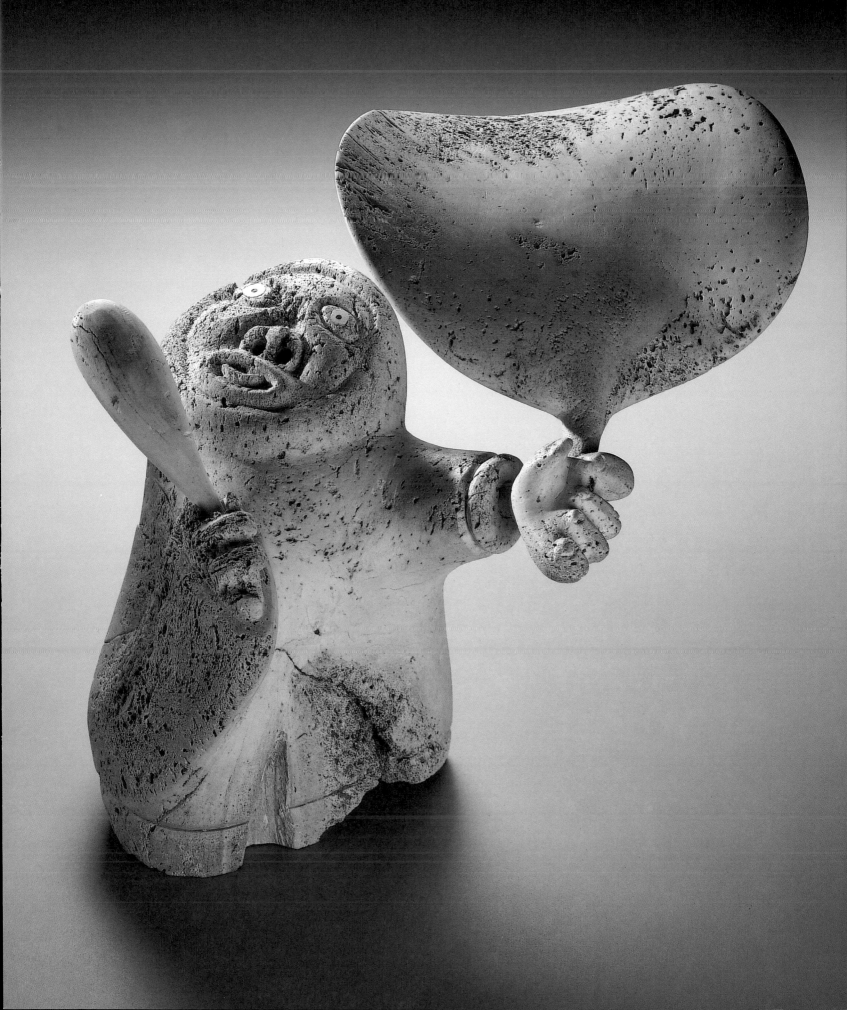

Karoo Ashevak

1940–1974

Taloyoak

By 1971 Karoo Ashevak had fully developed his own style of whimsical, often grotesque, spirit and shamanic figures made of assembled pieces of whalebone. The distorted faces are reminiscent of Tupilak spirit figures from Greenland and Alaskan masks. Ashevak initiated an approach that has to this day influenced the style of artists from Taloyoak and neighbouring Gjoa Haven.

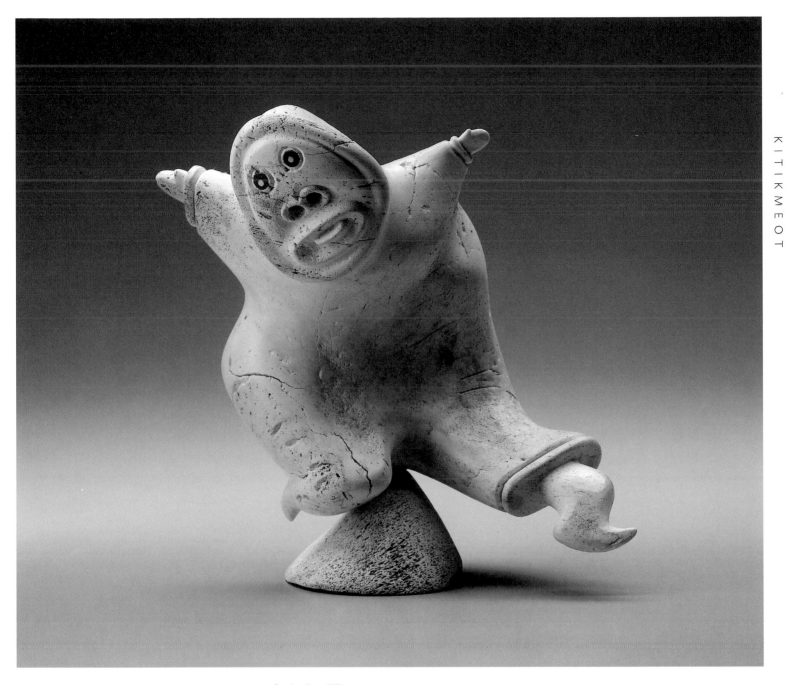

Dancing Man c.1971

whalebone, stone, ivory

24 x 24.6 x 15 cm

signed with syllabics

Canadian Museum of Civilization, gift of Samuel and Esther

Sarick, Toronto, 1972 (IV-C-4299)

Provenance: Innuit Gallery, Toronto, 1972; Samuel and Esther

Sarick, Toronto, 1972.

Notes

Fifty Years of Thinking It Over

1 Jorgen Meldgaard, *Eskimo Sculpture*. (London: Methuen & Co., Ltd., 1960), 38.

2 Personal communication, Cape Dorset, 1953.

3 Jean Blodgett, *In Cape Dorset We Do It This Way: Three Decades of Inuit Printmaking*. (Kleinburg, Ontario: McMichael Canadian Art Collection, Matthews, Ingham & Lake Publishing Company, 1991), 67.

4 James Houston, *Zigzag: A Life on the Move*. (Toronto: McClelland & Stewart, 1998), 262.

5 *The Spark*, Houston Films, 1999.

6 Blodgett, 101.

7 Ibid., 93.

8 Ibid., 66–67.

9 Ibid., 67.

10 Dorothy Eber, ed., *Pitseolak: Pictures Out of My Life*. (Toronto: Oxford University Press, 1977), 92.

The Artists Speak

1 Simionie Kunnuk, "John Arnalujuak: 'What is the point of not using ivory that is there to use?'" *Inuit Art Quarterly* 13, no. 4: 24.

2 Virginia Watt, "In Retrospect," *Inuit Art Quarterly* 3, no. 4: 39.

3 Ed Horn, "A Sense of Self: A Sense of Place," *Belcher Islands/Sanikiluaq* (Winnipeg: Winnipeg Art Gallery, 1981), 11.

4 Edmund Carpenter, *Eskimo* (Toronto: University of Toronto Press, 1959), n.p.

5 Mame Jackson, "The Ashoonas: In Touch with Tradition," *North* 19, no. 3 (Fall 1982): 16.

6 July Papatsie, "Historic Events and Cultural Reality: Drawings of Simon Shaimaiyuk," *Inuit Art Quarterly* 12, no. 1: 21.

7 Felix Klee, ed., *The Diaries of Paul Klee* (Berkeley and Los Angeles; University of California Press, 1974).

8 Jean Blodgett and Marie Bouchard, *Jessie Oonark: A Retrospective* (Winnipeg: Winnipeg Art Gallery, 1986), 24.

9 William Noah, "Part of My Life," *Baker Lake 1972* (Ottawa: Canadian Arctic Producers, 1972), n.p.

10 Blodgett, 20.

11 Dorothy Eber, *Pitseolak: Pictures* of My Life (Toronto: Oxford University Press, 1971), n.p.

12 Dorothy Eber, "Talking with Artists," *In the Shadow of the Sun: Perspectives on Contemporary Native Art* (Hull: Canadian Museum of Civilization, 1988), 440.

13 Andy Mamgark, "Of Fading Tradition and Survival," *Ajurnarmat*, Autumn 1978: 108.

14 *Pangnirtung 1976 Prints* (annual catalogue).

15 Simionie Kunnuk, "Pauta Saila: I've been carving soapstone the whole time so my family won't go hungry," *Inuit Art Quarterly* 11, no. 4: 4.

16 George Swinton, *Sculpture of the Inuit* (Toronto: McClelland and Stewart, 1994), 142.

17 *West Baffin Eskimo Cooperative* (Toronto: Herzig Somerville Ltd., 1978), 67.

18 Bernadette Driscoll, *Uumajut: Animal Imagery in Inuit Art* (Winnipeg: Winnipeg Art Gallery, 1985), 46.

19 Eber, *Pitseolak*, n.p.

20 Ibid.

21 Henry Kudluk, unpublished interviews (Canadian Museum of Civilization and Inuit Art Foundation).

22 Marybelle Myers (Mitchell), ed., *Davidialuk 1977* (Montreal: La Fédération des Cooperatives du Nouveau-Québec, 1977).

23 Swinton, 23.

24 Ibid.

25 Kunnuk, "Pauta Saila": 23.

26 *The Inuit World* (Cape Dorset: Kingait Press, 1977), 20.

27 Marybelle Myers (Mitchell), "Josie Papialuk," *The Beaver*, Summer 1982: 23.

28 Kudluk.

29 Kenojuak Ashevak, "Foreword," *1993 Cape Dorset Annual Graphics Collection* (Toronto: Dorset Fine Arts, 1993), n.p.

30 Eber, *Pitseolak*, n.p.

31 Marybelle Mitchell (Myers), "Paulosie Sivouak talks about the beginning of carving in Povungnituk," *Inuit Art Quarterly* 10, no. 4: 52–59.

32 Watt, 39.

33 Christopher Paci, "Commercialization of Inuit Art: 1954–1964," *Etudes Inuit Studies* 20, no. 1 (1996): 50.

34 Darlene Wight, *The First Passionate Collector: The Ian Lindsay Collection of Inuit Art* (Winnipeg: Winnipeg Art Gallery, 1991), 81.

35 Ibid.

36 Ibid., 61.

37 Ibid., 71.

38 Mark Kalluak, *Pelts to Stone: A History of Arts and Crafts Production in Arviat* (Ottawa: Indian and Northern Affairs Canada, 1993), 3.

39 Kudluk.

Bibliography

The Artists Speak

Ashevak, Kenojuak. "Foreword." 1993 Cape Dorset Annual Graphics Collection. Toronto: Dorset Fine Arts, 1993.

Bagg, Shannon. "Without Carving How Would I Survive? Economic Motivation and its Significance in Contemporary Inuit Art." Ottawa: Carleton University. M.A. thesis, 1997.

Blodgett, Jean, and Marie Bouchard. Jessie Oonark: A Retrospective. Winnipeg: Winnipeg Art Gallery, 1986.

Carpenter, Edmund. Eskimo. Toronto: University of Toronto Press, 1959.

Driscoll, Bernadette. Uumajut: Animal Imagery in Inuit Art. Winnipeg: Winnipeg Art Gallery, 1985.

Eber, Dorothy. Pitseolak: Pictures of My Life. (tape-recorded interviews) Toronto: Oxford University Press, 1971.

———. People from our Side (a life story with photographs by Peter Pitseolak and oral biography by Dorothy Eber). Edmonton: Hurtig Publishers, 1975.

———. "Talking with the Artists." In the Shadow of the Sun: Perspectives on Contemporary Native Art, 425–42. Hull: Canadian Museum of Civilization, 1988.

Horn, Ed. "A Sense of Self/A Sense of Place." Belcher Islands/Sanikiluaq, 11–15. Winnipeg: Winnipeg Art Gallery, 1981.

Houston, James. "Eskimo Handicrafts: A Private Guide for the Hudson's Bay Company Manager," (unpublished ms), 1953.

Inuit World, The (Cape Dorset: Kingait Press, 1977).

Jackson, Mame. "The Ashoonas: In Touch with Tradition." North 19, no. 3 (Fall 1982): 14–18.

Kalluak, Mark. Pelts to Stone: A History of Arts and Crafts Production in Arviat. Ottawa: Indian and Northern Affairs Canada, 1993.

Klee, Felix, ed. The Diaries of Paul Klee. Berkeley and Los Angeles: University of California Press, 1974.

Kudluk, Henry. Interviews from 1998 with the following artists: (unpublished ms) Canadian Museum of Civilization and Inuit Art Foundation: Martina Anoee, Arviat; Mathew Akeeah, Baker Lake; Charlie Inukpuk, Inukjuak; Johnny Inukpuk, Inukjuak; Jacob Irkok, Arviat; Davidee Ittulu, Kimmirut; Henry Isluanik, Arviat; Pierre Karlik, Rankin Inlet; Iyola Kingwatsiak, Cape Dorset; Nuvaliaq Qimirkpiq, Kimmirut; Thomas Sivuraq, Baker Lake; Pauta Saila, Cape Dorset; Lukta Qiatsuk, Cape Dorset.

Kunnuk, Simionie. "An Interview with Qaqaq Ashoona." Inuit Art Quarterly 11, no. 2: 21–27.

———. "Pauta Saila: I've been carving soapstone the whole time so my family won't go hungry." Inuit Art Quarterly 11, no. 4: 4–5.

———. "John Arnalujuak: 'What is the point of not using ivory that is there to use?'" Inuit Art Quarterly 13, no. 4: 24–26.

Mamgark, Andy. "Of Fading Tradition and Survival." Ajurnarmat, Autumn 1978: 108–113.

Mitchell (Myers), Marybelle. Paulosie Sivouak talks about the beginning of Carving in Povungnituk. Inuit Art Quarterly 10, no. 4: 52–59.

Myers, Marybelle (Mitchell). "Josie Papialuk." The Beaver, Summer 1982: 22–29.

Myers, Marybelle (Mitchell), ed. Davidialuk 1977. Montreal: La Fédération des Coopératives du Nouveau-Québec, 1977.

Noah, William. "Part of My Life." Baker Lake 1972. Ottawa: Canadian Arctic Producers, 1972.

Paci, Christopher. "Commercialization of Inuit Art: 1954–1964." Etudes Inuit/Studies 20, no. 1: 45–62.

Papatsie, July. "Historic Events and Cultural Reality: Drawings of Simon Shaimaiyuk." Inuit Art Quarterly 12, no. 1: 18–22.

Swinton, George. Sculpture of the Inuit. Toronto: McClelland & Stewart, 1994.

Watt, Virgina. "In Retrospect." Inuit Art Quarterly 3, no. 4.

———. "In Retrospect." Inuit Art Quarterly 5, no. 1.

Wight, Darlene. The First Passionate Collector: The Ian Lindsay Collection of Inuit Art. Winnipeg: Winnipeg Art Gallery, 1991.

Williamson, Robert. "Eskimo Underground: Socio-Cultural Change in the Canadian Central Arctic." Occasional Papers II, Institutionen for Allman och Jamforande Etnografi vid Uppsala Universitet. Uppsala: Uppsala University, 1974.